纽约建筑摄影

老阎 著

清华大学出版社
北京

内 容 简 介

作者以纽约的市中心曼哈顿为拍摄对象，精选了三百多张精美的黑白照片。在这本摄影集里，可以看到建筑空间与人的生活交融在一起，形成生动的日常图景。曼哈顿从规划设计上和使用管理上都充分体现了人本主义，也展现了城市发展的时间延续性和包容性，呈现出丰富的空间多样性。作者老阎（毕业于清华大学建筑系）以建筑师和开发商的双重身份，聚焦于曼哈顿的新建筑与老建筑、建筑与人的关系。本书真实地记录了2022—2023年间的曼哈顿，对于建筑设计、建筑摄影及建筑实录都有一定的价值。

版权所有，侵权必究。举报：010-62782989，beiqinquan@tup.tsinghua.edu.cn。

图书在版编目(CIP)数据

纽约建筑摄影 / 老阎著. -- 北京：清华大学出版社，2024.8. -- ISBN 978-7-302-66766-7

I. J439.3

中国国家版本馆CIP数据核字第2024Y6J164号

责任编辑：刘一琳
封面设计：道　辙 @Compus Studio
责任校对：王淑云
责任印制：沈　露

出版发行：清华大学出版社
　　　　　网　　址：https://www.tup.com.cn，https://www.wqxuetang.com
　　　　　地　　址：北京清华大学学研大厦A座　　邮　　编：100084
　　　　　社 总 机：010-83470000　　　　　　　　邮　　购：010-62786544
　　　　　投稿与读者服务：010-62776969，c-service@tup.tsinghua.edu.cn
　　　　　质量反馈：010-62772015，zhiliang@tup.tsinghua.edu.cn
印 装 者：北京雅昌艺术印刷有限公司
经　　销：全国新华书店
开　　本：160mm×230mm　　印　　张：23.5　　字　　数：122千字
版　　次：2024年8月第1版　　　　　　　　　印　　次：2024年8月第1次印刷
定　　价：378.00元

产品编号：106336-01

前言

纽约的市中心，是由哈德孙河、伊斯特河及哈莱姆河围合的曼哈顿。而曼哈顿则主要是曼哈顿岛，也包括罗斯福岛及几个更小的岛。尽管曼哈顿的土地面积不足六十平方千米，但这个长约二十一千米、平均宽度不到三千米的狭长岛在三百多年的城市发展中，拥有了世界上数量最多、设计理念和建造技术最先进的摩天楼和众多共生其中的教堂、学校、图书馆、博物馆、司法和行政建筑、影音剧院、城市公园及各种商业建筑。可以说，曼哈顿建筑不仅代表着纽约甚至美国建筑的最高水平，也是世界近现代建筑的博览会。

出于专业兴趣，1996年夏至2021年的二十五年间，我曾多次造访曼哈顿，但都来去匆匆，印象最深的竟是只有一面之缘的世界贸易中心双子塔。双子塔令人如此震撼，以至于那天我顶着被摩天楼放大的乱风，仰视双塔并围着它转了两圈，却忘了拍照。

直到2022年和2023年，我有幸先后两次在曼哈顿的百老汇居住了近九个月。在此期间，我尽量步行外出，试图游览曼哈顿所有的重要建筑和时尚走廊。但由于曼哈顿的建筑太过密集且建筑工地格外多（既有新建，又有大量

老建筑在修复和改造），求全远不可能。我所能做的，就是认真地拍好我可以捕捉到的有趣瞬间。

这段时间我收获了大约七千张照片，从中精选约百分之五的黑白照片，编辑成书与您分享。游览曼哈顿令我感触颇多，拍摄建筑及其环境是有感而动的结果。回到北京，在整理照片的过程中，曼哈顿的建筑特色在我的脑海中愈发清晰起来。

首先，曼哈顿在规划设计上和使用管理上都体现了建筑人本主义。这是令我感触最深的，并自然而然地体现在我的摄影构图中。建筑无论多么高大或庄严，都应有接近人尺度的细节方便使用。曼哈顿建筑的台阶、门廊、广场及水池都是对人友好且开放的，甚至连施工工地的安全廊都很人性化。建筑为人的休闲、交往和行走增添了方便和情趣，同时，活跃在其中的人也为建筑和环境增添了活力。

其次，曼哈顿的建筑展现了城市发展的时间延续性和包容性。这既得益于私营组织在曼哈顿城市发展中与生俱来的对已有建筑的保护意识，又得益于曼哈顿城市规划对最初发展而成的下城道路系统和纵向贯穿曼哈顿岛的百老汇大道原始路由的保护，当然更离不开1966年颁布的美国《国家历史保护法》及之后的纽约土地开发权转移交易法规的实施。土地开发权转移的理念，对曼哈顿城市建筑的发展至关重要，既满足了保护历史建筑的资金需求，也鼓励了开发创新建筑的空间突破，使新老建筑实现了双赢并彼此尊重。

最后，曼哈顿的建筑呈现出丰富的空间多样性。究

其原因，恰恰是历史保护、人文情怀及技术创新综合作用的结果。其中较为突出的是曼哈顿的天际线和山脊线给人的视觉震撼和空间体验。曼哈顿的天际线融合了三百多年历史建筑的文脉和创新超高建筑的跳跃，凝固成波澜壮阔的交响乐。曼哈顿的山脊线则源于因印第安人在岛上打猎、交往而自然形成的纵贯狭长岛的步道，形成了在城市规划中被重点保留和发展的交通和视觉主轴——全程近二十五千米的百老汇大道。其起点的第一个大型建筑恰好是美国印第安人博物馆，末端则是连接布朗克斯的百老汇桥。其间串连铜牛、华尔街、三一教堂、世界贸易中心、市政厅、纽约大学、格雷斯教堂、联合广场、麦迪逊广场、时代广场、众多百老汇剧院、中央公园、林肯艺术中心、圣约翰大教堂、哥伦比亚大学、修道院博物馆等，令人目不暇接。

曼哈顿的建筑异常丰富和密集，摄影具有不小的挑战。面对铺天盖地、步移景异的建筑群，我时常感到力不从心。好在随着对曼哈顿了解的加深，我拍摄的主观逻辑和感受越来越清晰，不至于迷失在茫茫的建筑森林中。

谨以此为本书前言。

PREFACE

The central district of New York City is Manhattan, which is bounded by the Hudson River, the East River, and the Harlem River. Manhattan consists mainly of Manhattan Island, Roosevelt Island and several smaller islands. Despite Manhattan's land area being less than 60 square kilometers, this elongated island, approximately 21 kilometers long and averaging less than 3 kilometers wide, has acquired the world's largest number of cutting-edge skyscrapers and numerous other coexisting structures such as churches, schools, libraries, museums, judicial and administrative buildings, theaters, urban parks, and various commercial buildings throughout its over 300 years of urban development. It can be said that Manhattan's architecture not only represents the highest level of New York City and even the United States, but also serves as an exposition of modern and contemporary architecture around the world.

Due to my professional interests, I have visited Manhattan many times in the 25 years between the first time of summer in 1996 and 2021. However, my visits were always brief, and the most memorable impression I have is the World Trade Center's Twin Towers, which I encountered only once. The towers were so amazing that on that day, despite the chaotic winds amplified by the skyscrapers, I walked around twice

looking up at them, completely forgetting to take any photos.

It wasn't until 2022 and 2023 that I was fortunate enough to have the opportunity to live in Midtown Manhattan, Broadway, for a total of nearly nine months on two separate occasions. During this period, I made every effort to explore as many of Manhattan's important buildings and fashionable corridors as possible, primarily on foot. However, due to the dense of architecture and the exceptionally high number of construction sites (including both new construction and extensive renovation and remodeling of older buildings) in Manhattan, it was far from possible to cover everything comprehensively. All I could do was to diligently capture the interesting moments I encountered.

Throughout this time, I amassed around 7000 photos. From these, I have carefully selected about 5% which are in black and white to be edited into this book and would like to share with you. Touring the architecture in Manhattan left me with many reflections, and capturing the buildings and their environments were a result of being emotionally moved. Back in Beijing, during the process of selecting photos, I couldn't shake off the subjective feelings I gradually formed in Manhattan about its architecture. I would like to take this opportunity to share and exchange these thoughts with you.

First and foremost is the architectural humanism reflected both in architectural design and in usage management. This is what struck me the most, and it naturally overflowed into the composition of my photographs. Regardless of how grand or dignified, architecture should have details that cater to human scale for people's convenience and enjoyment. The

steps, porches, plazas, and pools of Manhattan's architecture are approachable and open, even the safety corridors at construction sites are humanized. As a result, architecture adds convenience and charm to people's leisure, social interactions, and walking experiences, at the same time, the freely moving people active in it also add vitality to both the architecture and the environment.

Secondly, Manhattan's architecture embodies the continuity and inclusivity of urban development over time. This is attributed not only to the inherent preservation awareness of existing buildings ingrained in private organizations' involvement in Manhattan's urban development, but also to Manhattan's urban planning, which protects the original street system of Downtown Manhattan and the original route of the Broadway that vertically traverses Manhattan Island. Of course, this wouldn't have been possible without the enactment of the *National Historic Preservation Act* in 1966 and the implementation of the subsequent regulations on the transfer transactions of land development rights in New York. The concept of *Transfer of Development Rights* is crucial to the development of Manhattan's urban architecture, both to meet the financial needs for preserving historical buildings and to encourage innovative breakthroughs in architectural development, so that new and old buildings achieve mutual respect and a win-win situation.

Lastly, Manhattan's architecture showcases a rich diversity of spaces, which is precisely the result of the combined effects of historical preservation, humanistic sentiment,

and technological innovation. One particularly outstanding aspect is the visual impact and spatial experience provided by Manhattan's skyline and ridgeline. The skyline of Manhattan integrates a 300-year-old architectural heritage with the leaps of innovation in skyscraper construction, creating a grand symphony frozen in time and space. The ridgeline of Manhattan originates from the natural trails traversing the narrow island formed by Native American hunting and interaction on the island, which have been preserved and developed as key transportation and visual axes in urban planning—the Broadway, spanning nearly 25 kilometers. Beginning with the Museum of the American Indian at its starting point and culminating at the Broadway Bridge connecting to the Bronx, this axis connects landmarks such as the Charging Bull, Wall Street, Trinity Church, the World Trade Center, City Hall, New York University, Grace Church, Union Square, Madison Square, Times Square, numerous Broadway theaters, Central Park, Lincoln Center, the Cathedral Church of Saint John the Divine, Columbia University, and the Met Cloisters, creating an overwhelming experience for visitors.

Manhattan's architecture is exceptionally rich and dense, posing quite a challenge for photography. Faced with the sprawling and ever-changing buildings, I often felt powerless. Fortunately, as I walked deeper into Manhattan, my subjective logic and feelings about what to capture became clearer and clearer, preventing me from getting lost in the vast forest of architecture.

With this, I respectfully offer it as the preface to this book.

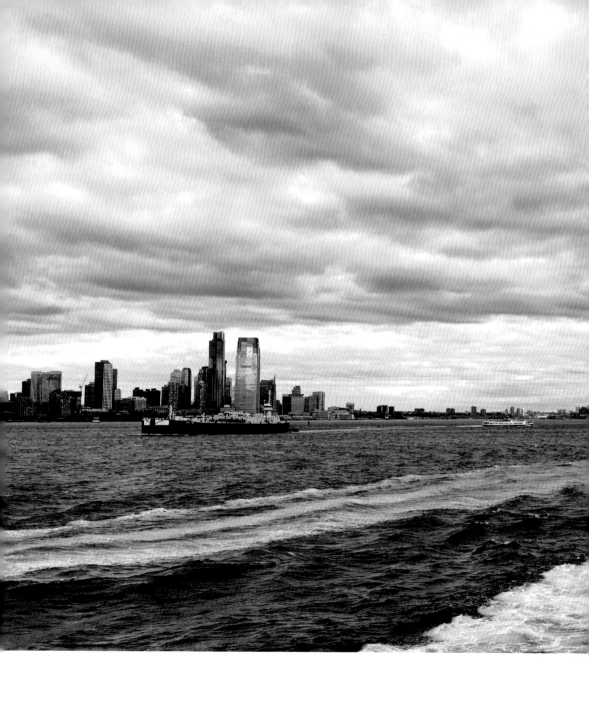

目录 CONTENTS

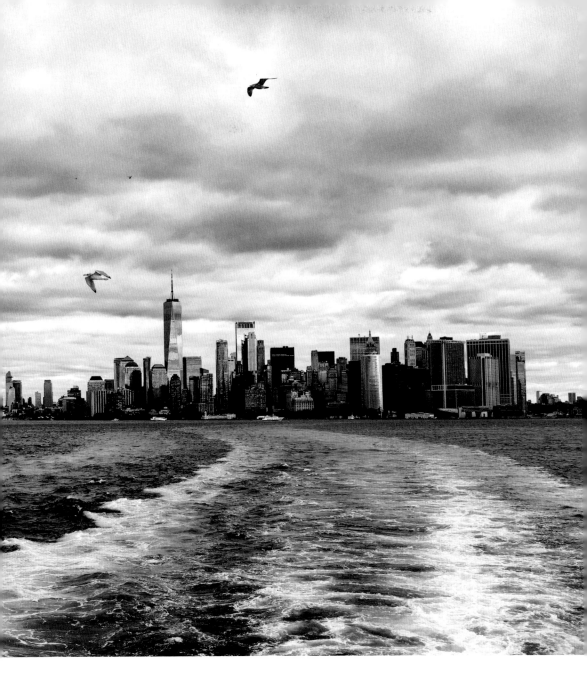

下城 | DOWNTOWN ／ 0　　中城 | MIDTOWN ／ 142　　上城 | UPTOWN ／ 300

下城

曼哈顿下城是曼哈顿岛临海的区域，即从最南端的炮台公园到十四街，面积大约为曼哈顿岛的四分之一。由于下城建设是从十七世纪荷兰人在曼哈顿岛的南端建贸易港开始的，因而楔形海岸线影响了城市生长的道路网络，使之呈现了错综复杂的结构。众多历史街区和历史建筑被保护及更新，与新建筑交相辉映以及三面环水的衬托，是曼哈顿下城的特色。

其中重要的建筑有：华尔街的联邦大厅（D29）、纽约证券交易所（D30／D31／D32）、美国印第安人国家博物馆（D10／D13／D17）、三一教堂（D19／D60／D61），圣马克教堂（D71）、市政厅（D72／D73）、纽约法院（D74）、纽约代理法院（D76/D77）、格雷斯教堂（D100／D101／D102／D103）、伍尔沃斯大楼（D65）、华尔街40号大厦(D21)、杰斐逊市场图书馆（D112）、世界贸易中心一号楼（D42／D54／D89／D90）、世界贸易中心交通枢纽（D37／D39）和圣尼古拉斯希腊东正教教堂（D43）等。

DOWNTOWN

Downtown Manhattan is the coastal area of Manhattan Island, stretching from Battery Park at the southernmost tip to 14th Street, covering approximately 1/4 of the island's area. The development of Downtown Manhattan began with the establishment of a trading port by the Dutch in the southern end of Manhattan Island in the 17th century, and the wedge-shaped coastline profoundly influenced the city's road network, resulting in a complex and intricate structure. The preservation and renovation of numerous historic neighborhoods and buildings, complemented by the newest constructions and skyscrapers, along with the waterfront setting on three sides, are the distinctive features of Downtown Manhattan.

The very important buildings in Downtown Manhattan include Federal Hall at Wall Street, the New York Stock Exchange, the National Museum of the American Indian, Trinity Church, St. Mark's Church, City Hall, New York Courthouse, Surrogate's Courthouse, Grace Church, the Woolworth Building, 40 Wall Street, the Jefferson Market Library, One World Trade Center, the Trade Center Transportation Hub, and the St. Nicholas Greek Orthodox Church, etc.

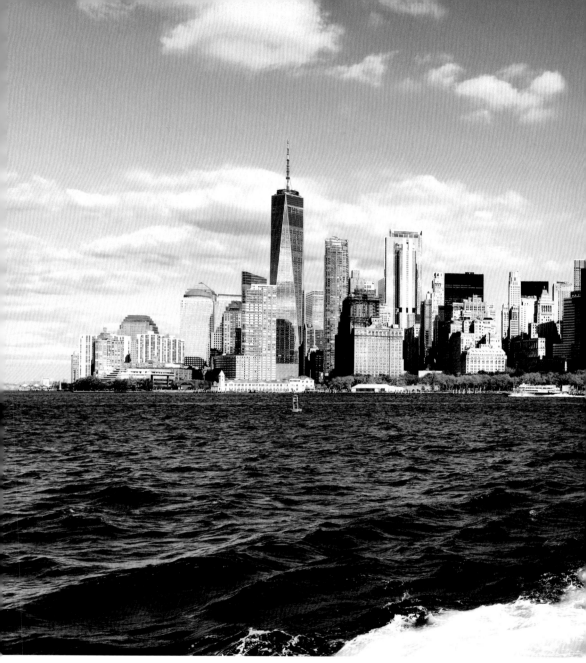

D1 从斯塔腾岛渡轮看曼哈顿 | Manhattan from Staten Island Ferry

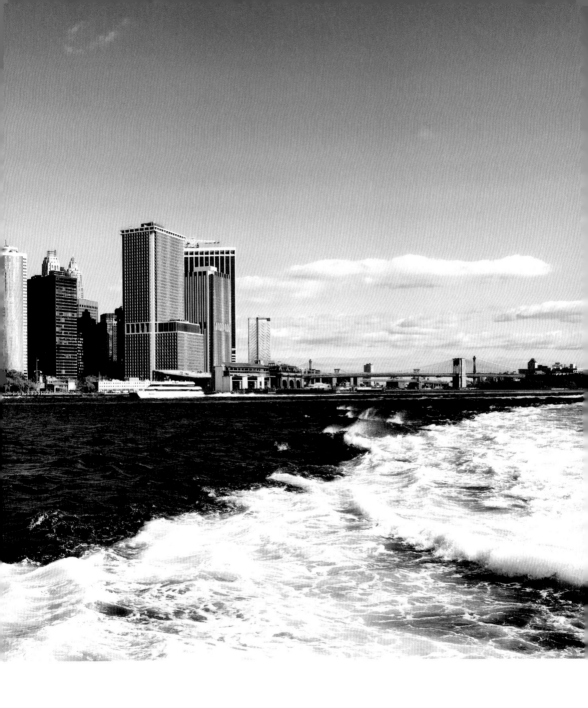

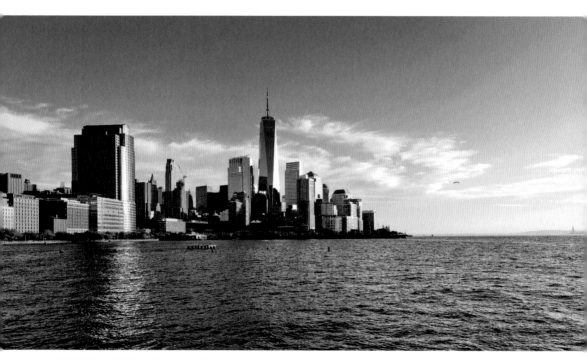

D2 从哈德孙河公园看曼哈顿和自由女神像 | Manhattan and Stature of Liberty from Hudson River Park

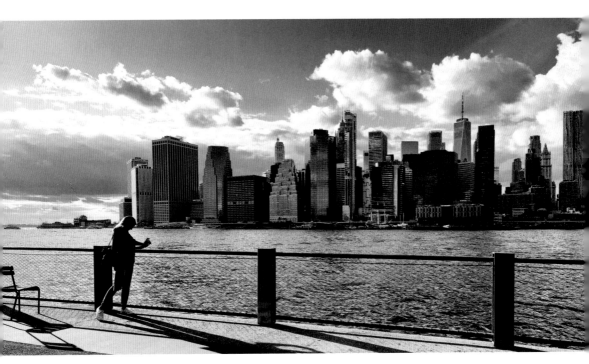

D3 从布鲁克林丹波看曼哈顿 | Manhattan from Dumbo Brooklyn

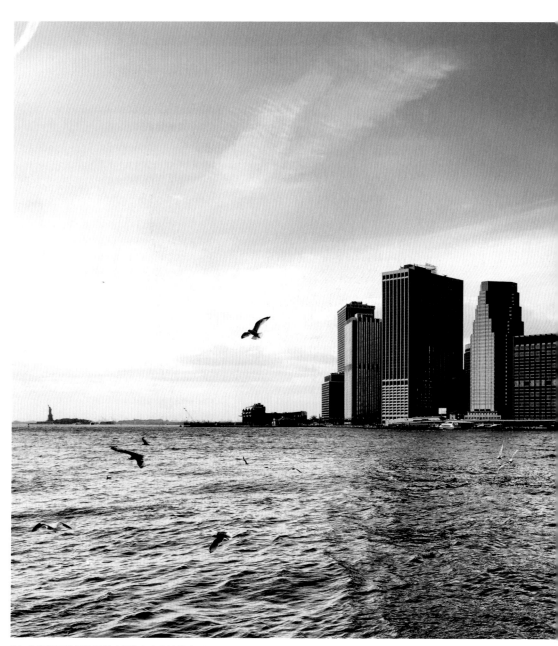

D4 从布鲁克林丹波看曼哈顿和自由女神像 | Manhattan and Statue of Liberty from Dumbo Brooklyn

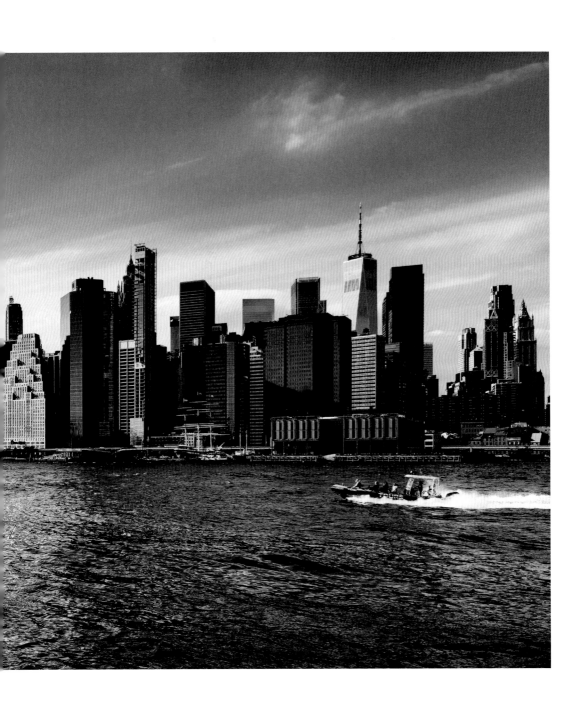

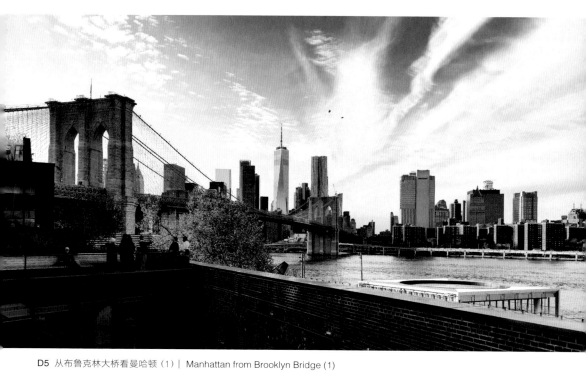

D5 从布鲁克林大桥看曼哈顿（1） | Manhattan from Brooklyn Bridge (1)

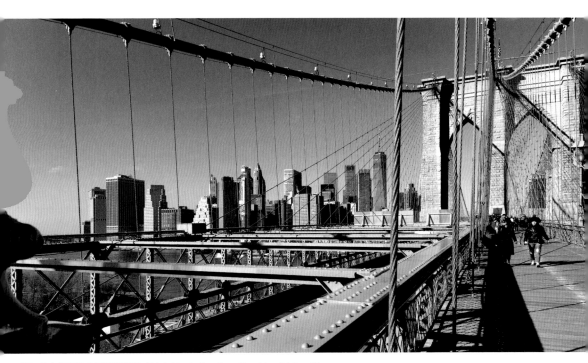

D6 从布鲁克林大桥看曼哈顿（2） | Manhattan from Brooklyn Bridge (2)

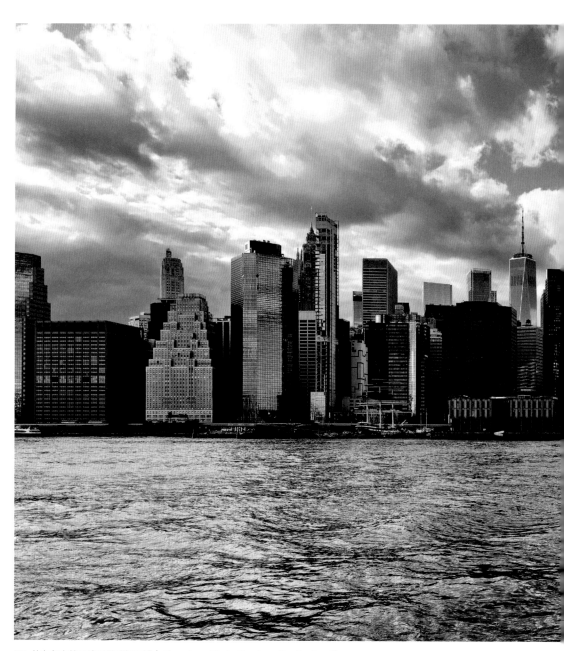

D7 从布鲁克林丹波看曼哈顿下城 | Downtown Manhattan from Dumbo Brooklyn

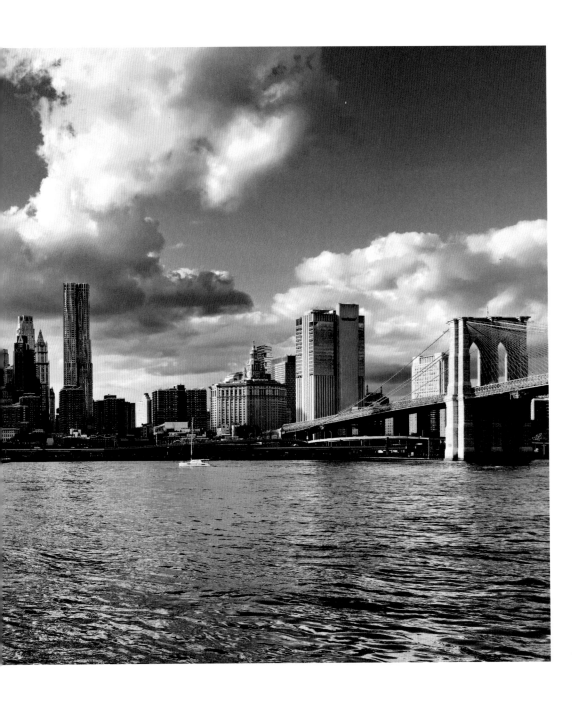

下城 | DOWNTOWN

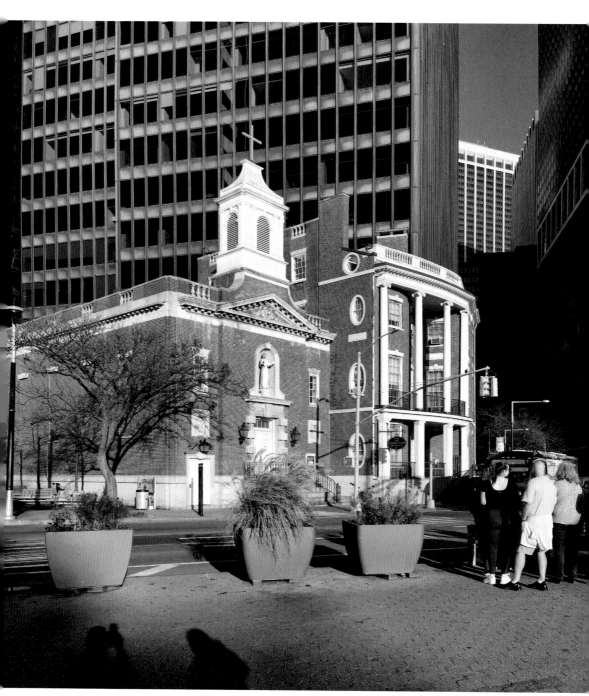

D8 圣伊丽莎白安西顿神殿 | St. Elizabeth Ann Seton Shrine

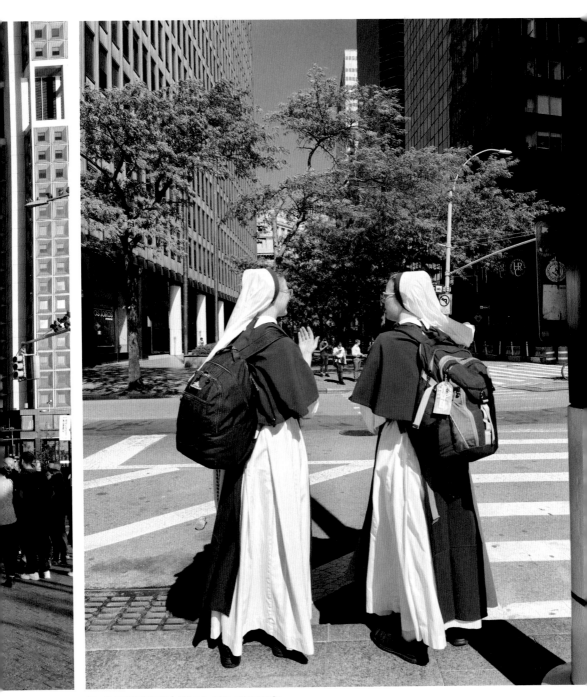

D9 从水街看白厅街 | Whitehall St. at Water St.

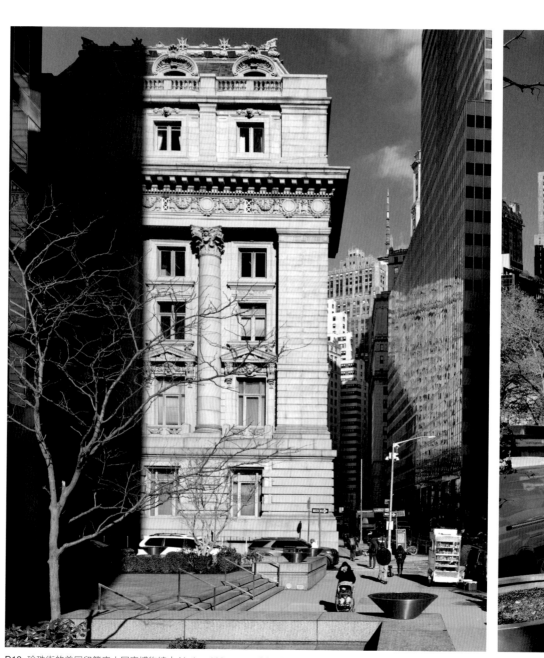

D10 珍珠街的美国印第安人国家博物馆 | National Museum of the American Indian at Pearl St.

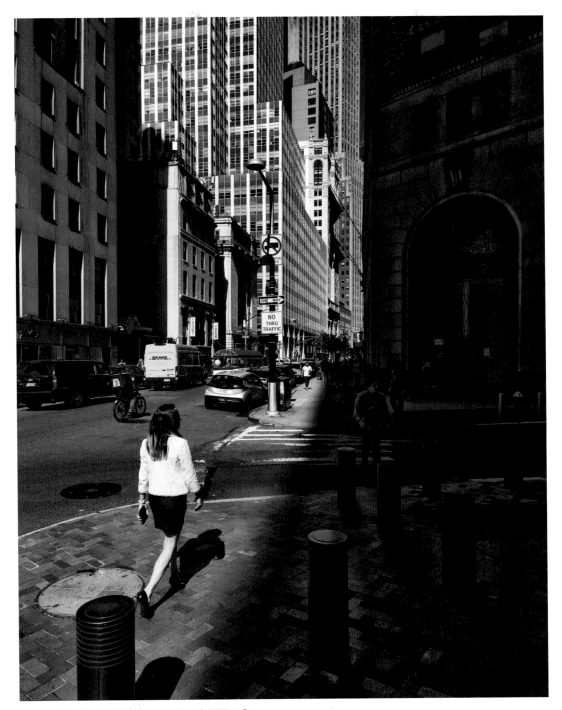

D23 从威廉南街看布罗德街 | Broad St. at S. William St.

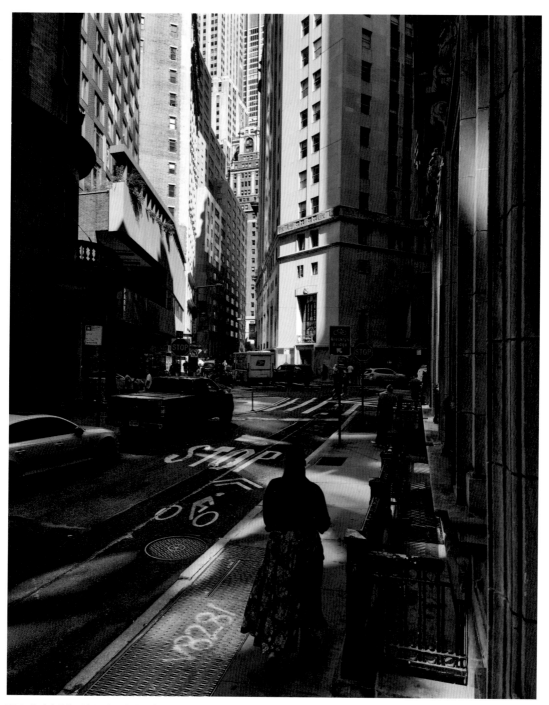

D24 从威廉南街看海狸街五十六号 | 56 Beaver St. at S. William St.

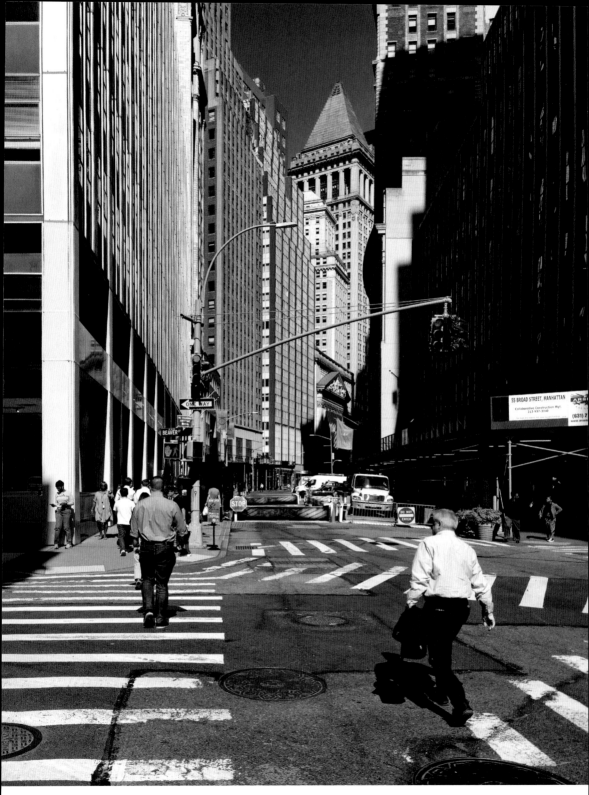

D25 从海狸街看布罗德街 | Broad St. at Beaver St.

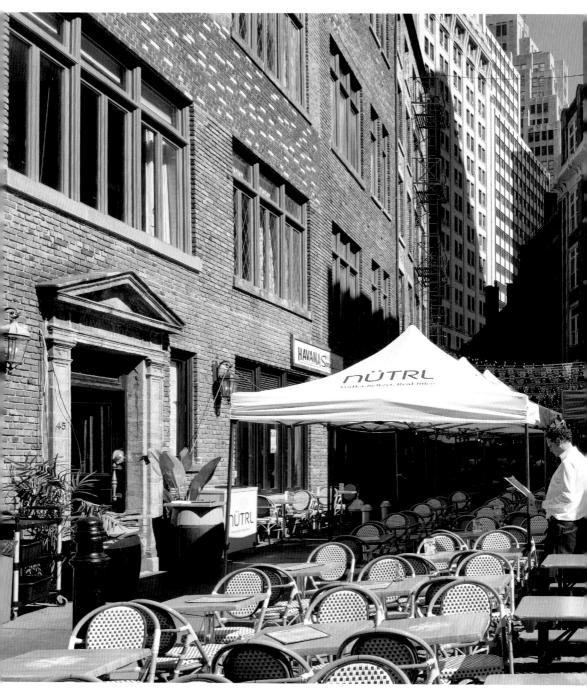

D26 石街 | Stone Street

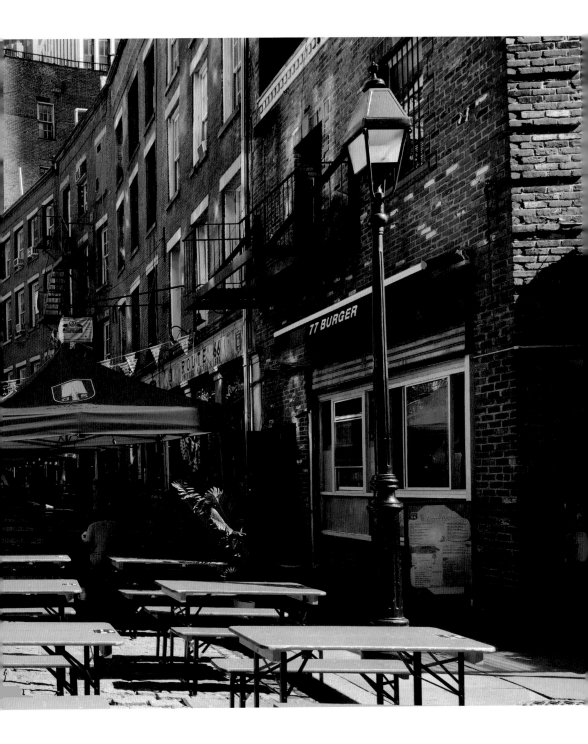

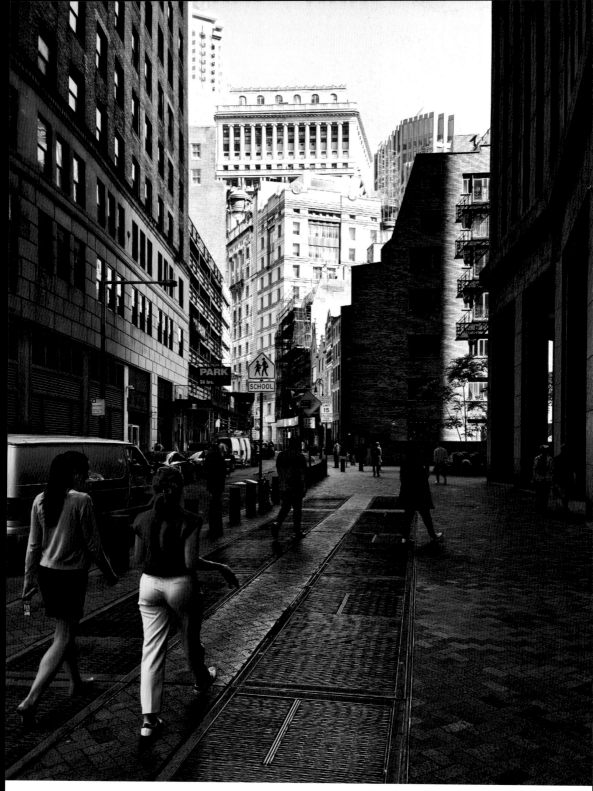

D27 从布罗德街看威廉南街 | S. William St. at Broad St.

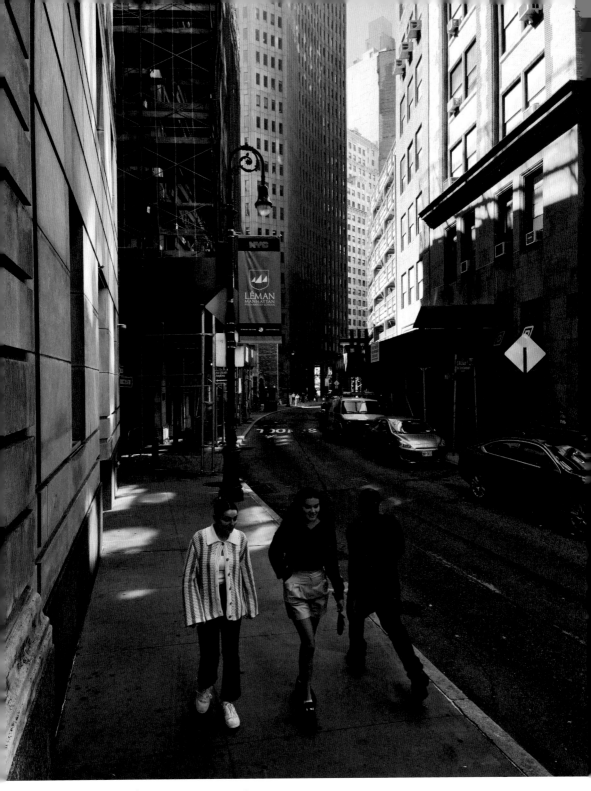

从威廉街看威廉南街 | S. William St. at William St.

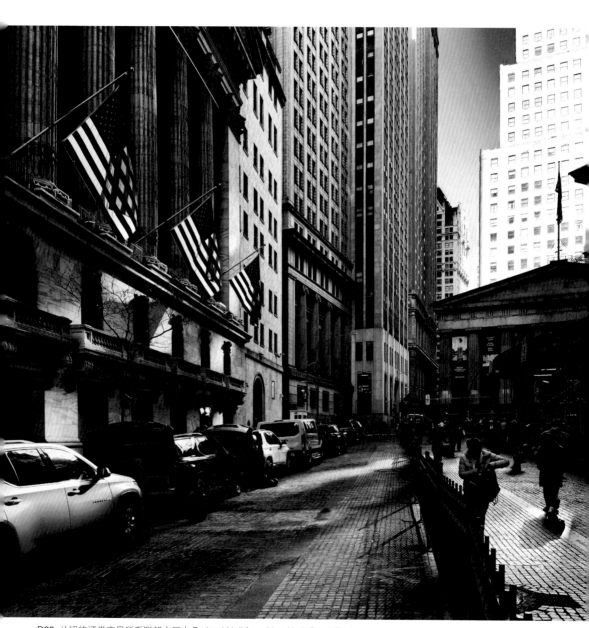

D29 从纽约证券交易所看联邦大厅 | Federal Hall from New York Stock Exchange

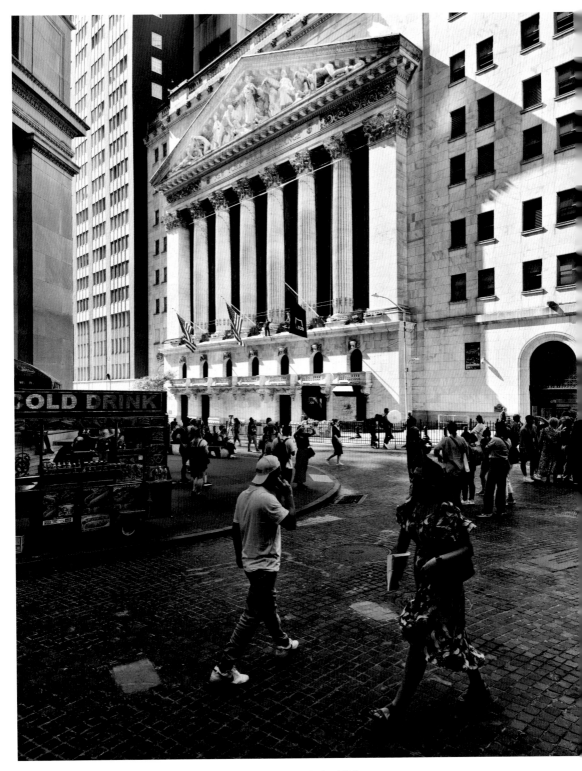

D30 从联邦大厅看纽约证券交易所 | New York Stock Exchange from Federal Hall

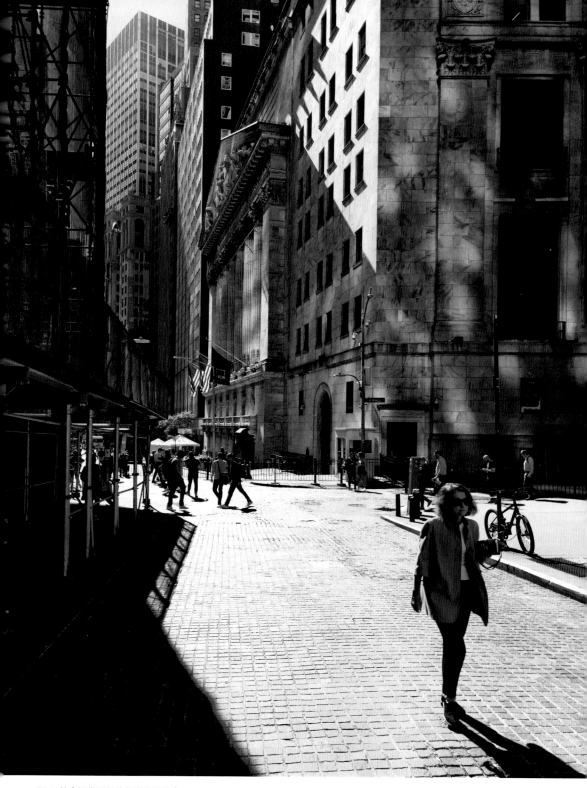

D31 从拿骚街看纽约证券交易所 | New York Stock Exchange from Nassau St.

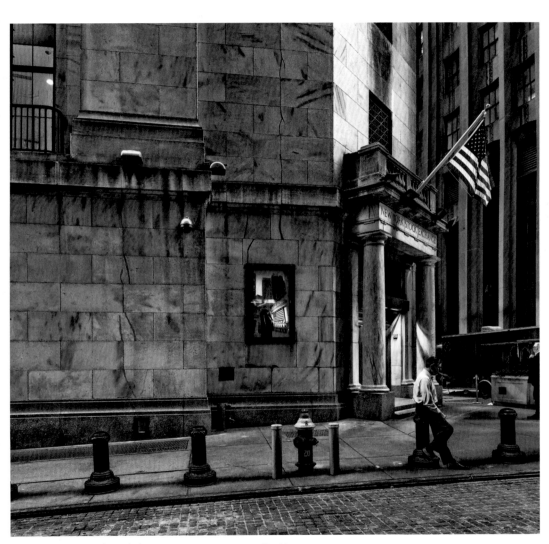

D32 纽约证券交易所（后门） | New York Stock Exchange (Back)

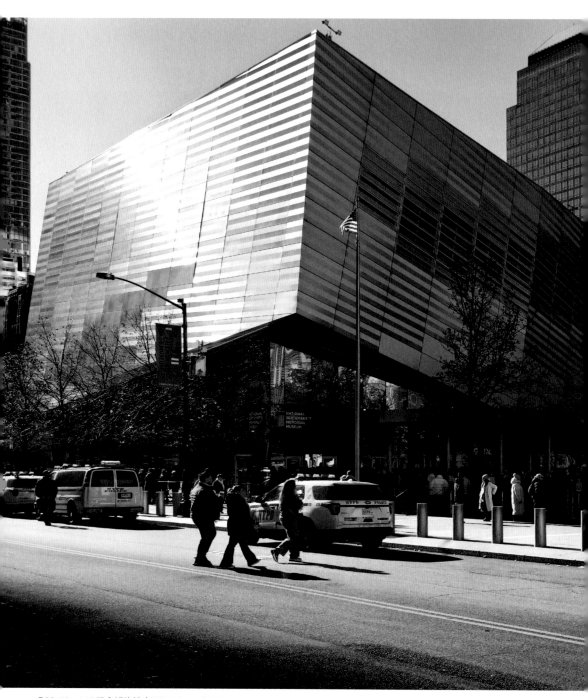

D33 "9·11"纪念博物馆 | 9/11 Memorial Museum

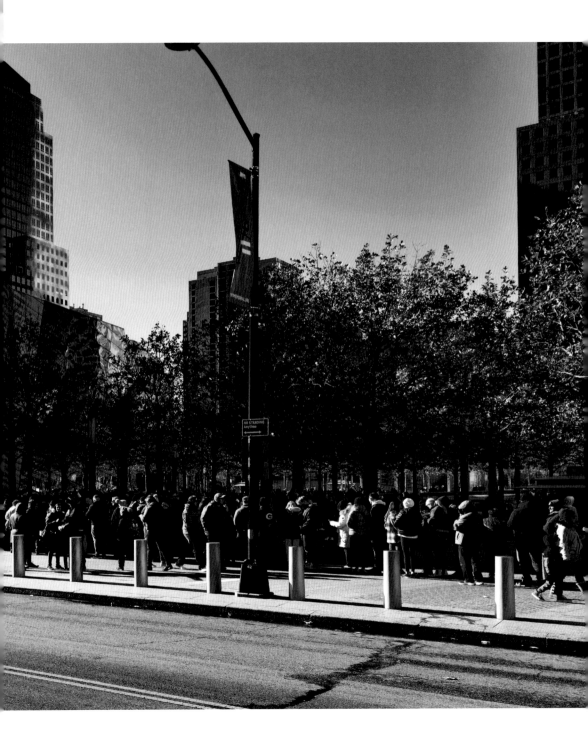

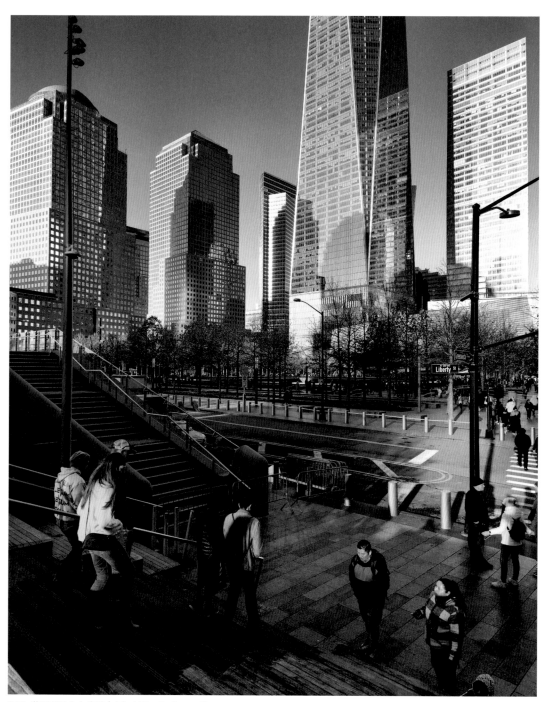

D34 世界贸易中心广场 | World Trade Center Square

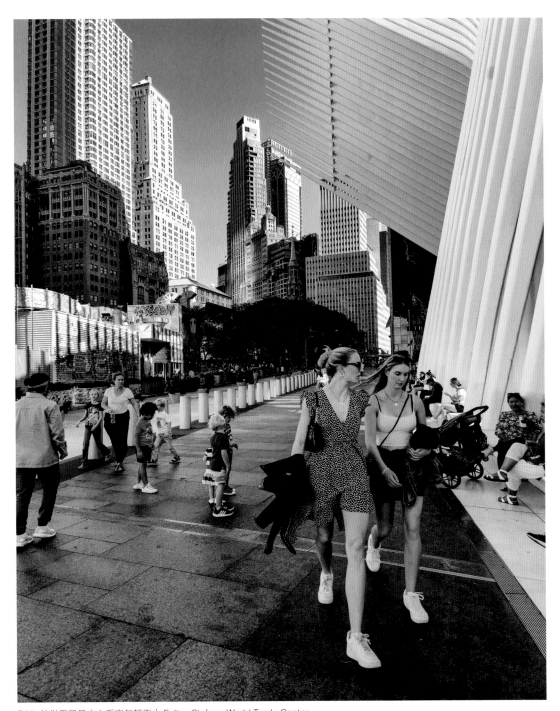

D35 从世界贸易中心看富尔顿街 | Fulton St. from World Trade Center

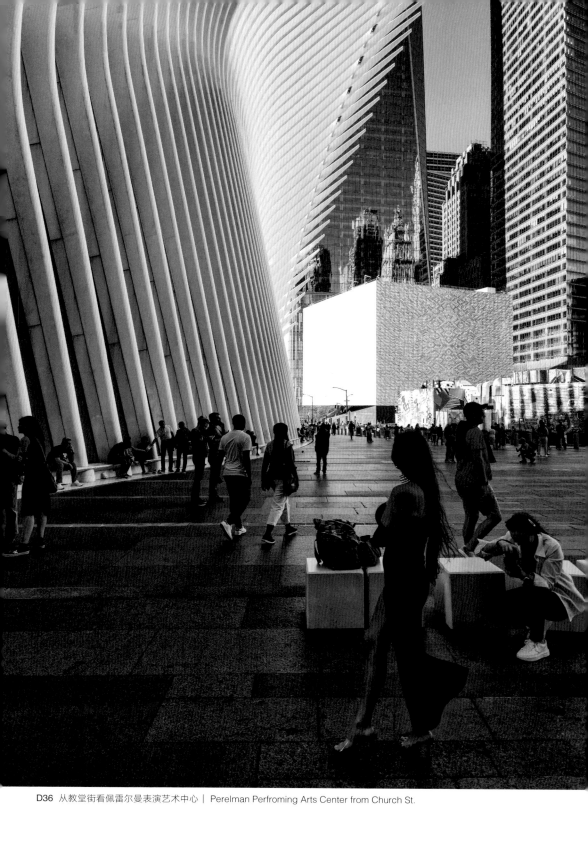

D36 从教堂街看佩雷尔曼表演艺术中心 | Perelman Perfroming Arts Center from Church St.

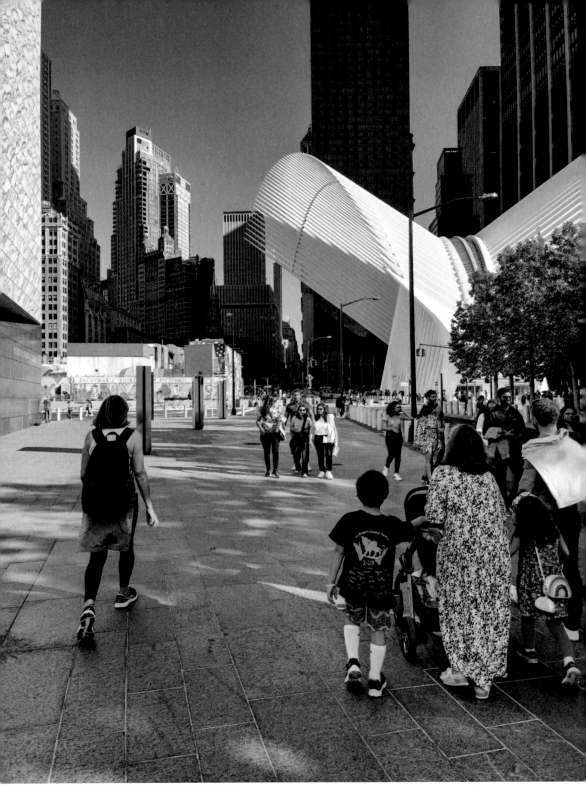

D37 从富尔顿街到教堂街 | Fulton St. to Church St.

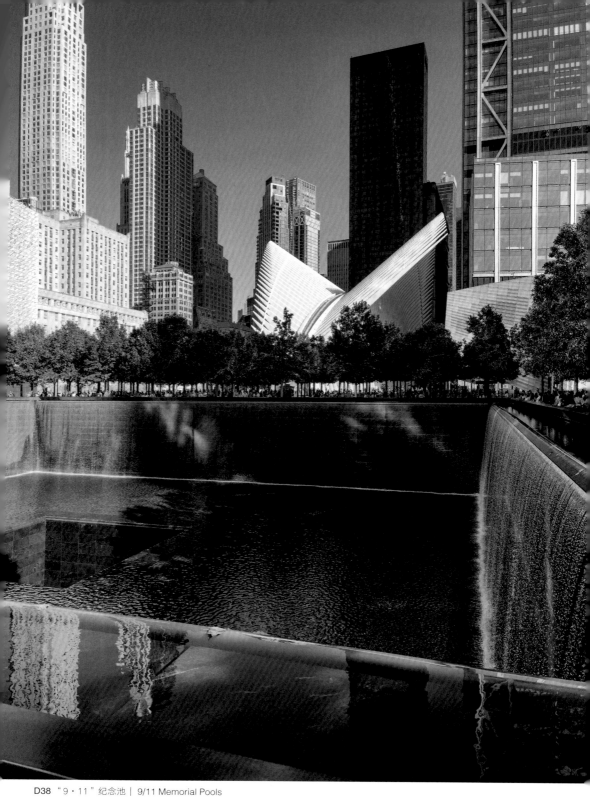

D38 "9·11"纪念池 | 9/11 Memorial Pools

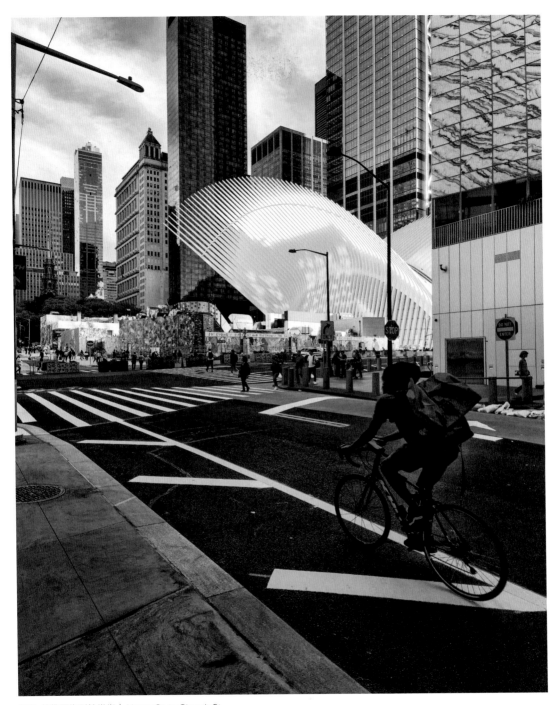

D39 从维西街到教堂街 | Vesey St. to Church St.

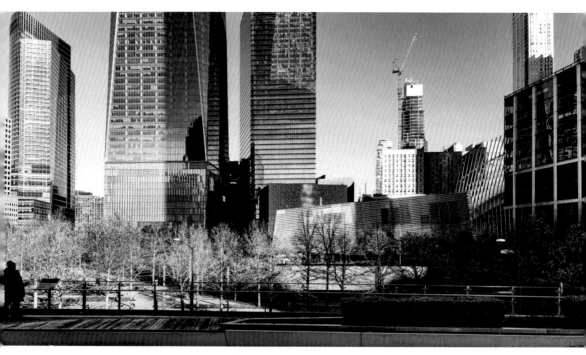
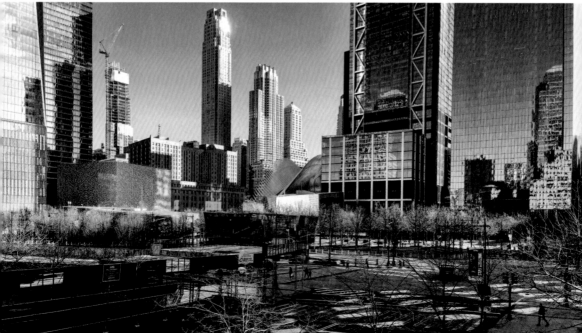

D40 / D41 从世界贸易中心看自由公园（1/2） | Liberty Park from World Trade Center（1/2）

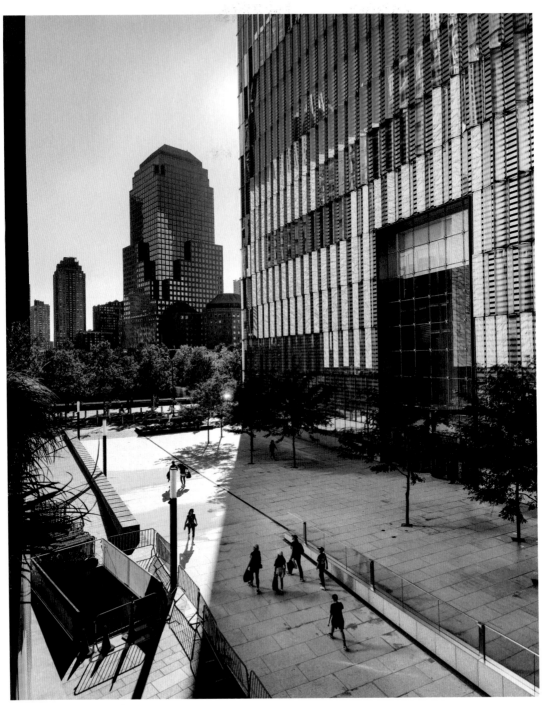

D42 世界贸易中心一号楼 | One World Trade Center

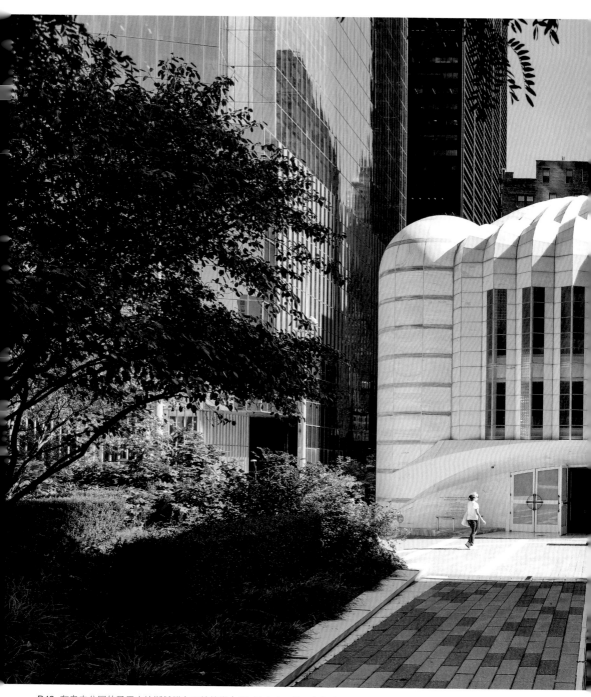

D43 在自由公园的圣尼古拉斯希腊东正教教堂 | St. Nicholas Greek Orthodox Church at Liberty Park

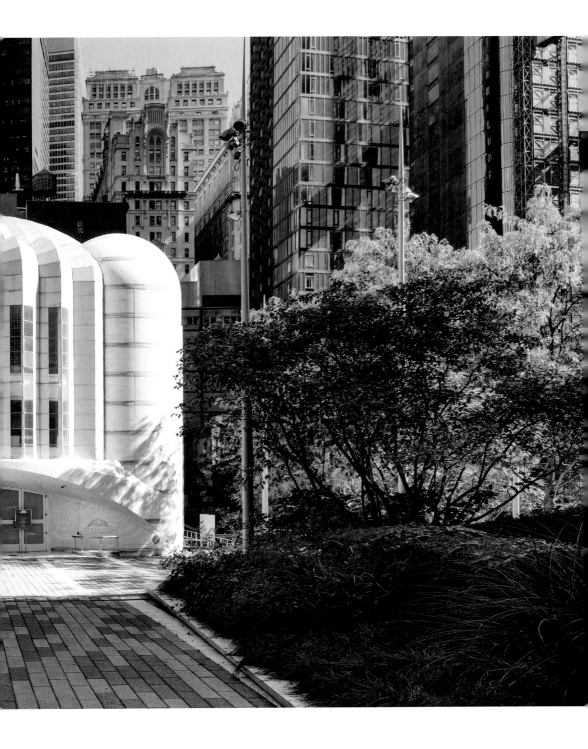

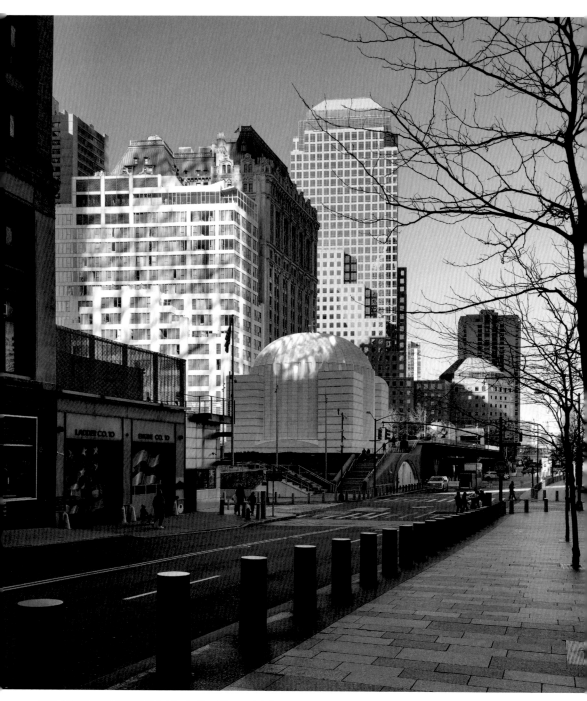

D44 从格林威治街看自由街 | Liberty St. at Greenwich St.

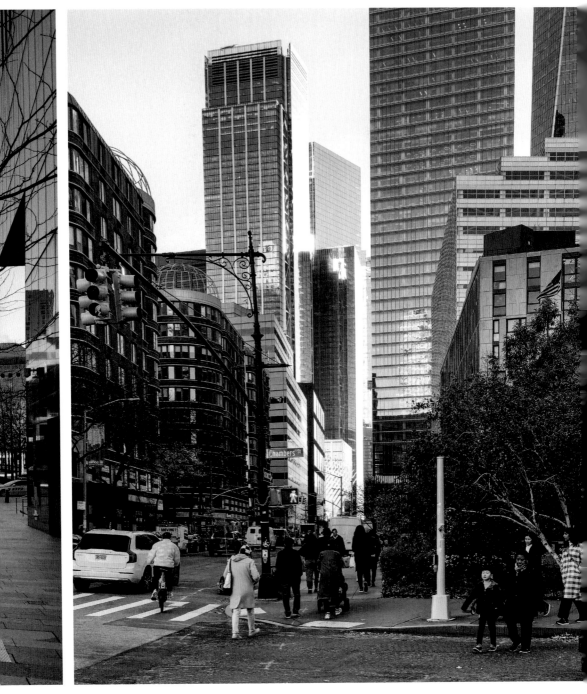

D45 从钱伯斯街看格林威治街 | Greenwich St. at Chambers St.

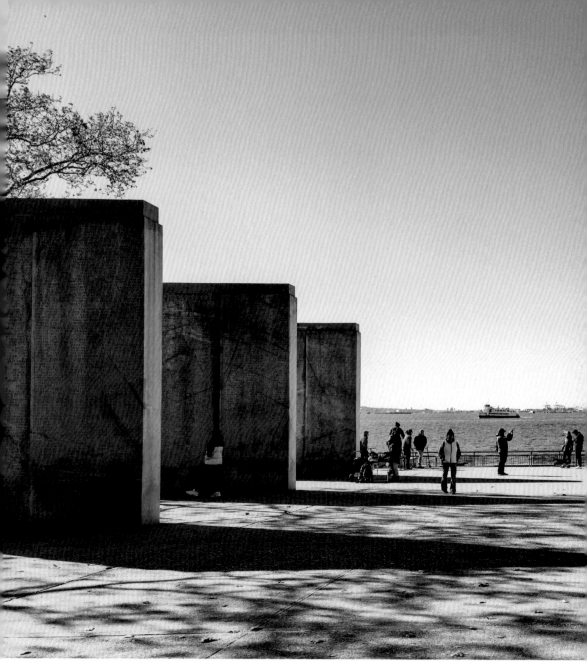

D46 面向自由女神像的东海岸纪念碑 | East Coast Memorial to Statue of Liberty

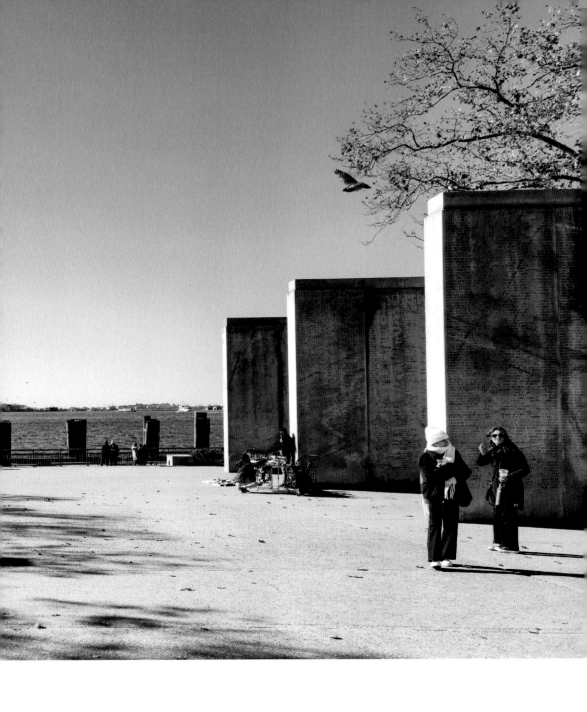

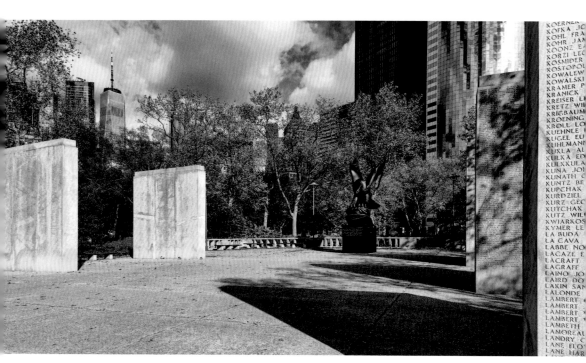

D47 面向世界贸易中心的东海岸纪念碑 | East Coast Memorial to World Trade Center

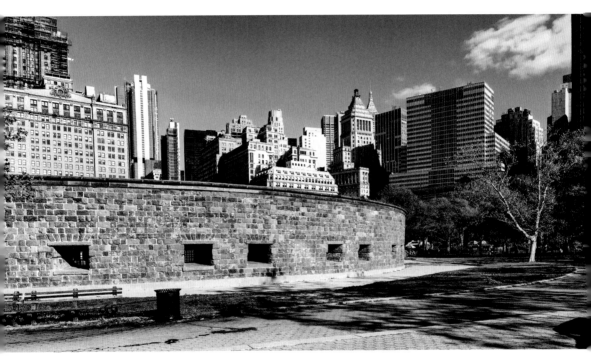

D48 克林顿城堡国家纪念碑 | Castle Clinton National Monument

D49 从炮台公园看曼哈顿下城（1）| Lower Manhattan from Battery Park (1)

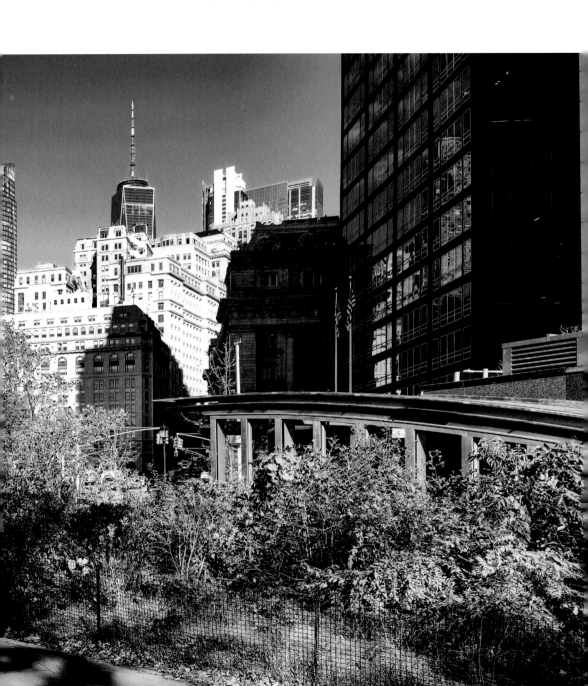

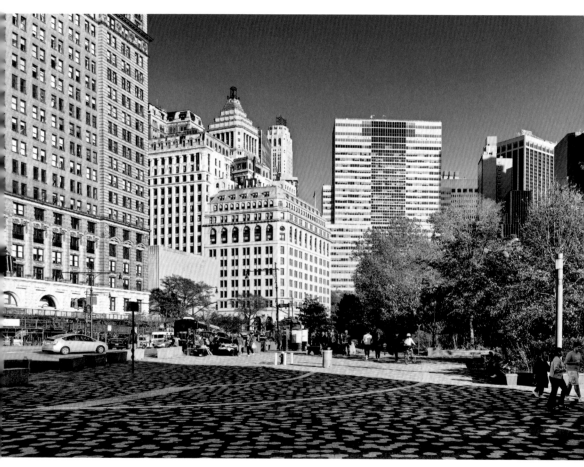

D50 从炮台公园看曼哈顿下城（2） | Lower Manhattan from Battery Park (2)

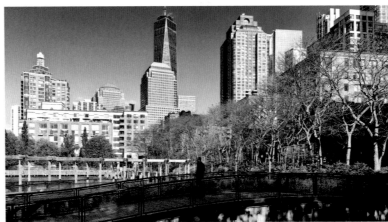
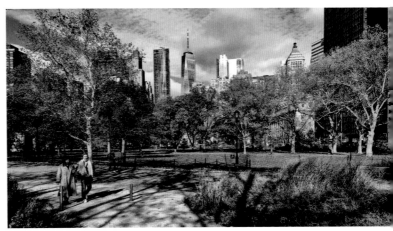

D51 / D52 从炮台公园看曼哈顿下城（3/4） | Lower Manhattan from Battery Park (3/4)

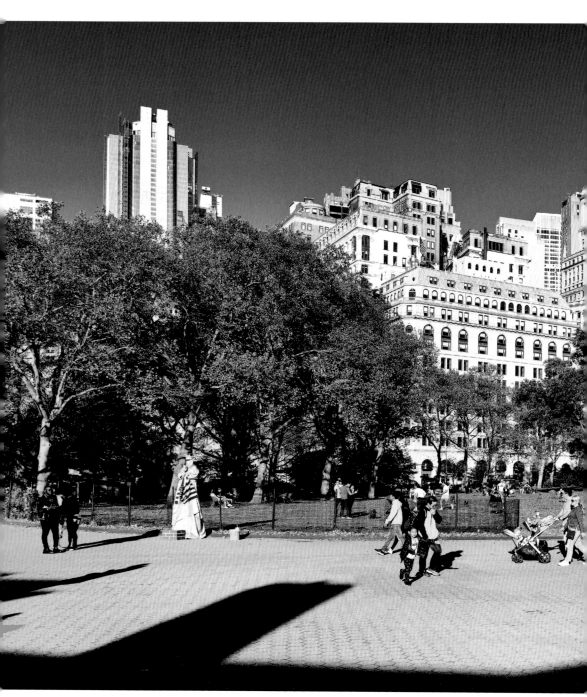

D53 从炮台公园看曼哈顿下城(5) | Lower Manhattan from Battery Park (5)

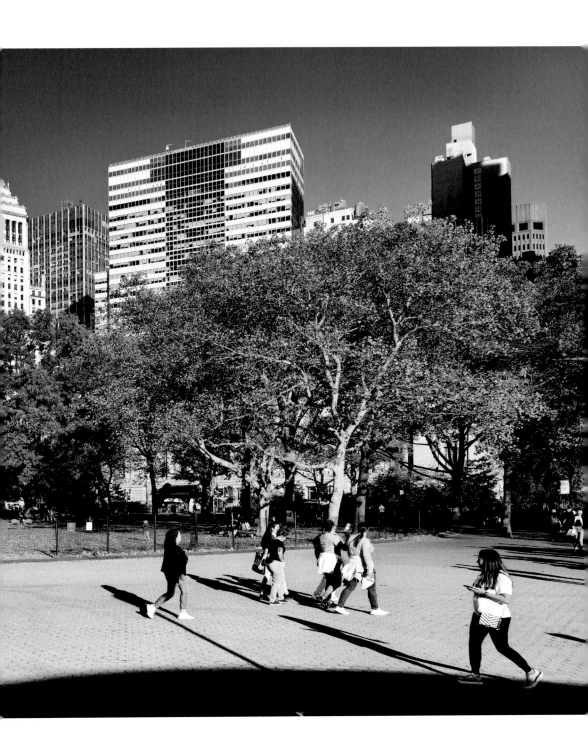

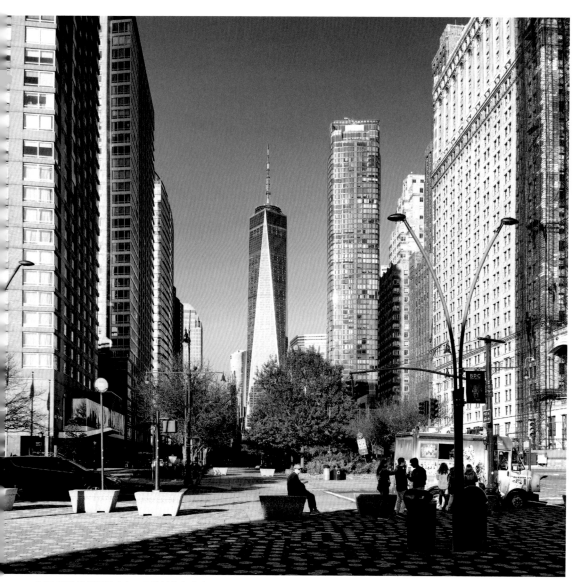

D54 面向世界贸易中心一号楼的炮台路 | Battery Pl. to One World Trade Center

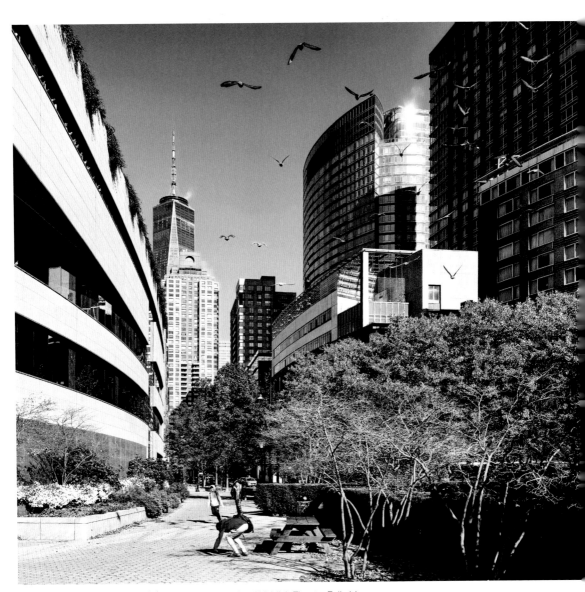

D55 国家依地绪剧院旁的炮台路 | Battery Pl. by National Yiddish Theatre Folksbiene

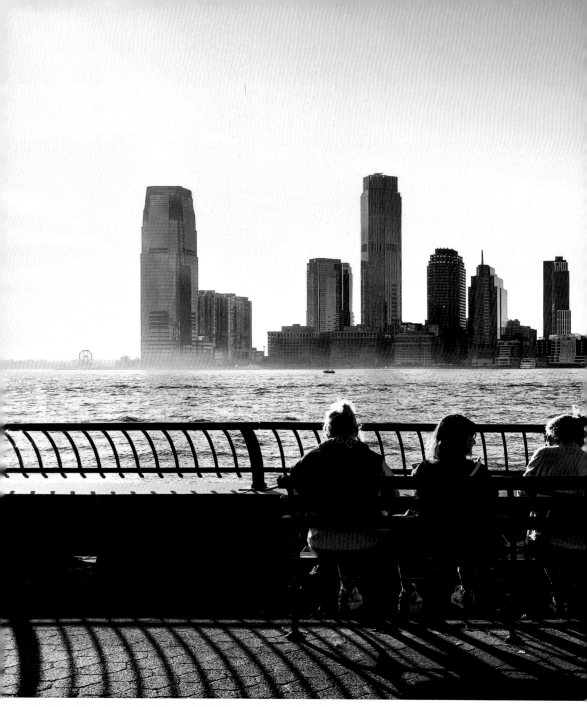

D56 面向新泽西州的炮台公园滨河广场 | Battery Park City Esplanade to New Jersey

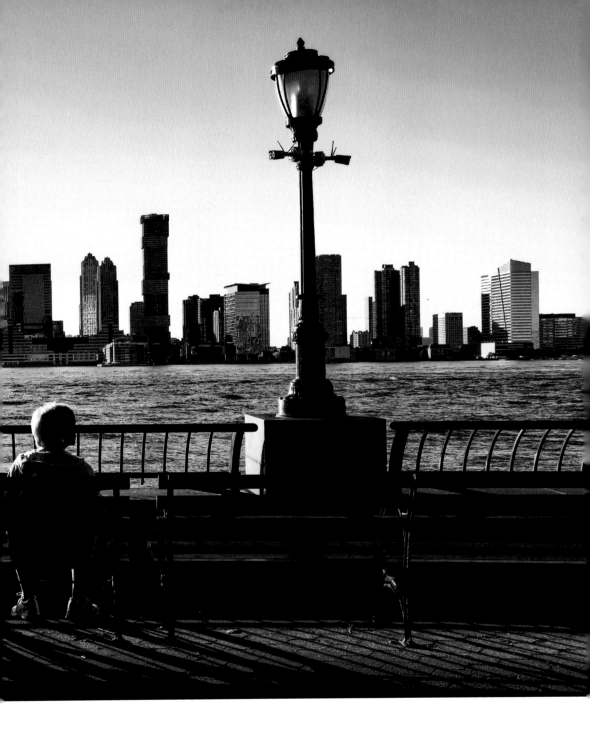

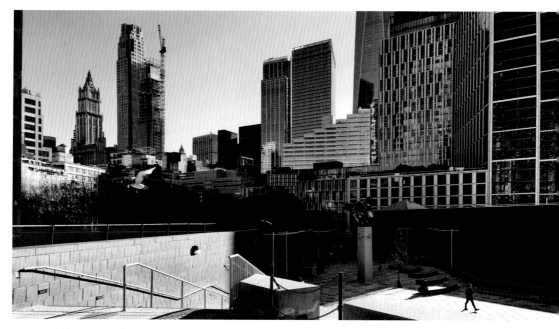

D57 曼哈顿社区学院东面 | East of Manhattan Community College

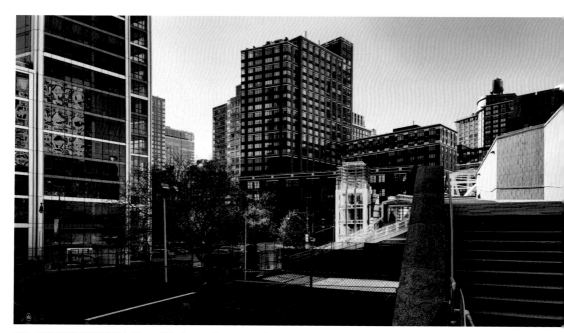

D58 曼哈顿社区学院西面 | West of Manhattan Community College

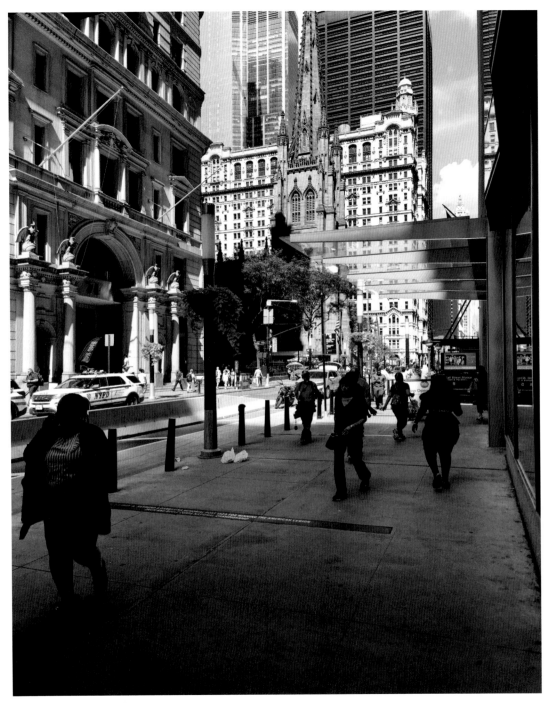

D59 从雷克托街看百老汇 | Broadway at Rector St.

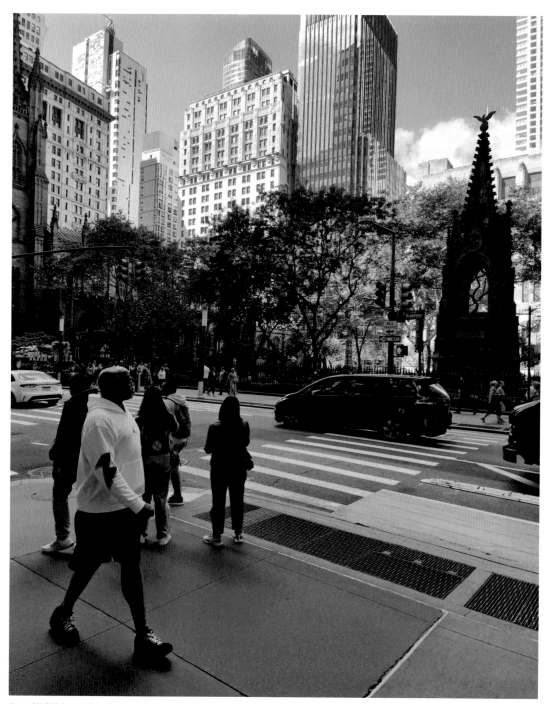

D60 从派恩街看百老汇 | Broadway at Pine St.

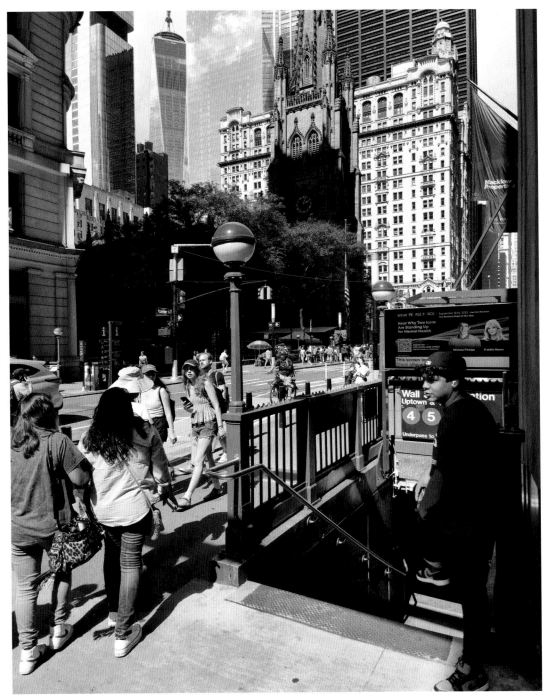

D61 从华尔街车站看三一教堂和世界贸易中心一号楼 | Wall St. Station to Trinity Church and One World Trade Center

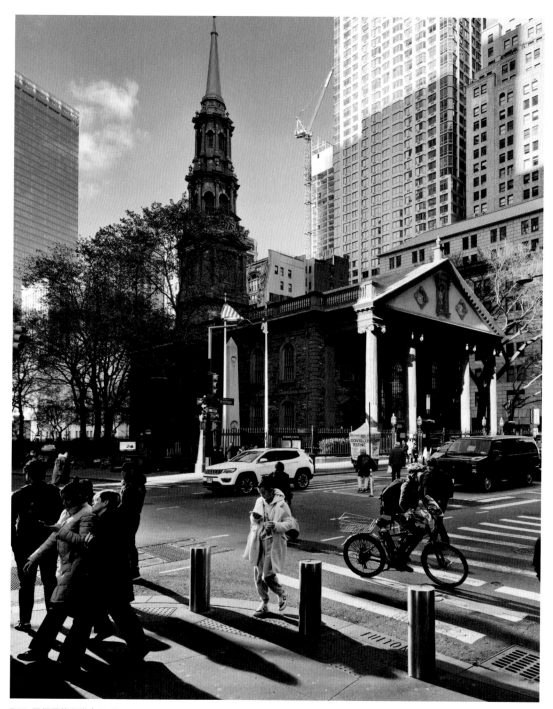

D62 圣保罗礼拜堂 | St. Paul's Chapel

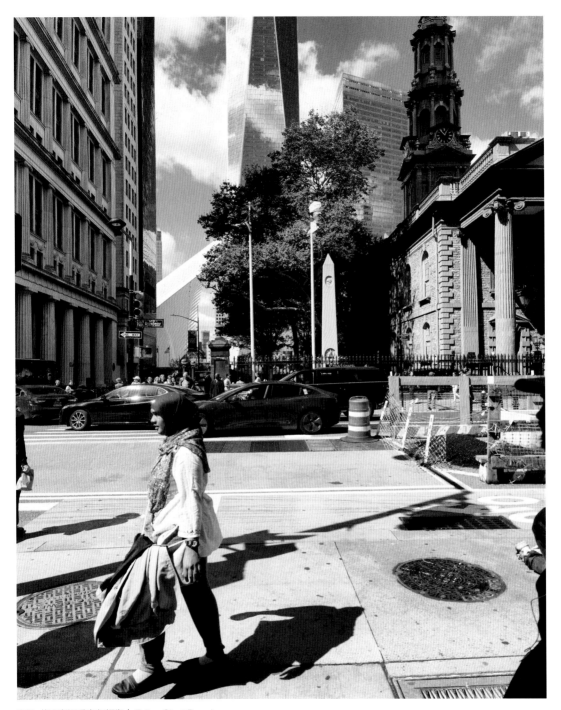

D63 从百老汇看富尔顿街 | Fulton St. at Broadway

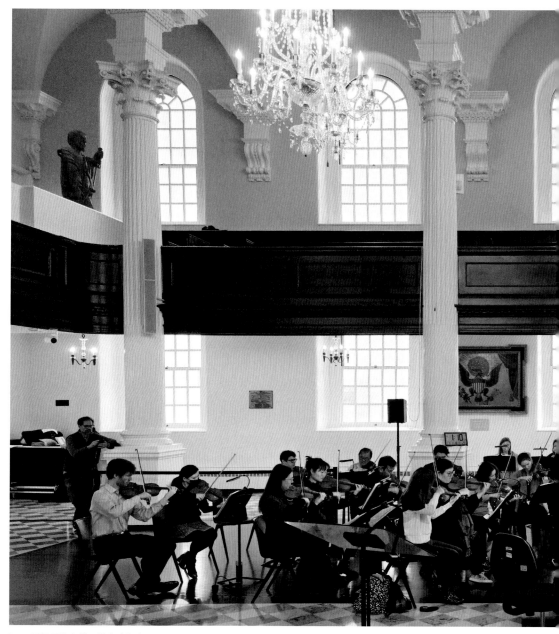

D64 圣保罗礼拜堂里的交响曲 | Symphony in St. Paul's Chapel

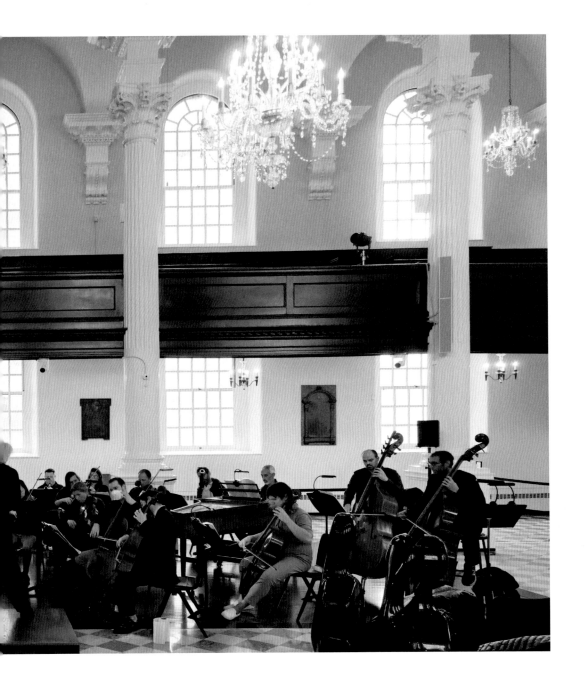

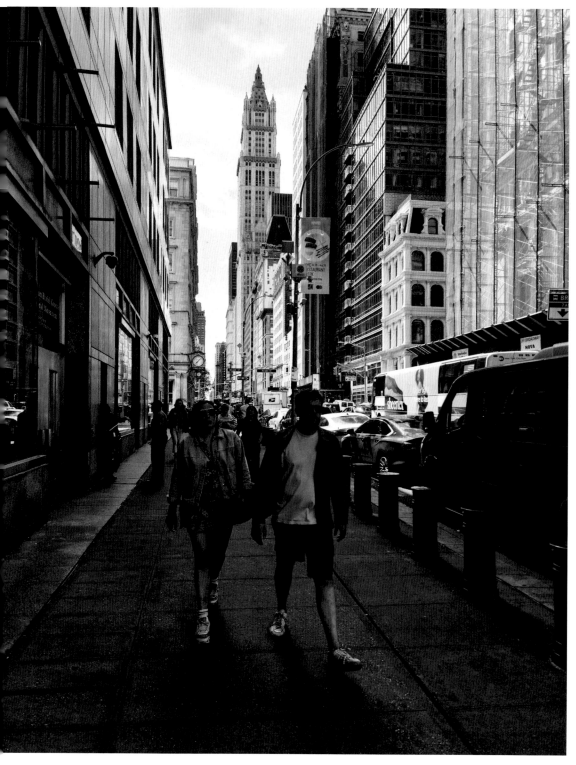

D65 杜安街至伍尔沃斯大楼之间的百老汇 | Broadway at Duane St. to Woolworth Building

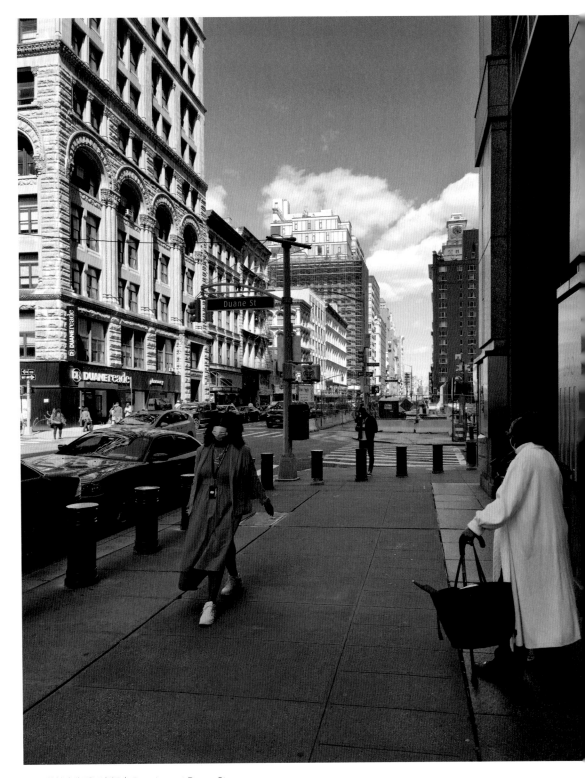

D66 从杜安街看百老汇 | Broadway at Duane St.

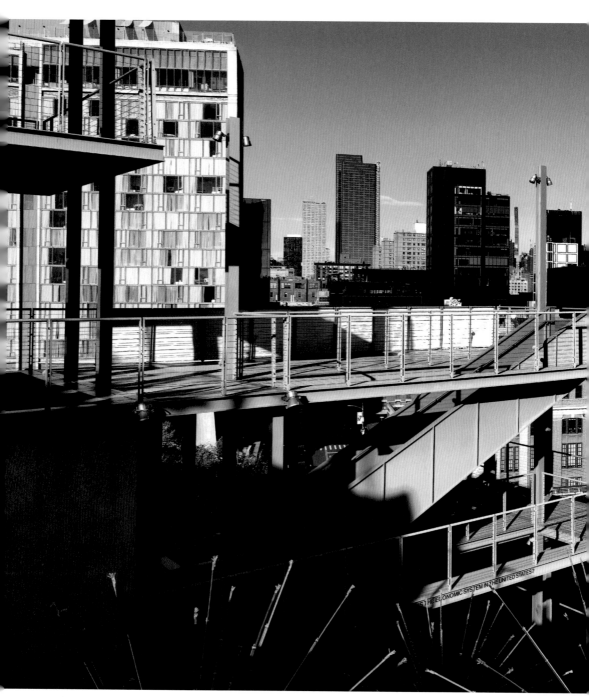

D67 惠特尼美国艺术博物馆（至帝国大厦） | Whitney Museum of American Art (to Empire State Building)

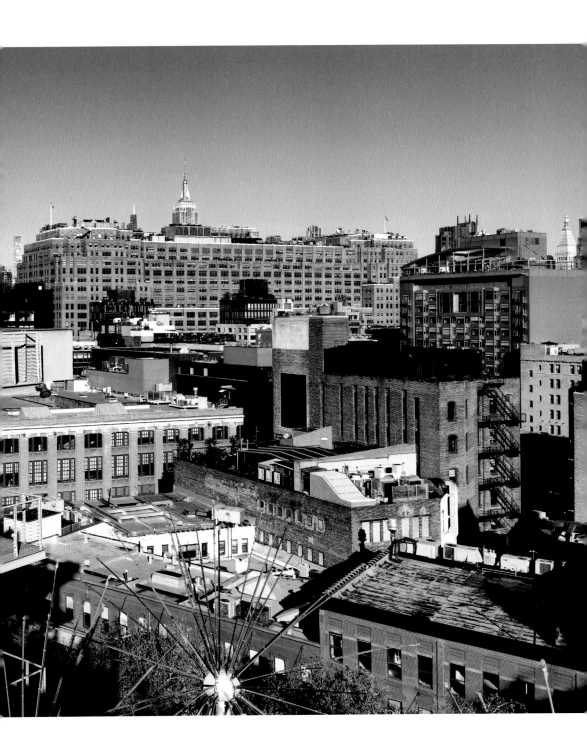

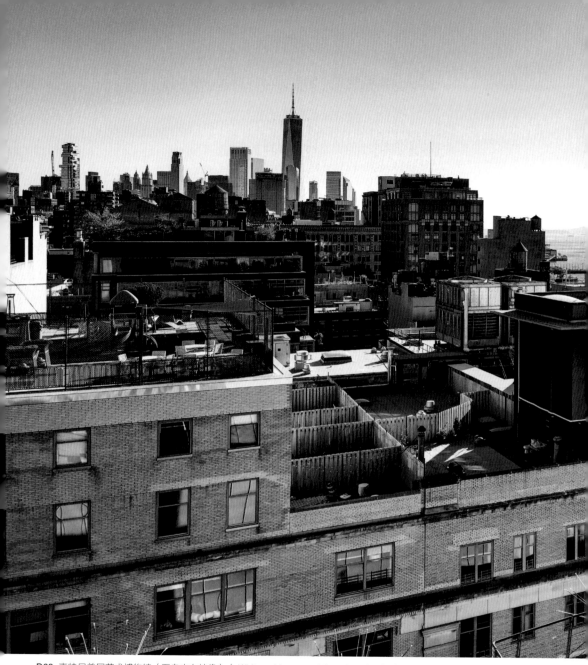

D68　惠特尼美国艺术博物馆（至自由女神像）　|　Whitney Museum of American Art (to Statue Liberty)

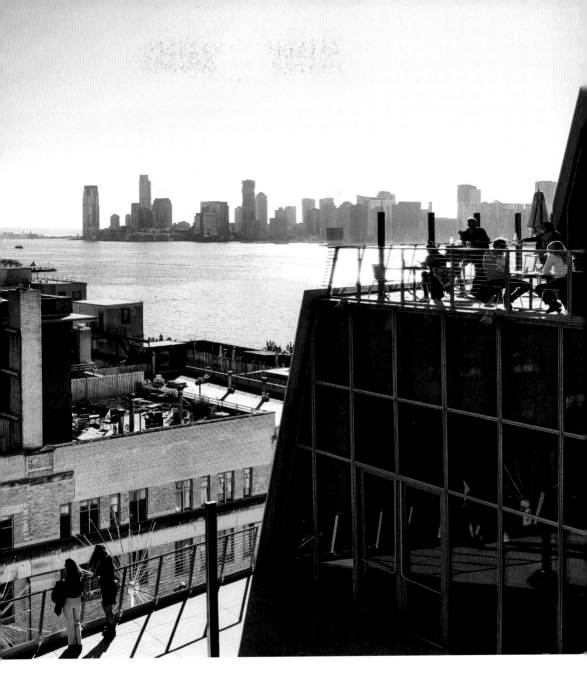

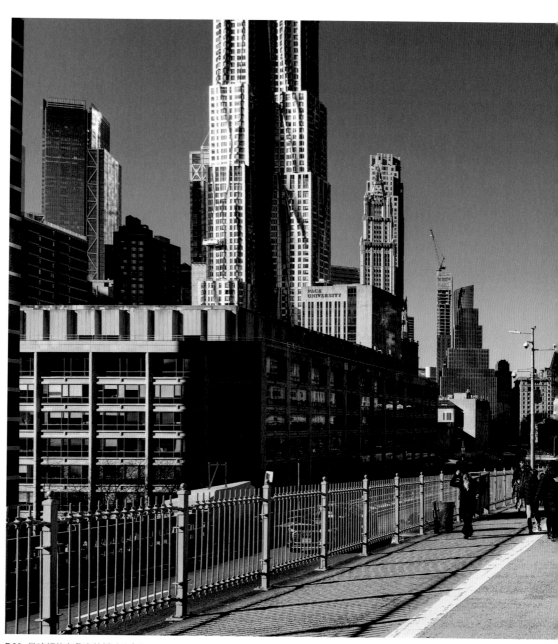

D69 曼哈顿的布鲁克林桥（1）| Brooklyn Bridge at Manhattan (1)

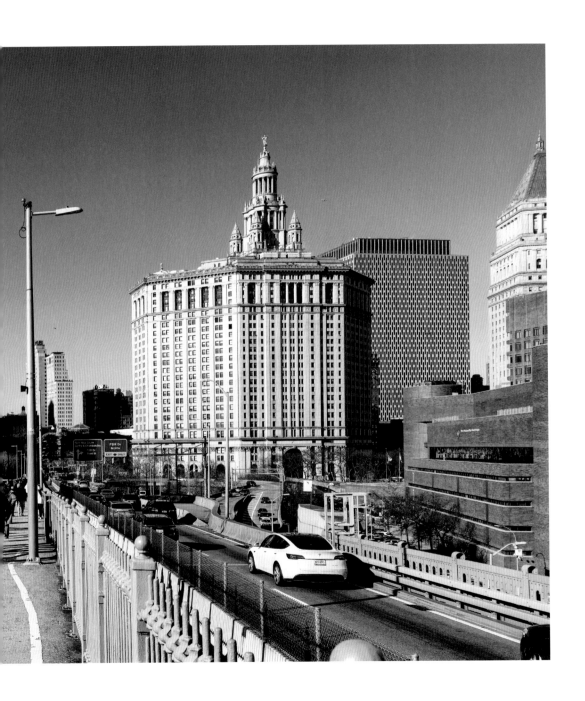

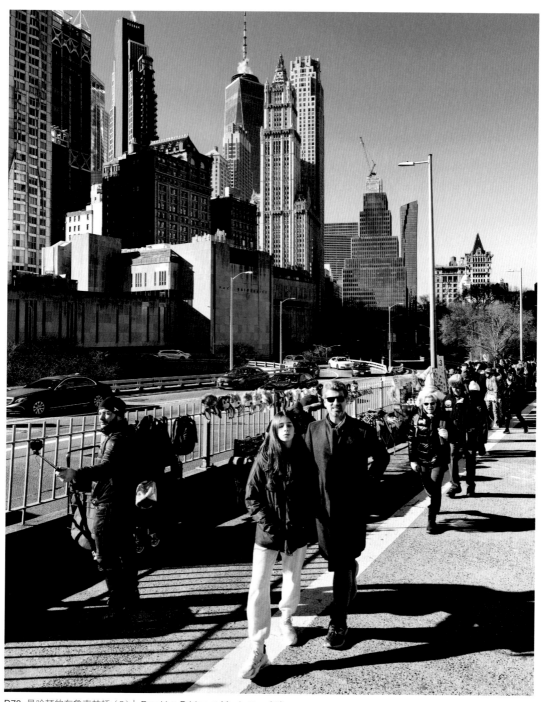

D70 曼哈顿的布鲁克林桥（2）| Brooklyn Bridge at Manhattan（2）

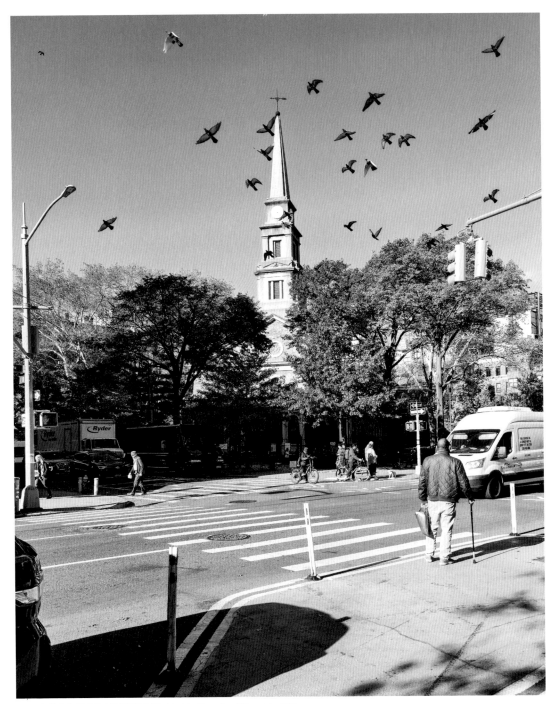

D71 史岱文森街的圣马克教堂 | St. Mark's Church at Stuyvesant St.

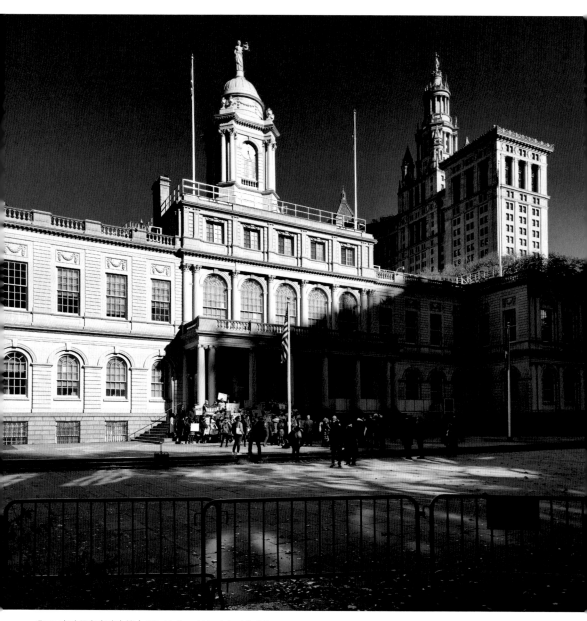

D72 市政厅和市政大楼 | City Hall and Municipal Building

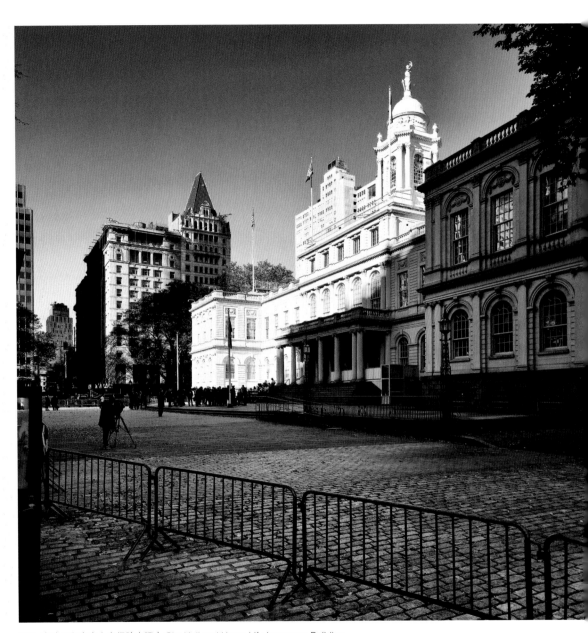

D73 市政厅和家庭人寿保险大楼 | City Hall and Home Life Insurance Building

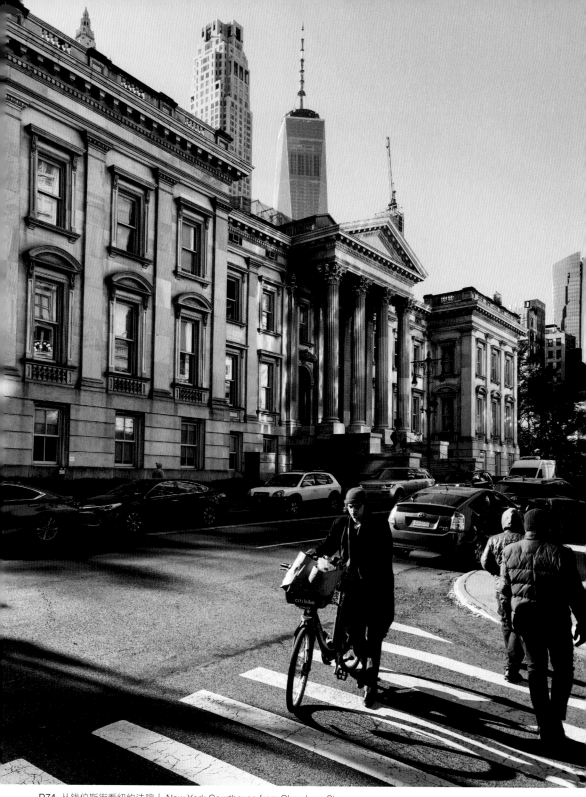

D74 从钱伯斯街看纽约法院 | New York Courthouse from Chambers St.

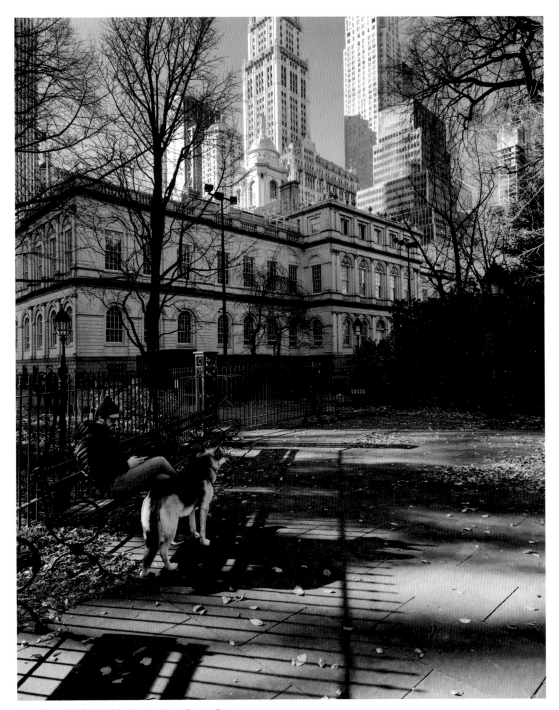

D75 从中心街看市政厅 | City Hall from Centre St.

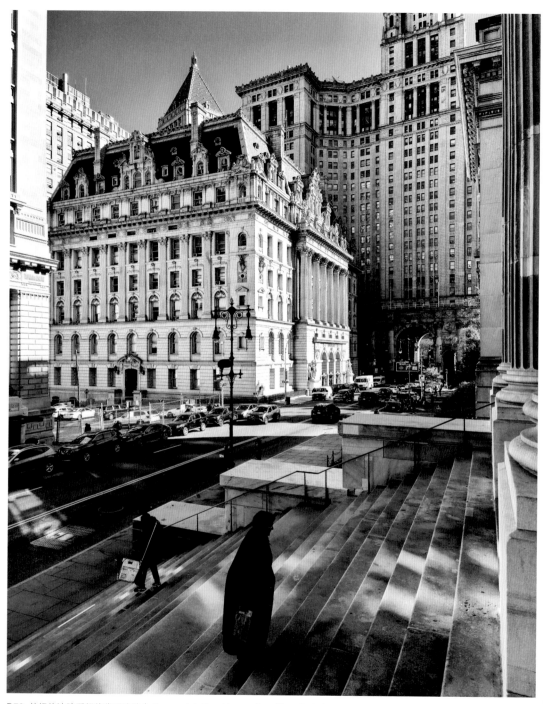

D76 从纽约法院看纽约代理法院 | Surrogate's Court house from New York Courthouse

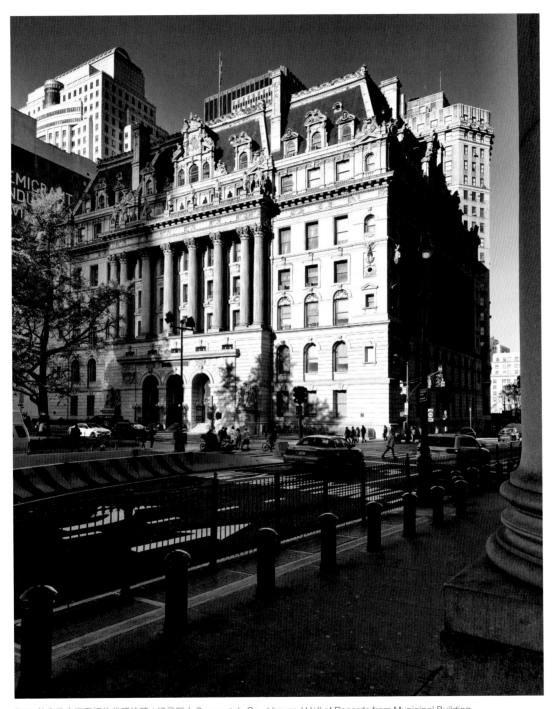

D77 从市政大楼看纽约代理法院 / 记录厅 | Surrogate's Court house / Hall of Records from Municipal Building

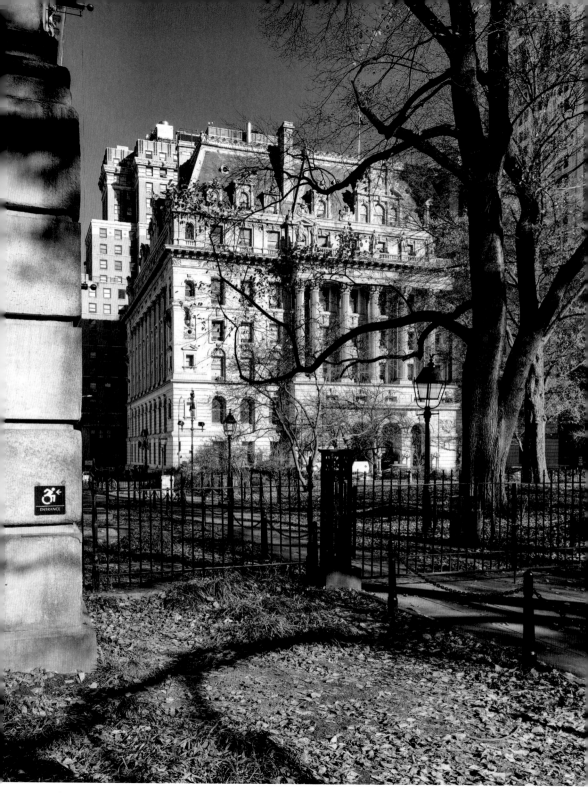

D78 从市政厅公园看纽约代理法院 | Surrogate's Court house from City Hall Park

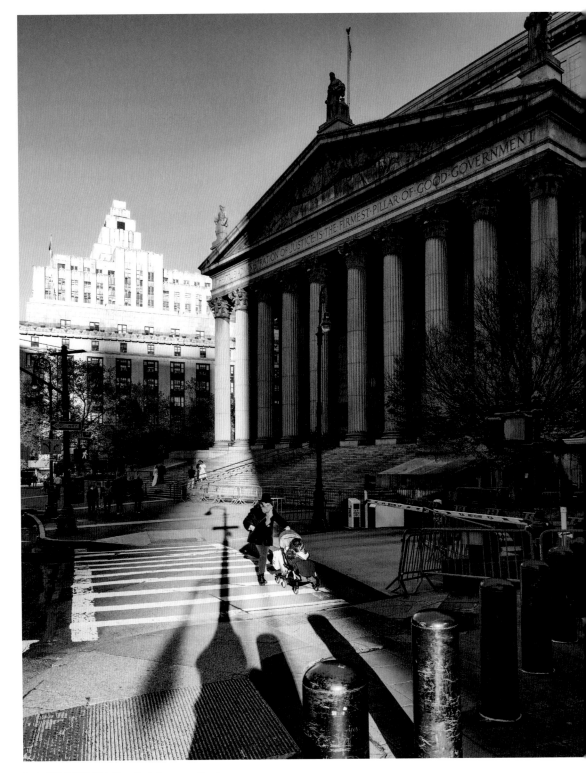

D79 纽约最高法院 | New York Supreme Court

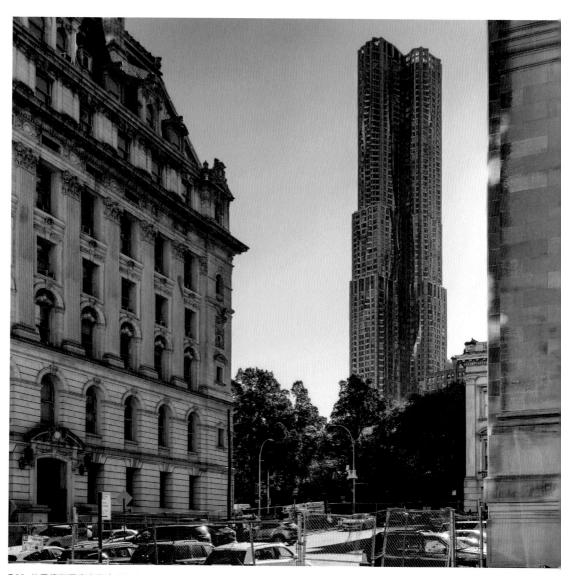

D80 从里德街看麋鹿街 | Elk. St. at Reade St.

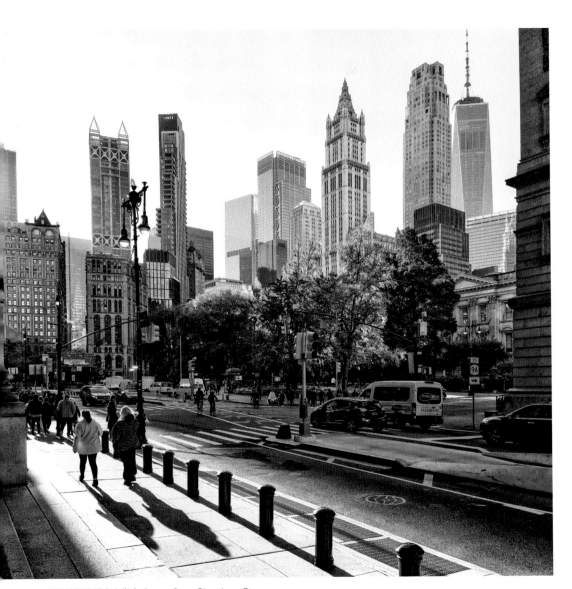

D81 从钱伯斯街看中心街 | Centre St. at Chambers St.

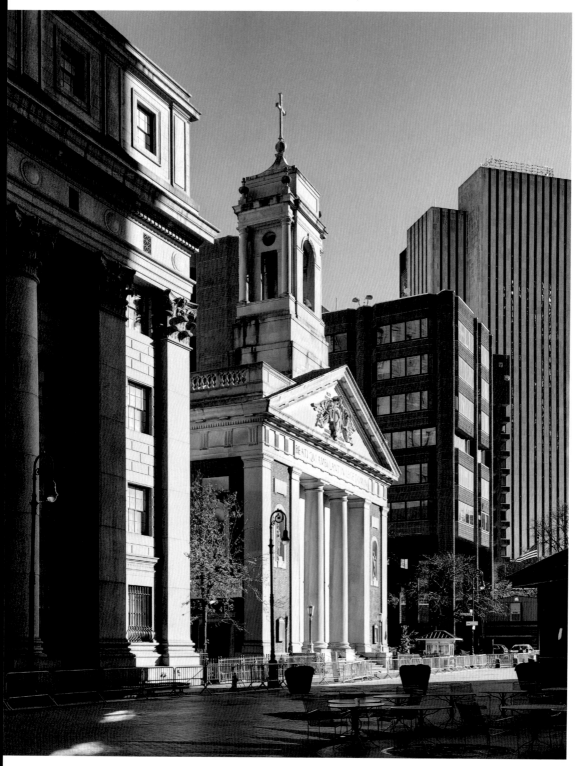

D82 从杜安街看圣安德鲁教堂 | St. Andrew's Church at Duane St.

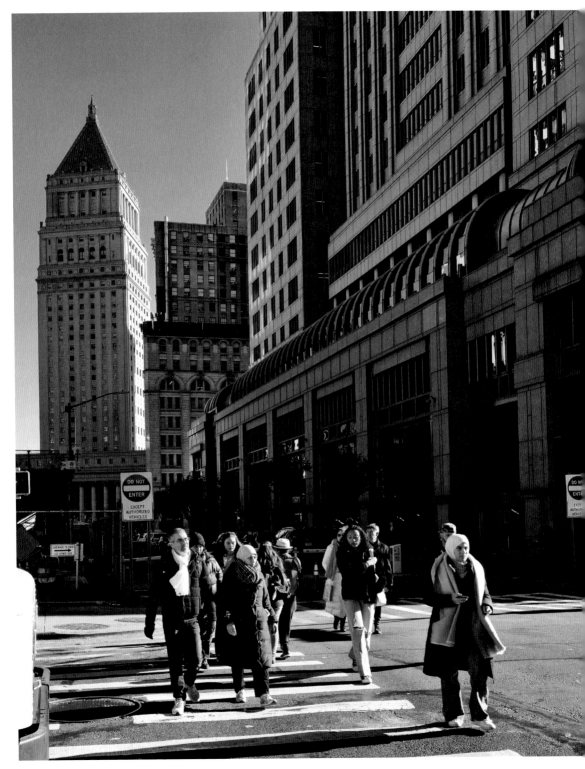

D83 百老汇至美国法院之间的杜安街 | Duane St. at Broadway to United States Courthouse

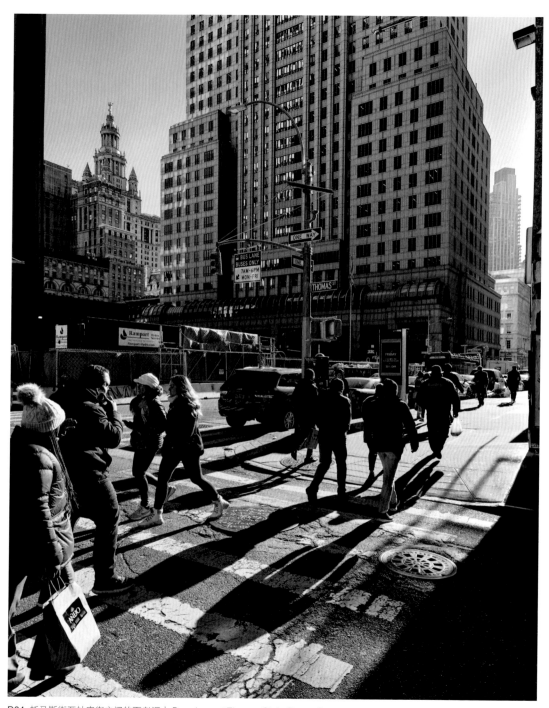

D84 托马斯街至杜安街之间的百老汇 | Broadway at Thomas St. to Duane St.

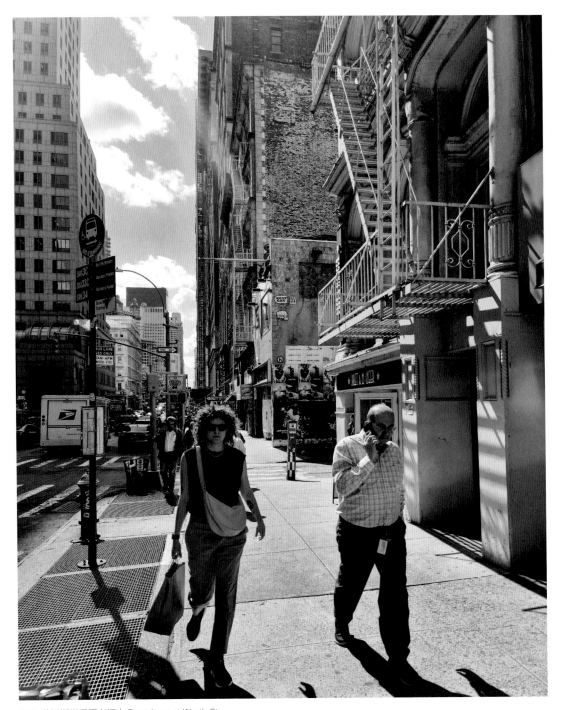

D85 从沃斯街看百老汇 | Broadway at Worth St.

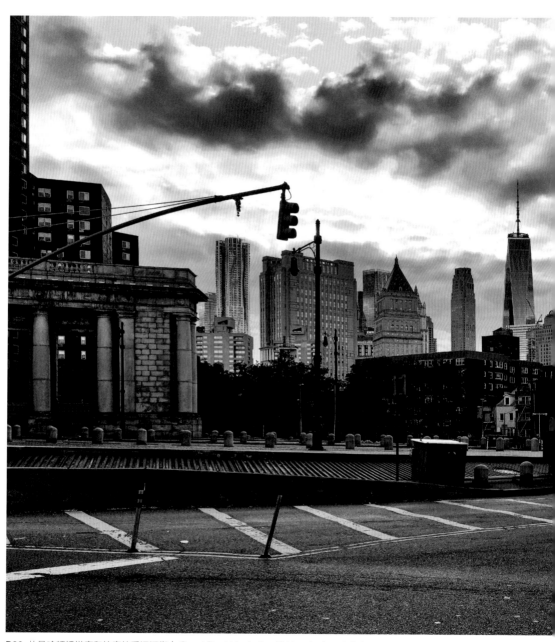

D86 从曼哈顿桥拱廊和柱廊处看运河街 | Canal St. at Manhattan Bridge Arch and Colonnade

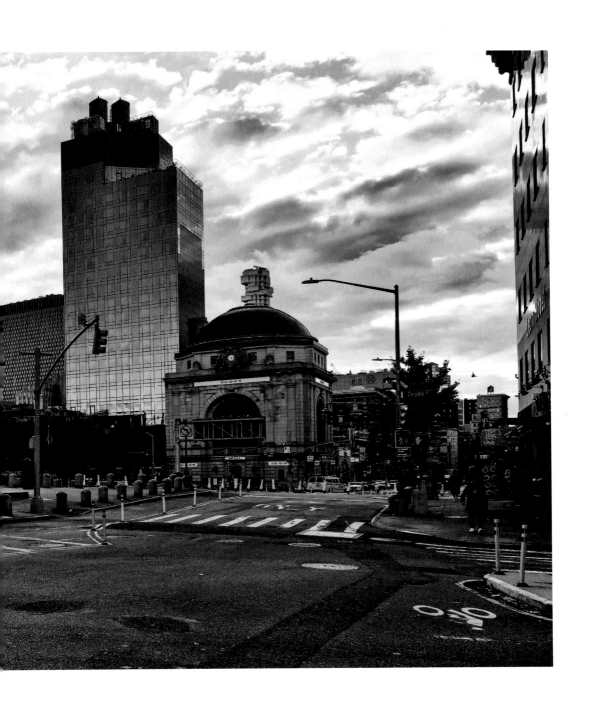

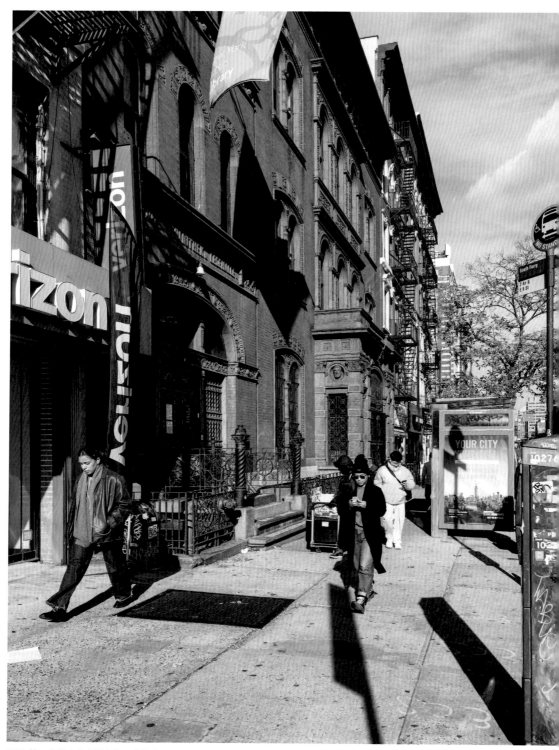

D87　第二大道旁的奥滕多弗图书馆 | Ottendorfer Library by 2th Ave.

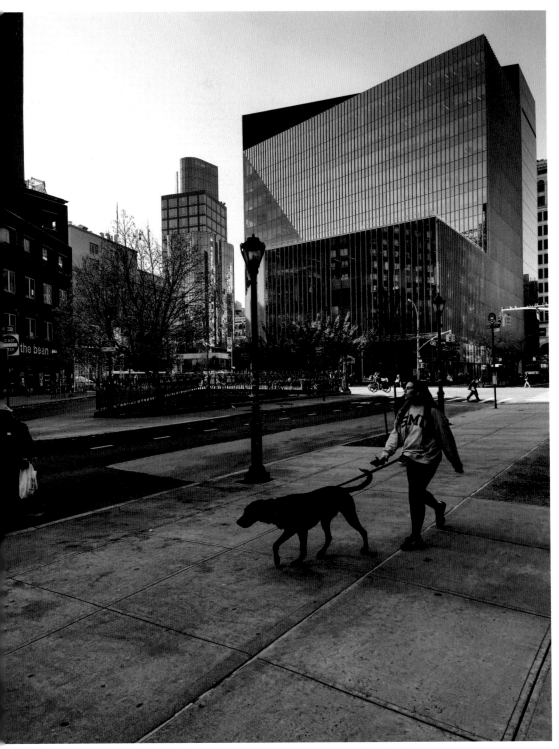

D88 从东九街和史岱文森街看第三大道 ｜ 3th Ave. at E. 9 St. & Stuyvesant St.

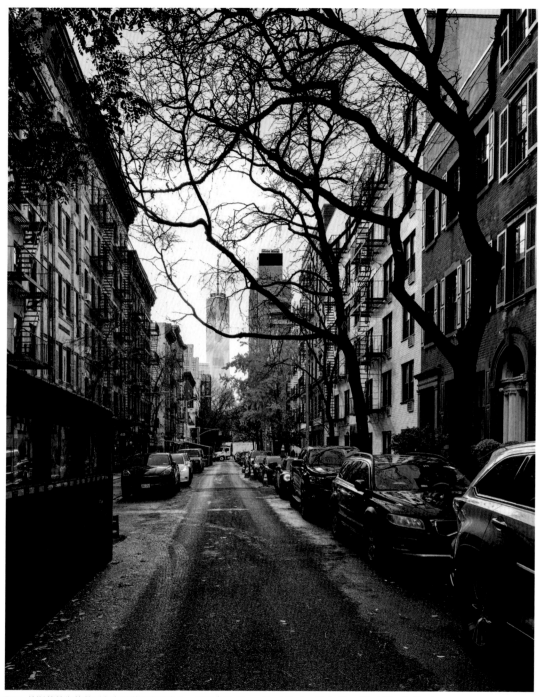

D89 从斯普林街的苏利文街看世界贸易中心一号楼 | Suillivan St. at Spring St. to One World Trade Center

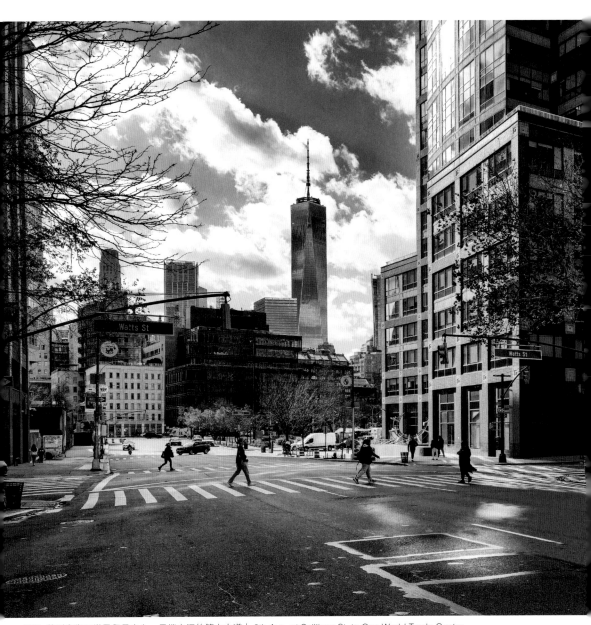

D90 苏利文街至世界贸易中心一号楼之间的第六大道 | 6th Ave. at Suillivan St. to One World Trade Center

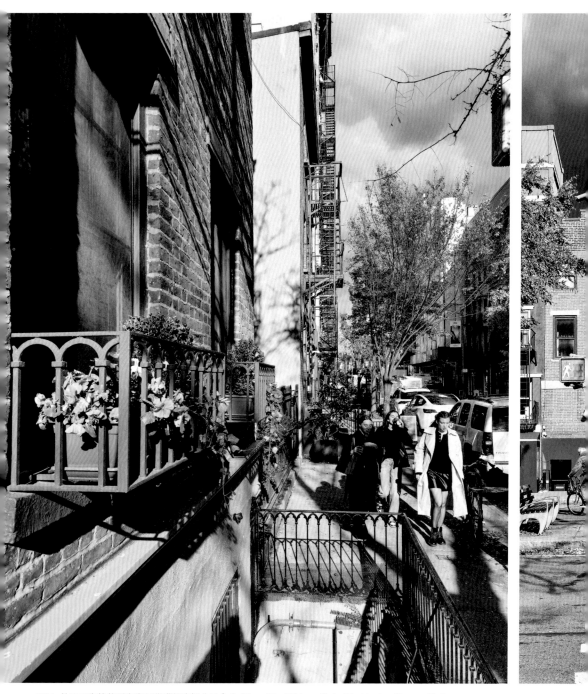

D91 从王子街的苏利文街至华盛顿广场公园 | Suillivan St. at Prince St. to Washington Square Park

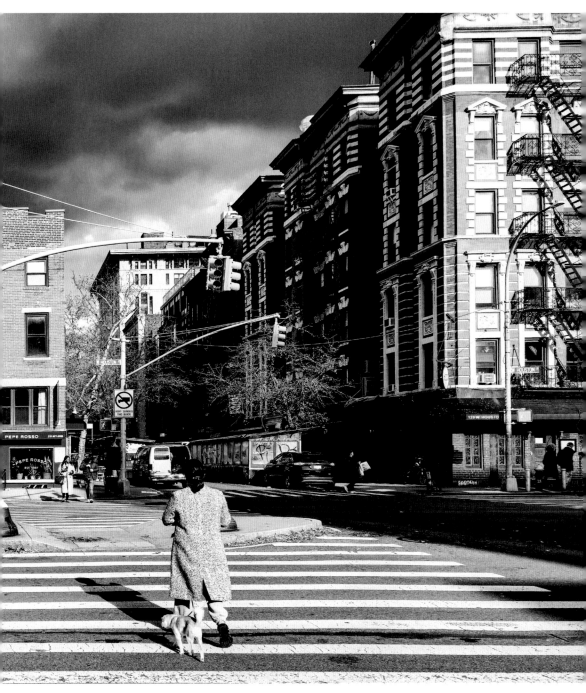

D92 从西休斯顿街看苏利文街 | Suillivan St. at W. Houston St.

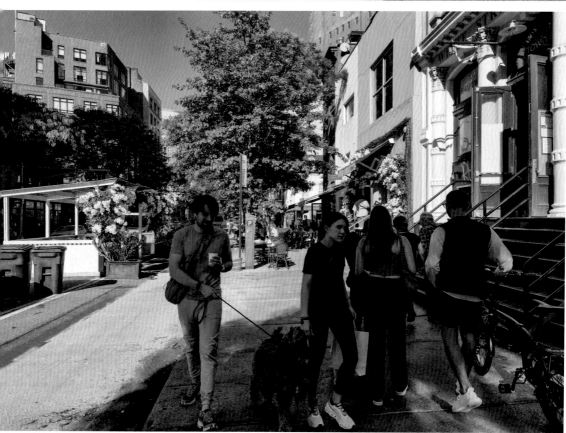

D93　从西百老汇看白色街 | White St. at W. Broadway　/　D94　从富兰克林街看西百老汇 | W. Broadway at Franklin St.

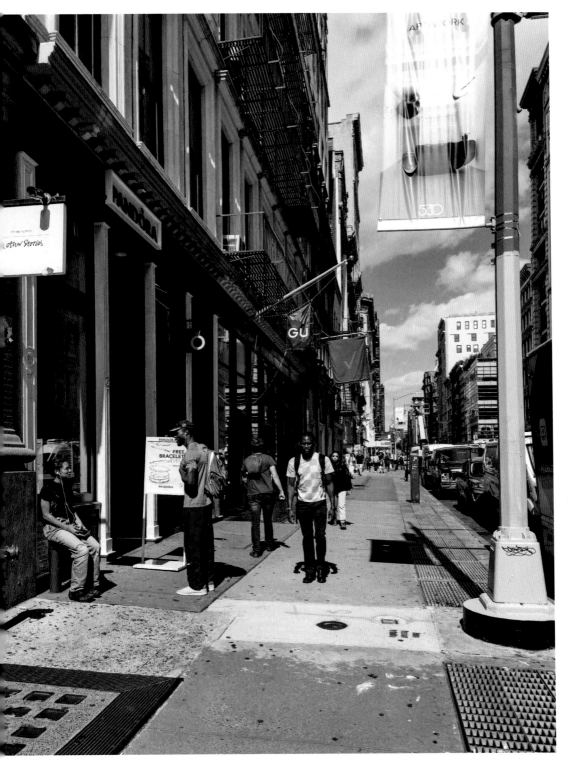

D95 从王子街看百老汇 | Broadway at Prince St.

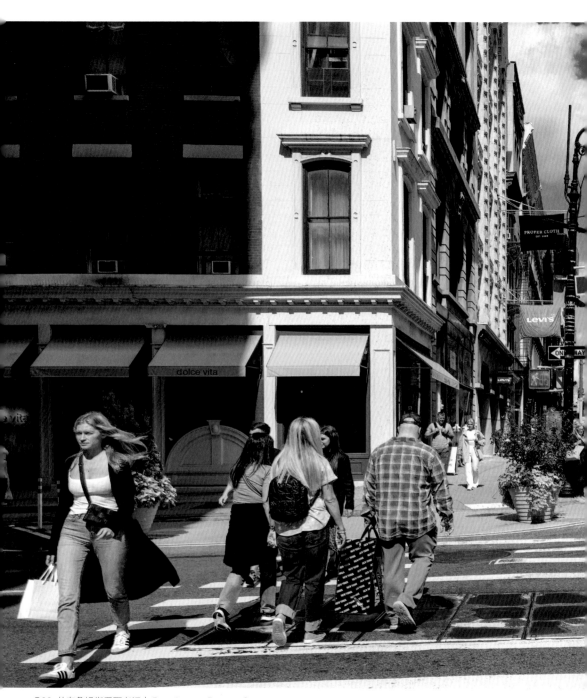

D96 从布鲁姆街看百老汇 | Broadway at Broome St.

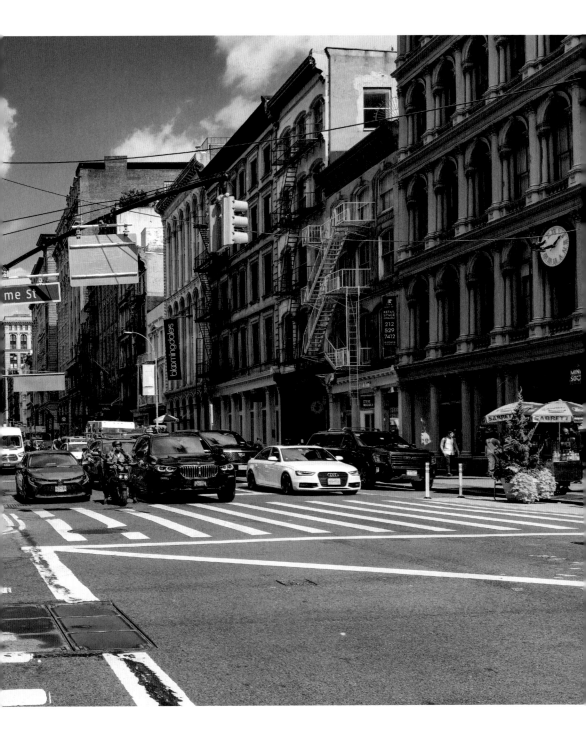

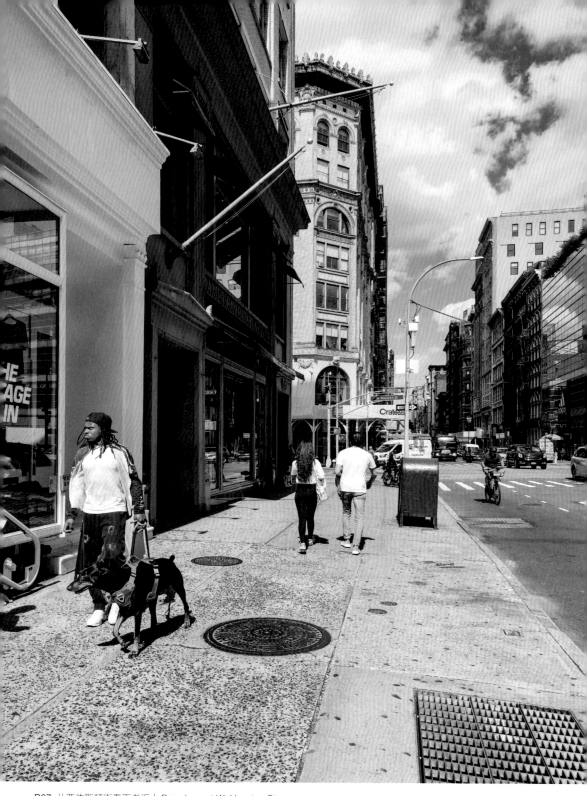

D97　从西休斯顿街看百老汇　|　Broadway at W. Houston St.

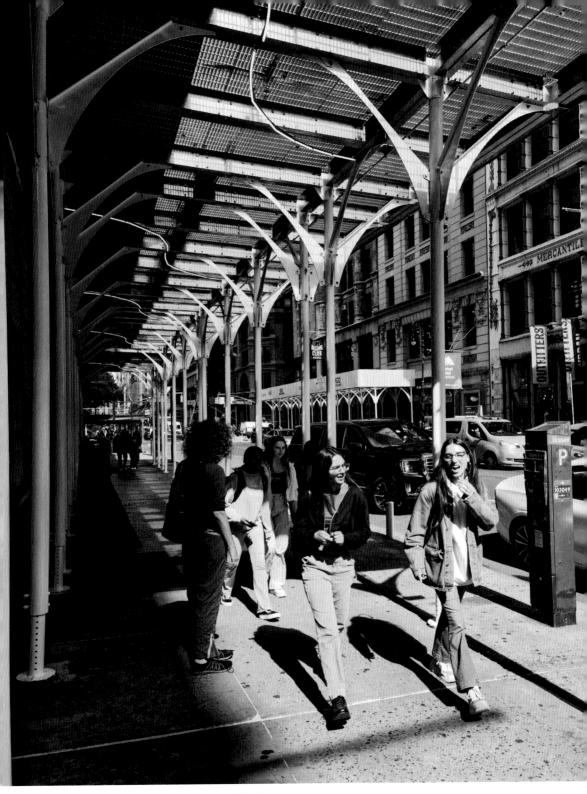

D98　百老汇施工安全走廊 | Broadway Pedestian Safety Corridor

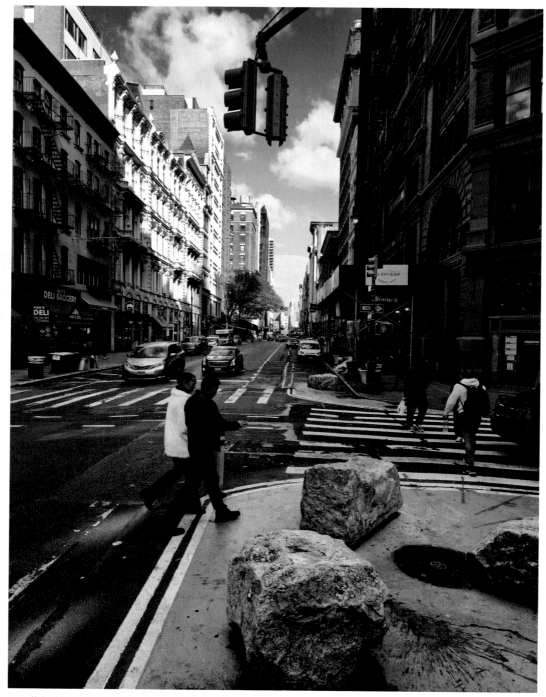

D99 从布利克街看百老汇 | Broadway at Bleecker St.

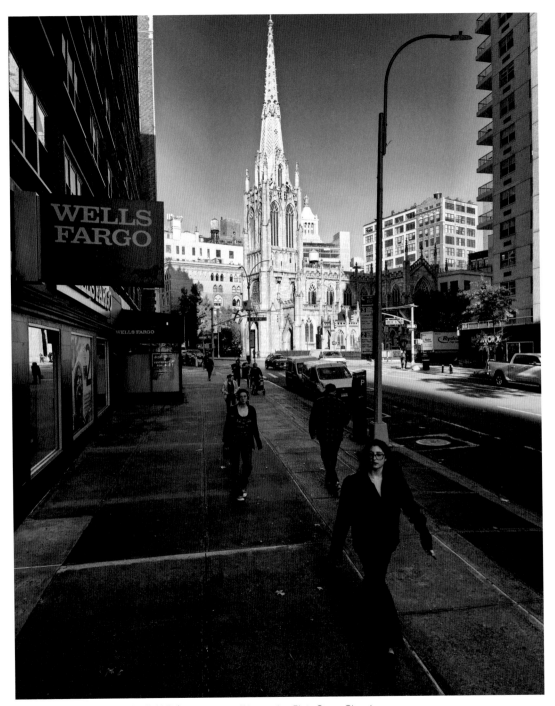

D100 沃纳梅克的百老汇至格雷斯教堂 | Broadway at Wanamaker Pl. to Grace Church

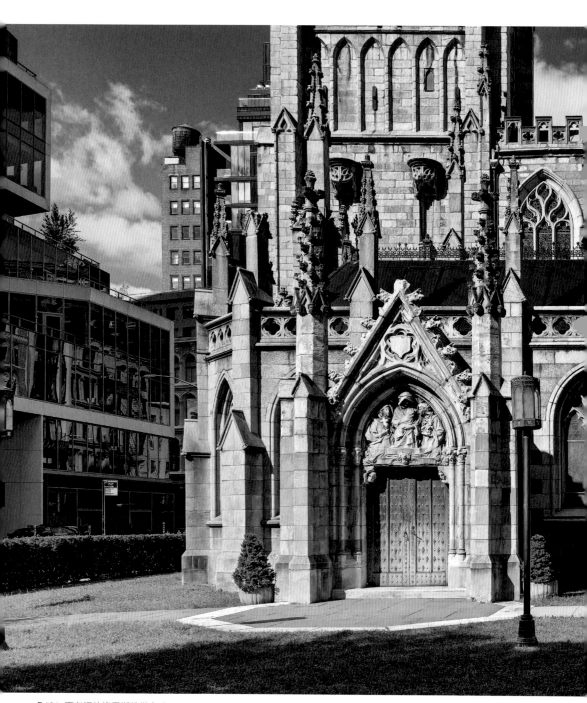

D101 百老汇的格雷斯教堂 | Grace Church by Broadway

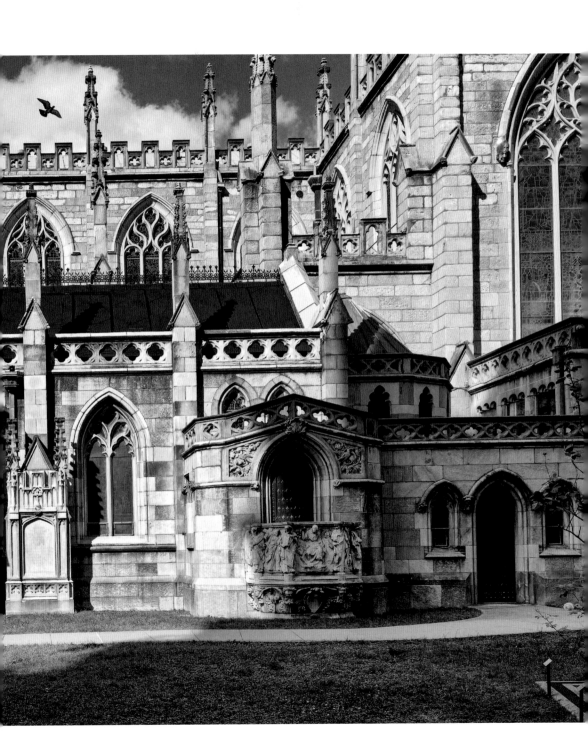

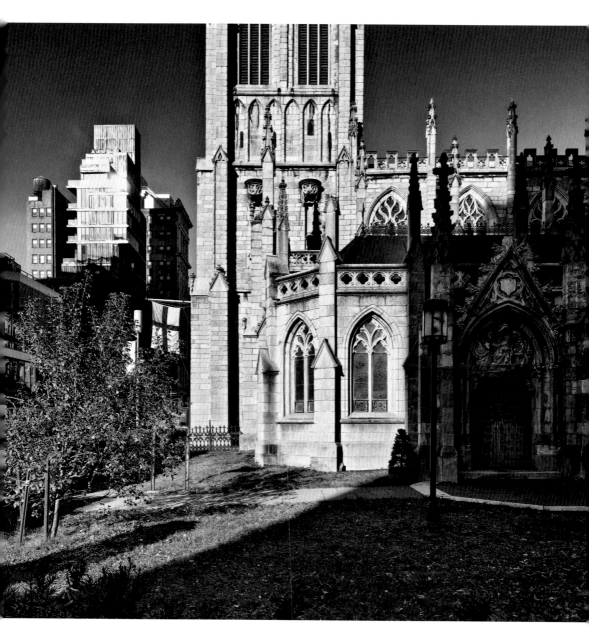

D102 格雷斯教堂 | Grace Church

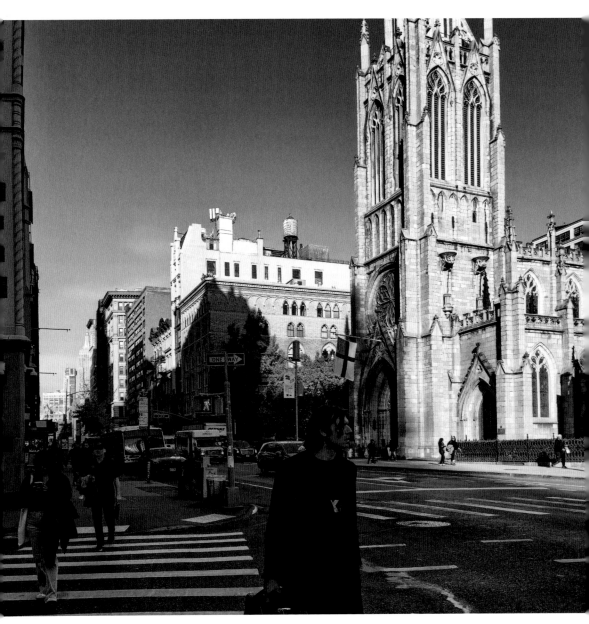

D103　从东十街看百老汇 | Broadway at E. 10 St.

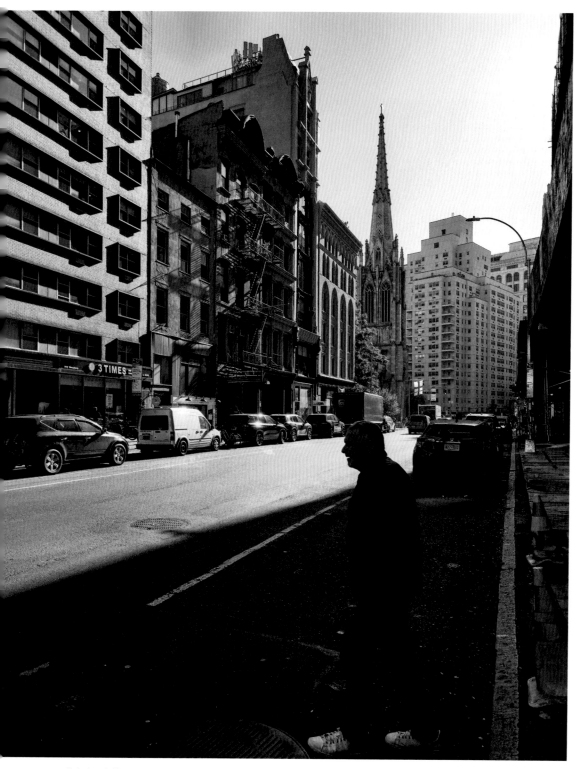

D104 从东十二街的百老汇至格雷斯教堂 | Broadway at E. 12th St. to Grace Church

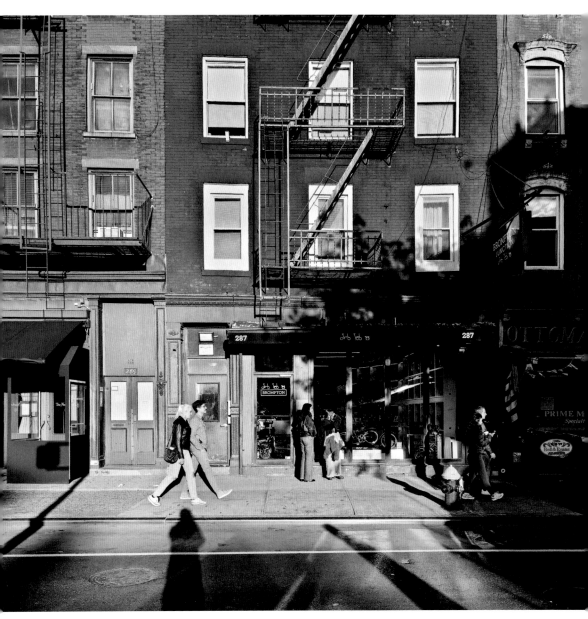

D105 从第七大道南端看布里克街 | Bleeker St. at 7th Ave. S.

D106 在勒罗伊街的卢克小道 | St. Lukes Pl at Leroy St.

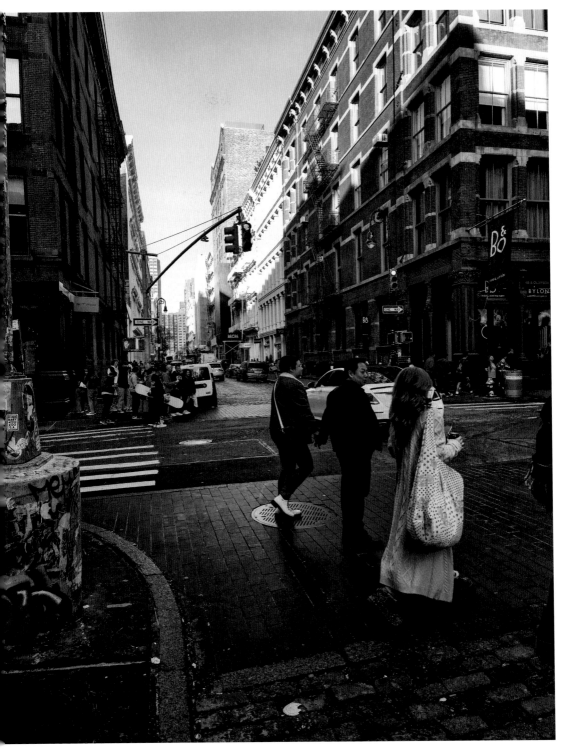

D107 从格林街看春天街 | Spring St. at Greene St.

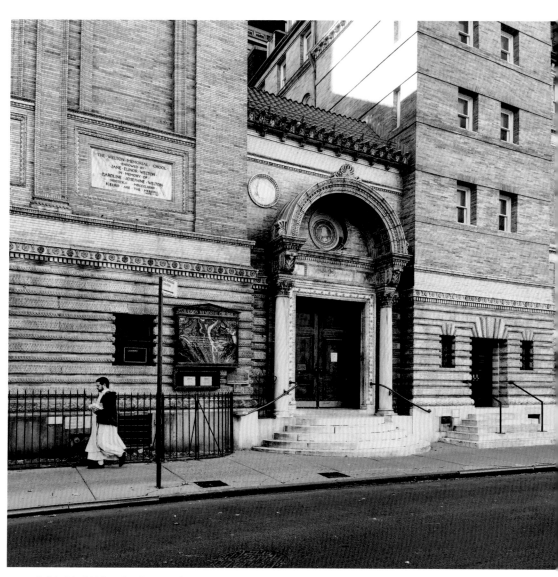

D108 华盛顿广场南端的贾德森庄园教堂（纽约大学） | Judson Menorial Church (NYU) by Washington Square S.

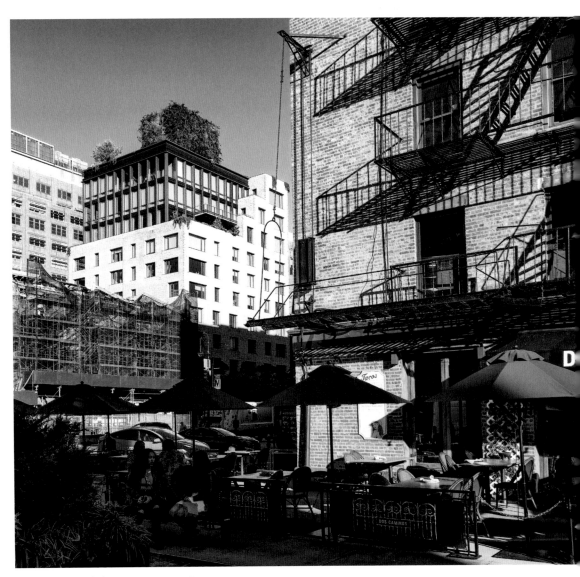

D109 十三街的街角 | Street Corner at 13 St.

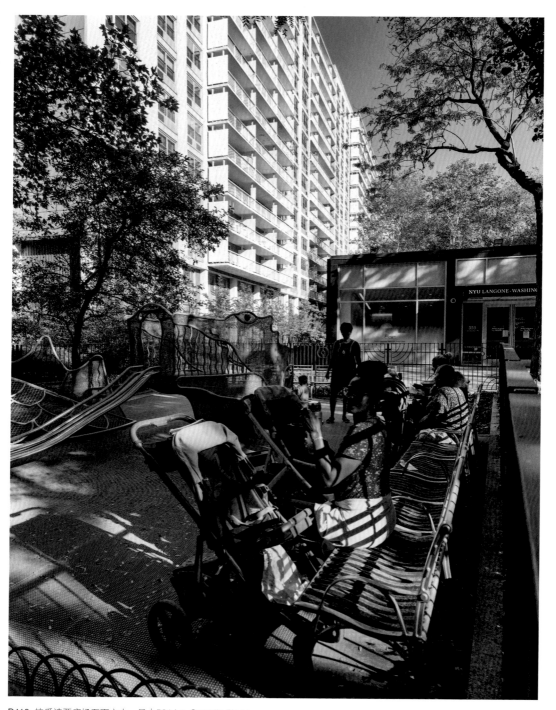

D110 拉瓜迪亚广场五百六十一号 | 561 La. Guardia Place

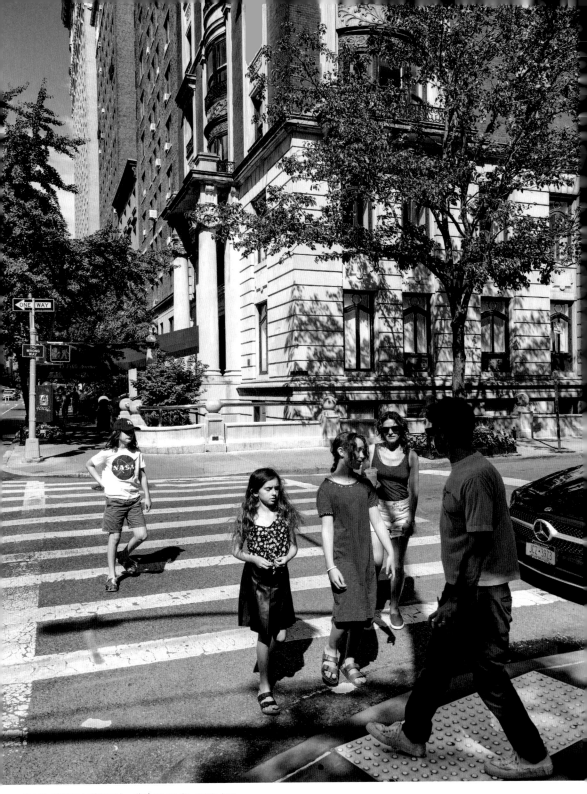

D111　从第五大道看西十一街 | W. 11 St. at 5th Ave.

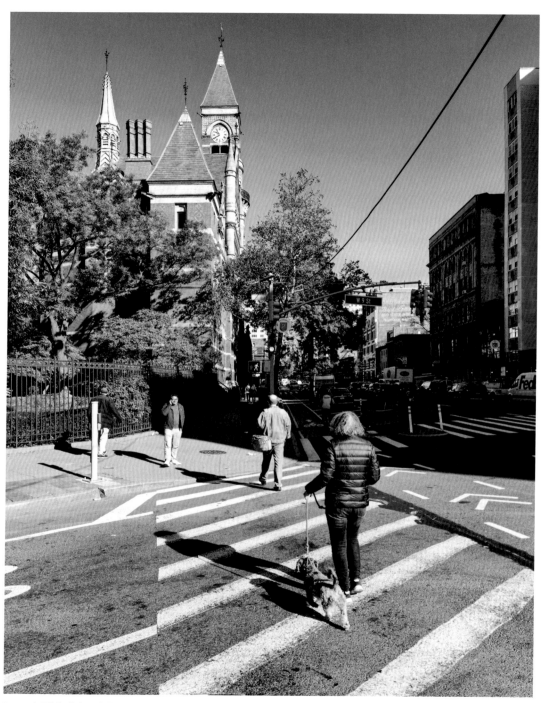

D112 克里斯托弗街至杰斐逊市场图书馆之间的第六大道 | 6th Ave. at Christopher St. to Jefferson Market Library

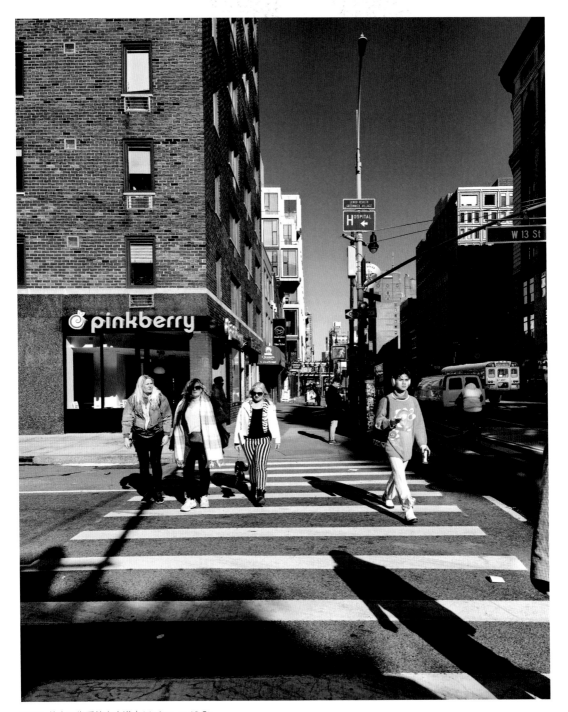

D113　从十三街看第六大道 | 6th Ave. at 13 St.

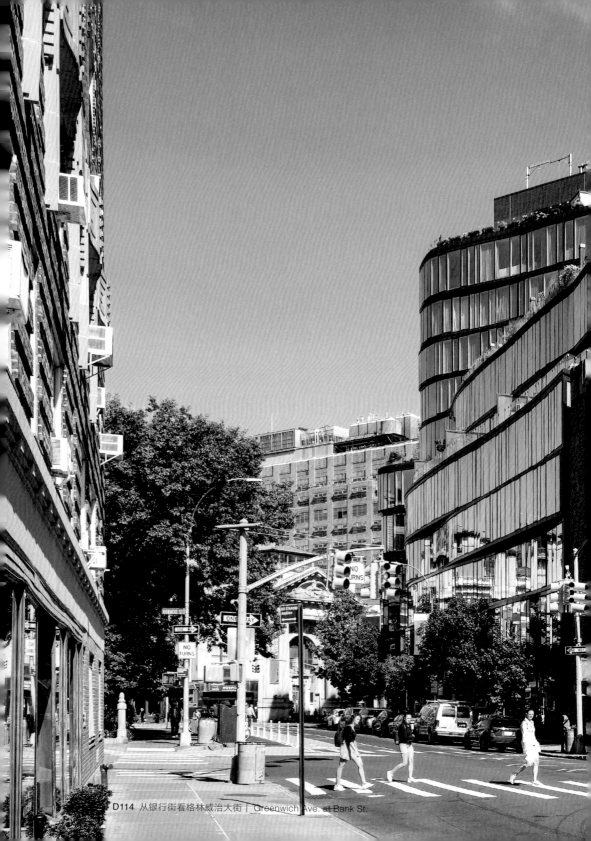

D114 从银行街看格林威治大街 | Greenwich Ave. at Bank St.

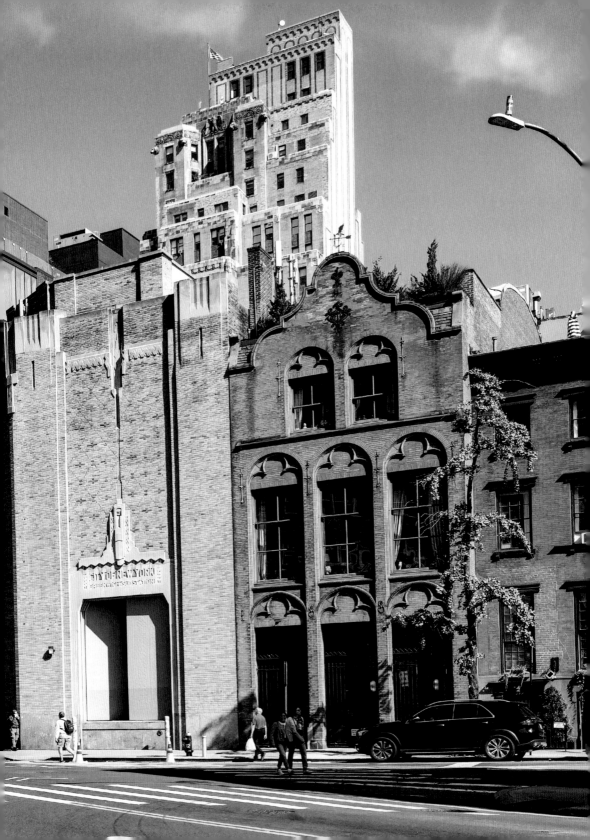

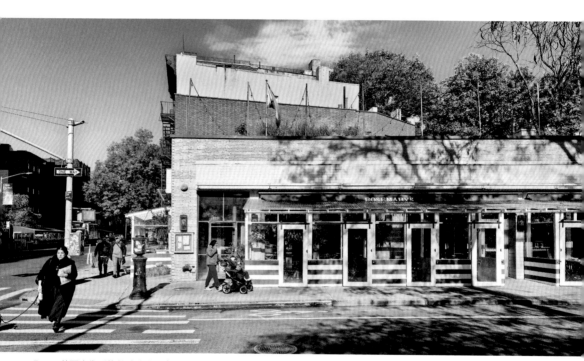

D115 从西十街看格林威治大街 | Greenwich Ave. at W. 10th St.

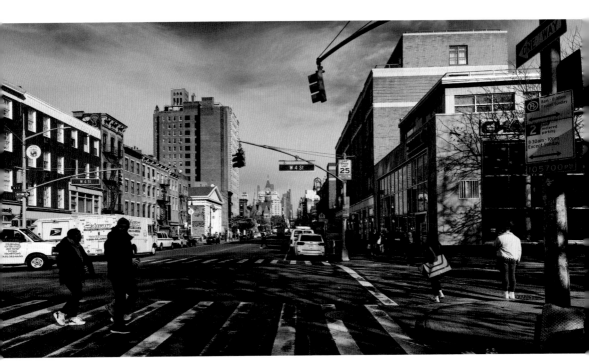

D116 从西四街看第六大道 | 6th Ave. at W. 4 St.

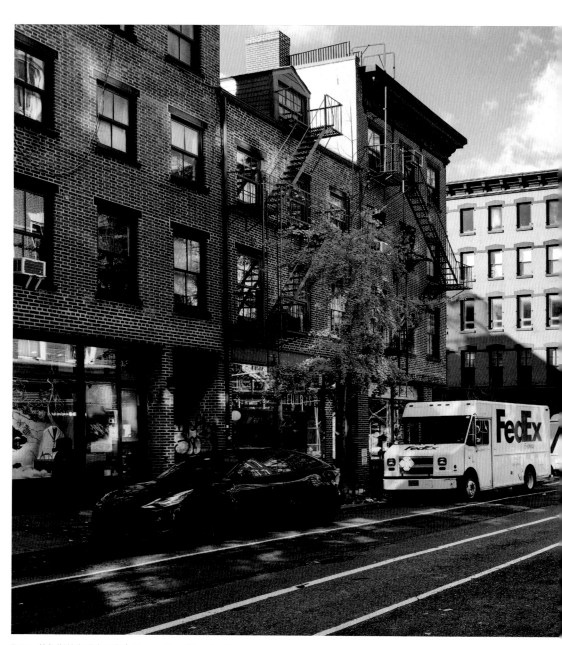

D117 从伍斯特街看春天街 | Spring St. at Wooster St.

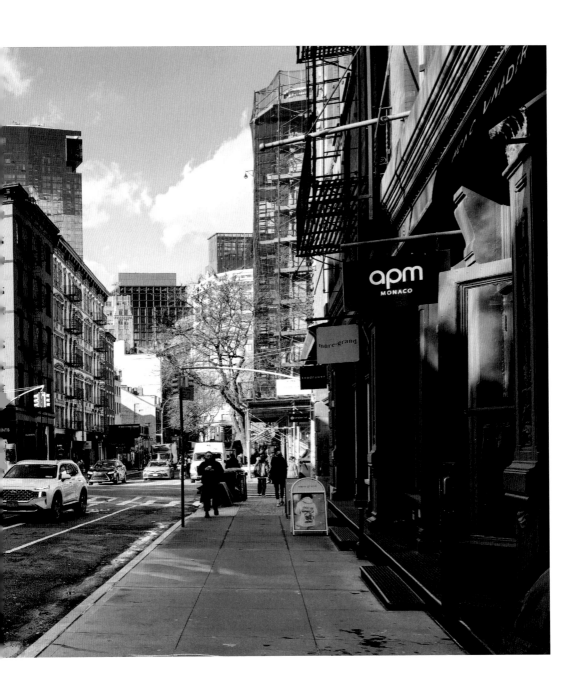

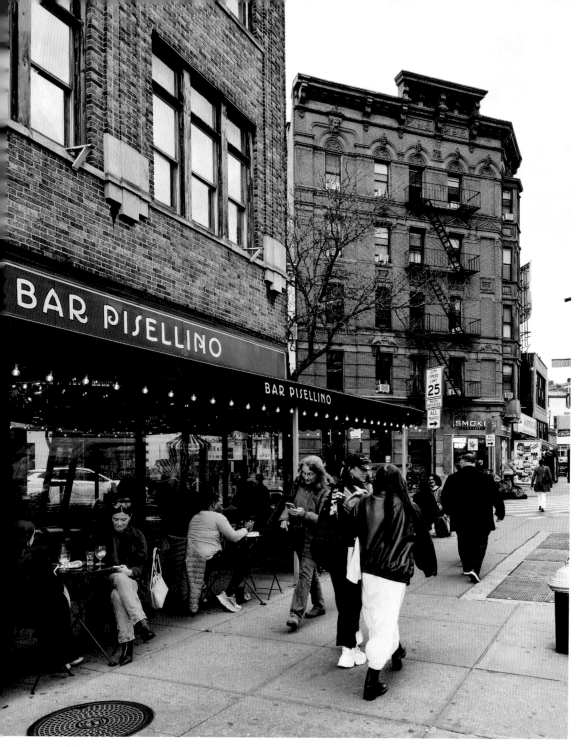

D118 从布里克街看步行街 | Walking St. at Bleecker St.

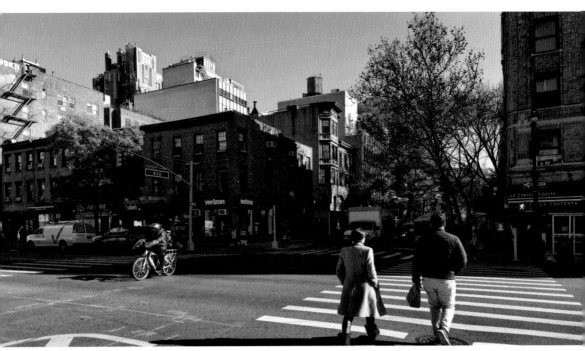
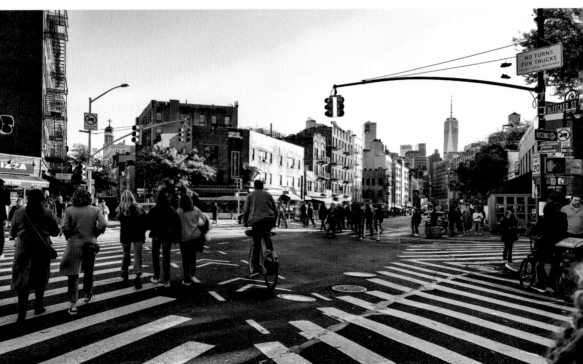

D119 从第六大道看西十一街 | W. 11 St. at 6th Ave. / D120 从第七大道看布里克街 | Bleecker St. at 7th Ave.

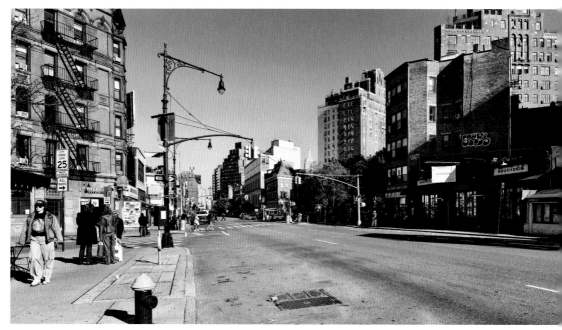

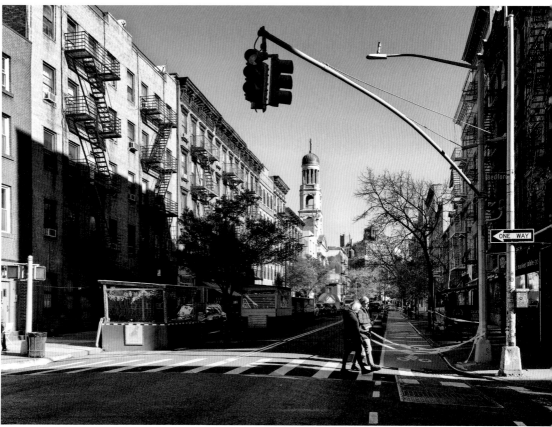

D121 从格罗夫街看第七大道 | 7th Ave. S. at Grove St. / **D122** 从贝德福德街看卡脂街 | Carmine St. at Bedford St.

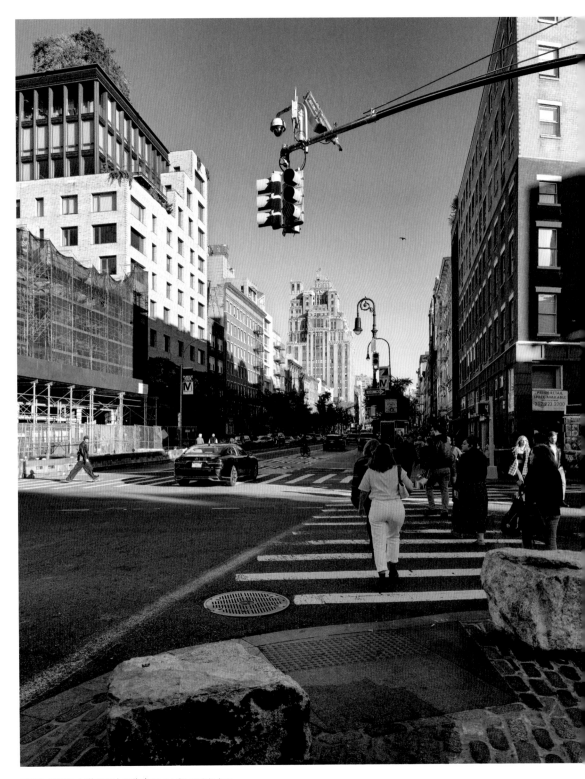

D123　从第九大道看西十四街 | W. 14 St. at 9th Ave.

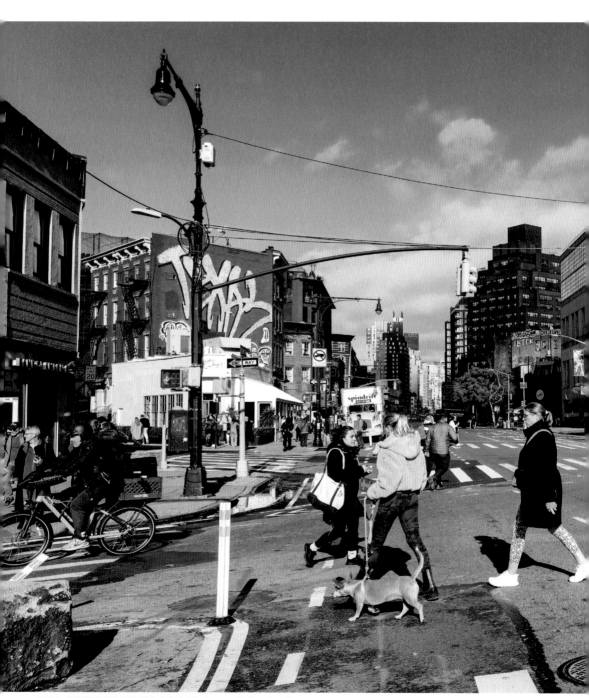

D124 从克里斯托弗街看第七大街 | 7th Ave. at Christopher St.

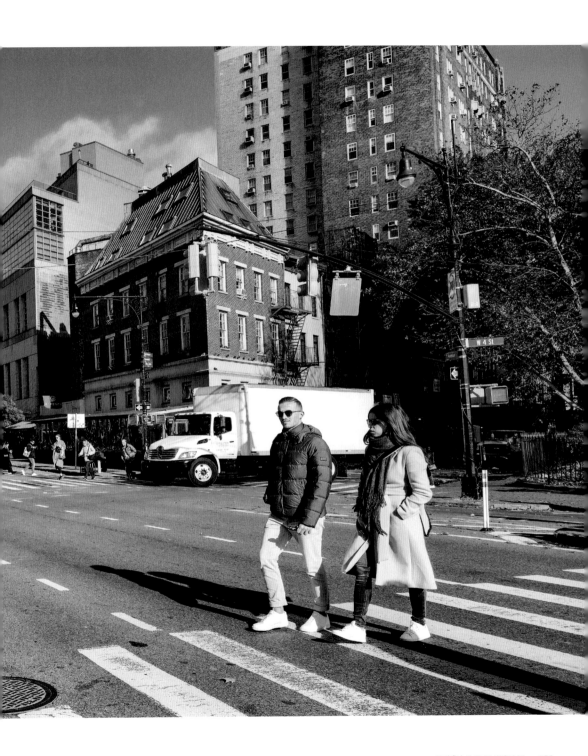

下城 | DOWNTOWN

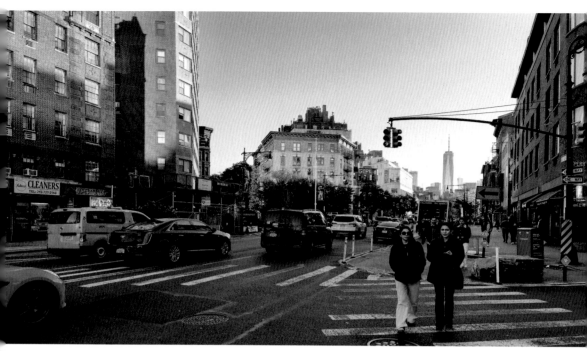

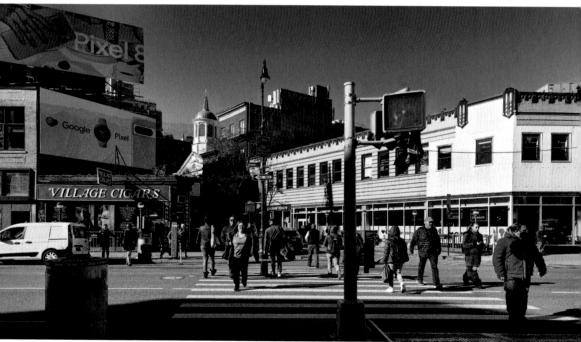

D125　从佩里街的第七大道到世界贸易中心一号 ｜ 7th Ave. at Perry St. to One World Trade Center
D126　从第七大道看克里斯托弗街 ｜ Christopher St. at 7th Ave.

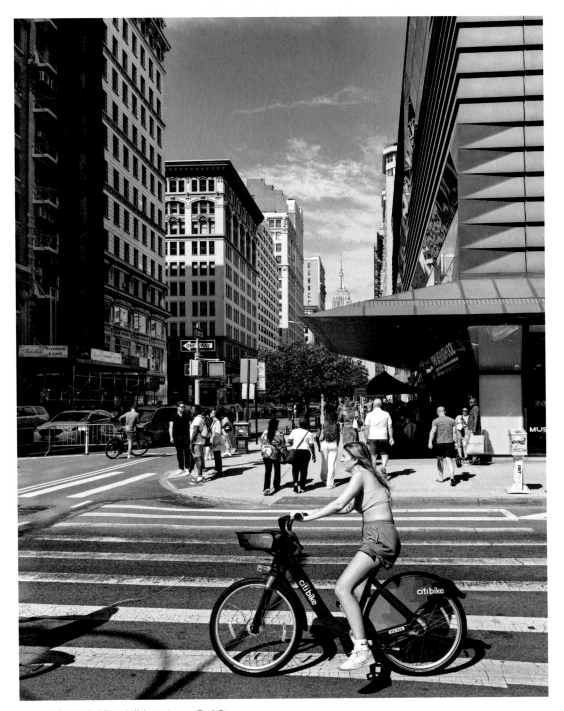

D127 从东十三街看第五大道 | 5th Ave. at E 13 St.

中城

曼哈顿中城是从十四街到五十九街的区域。占地面积与下城相近。从十四街开始，道路全面形成长方格的网络结构，只有百老汇大道蜿蜒贯穿。由于历史建筑明显比下城少以及钢材、新技术等的发展应用，中城建筑的整体高度和密度都明显超过了下城。

中城的重要建筑有：中央火车站（M45／M48／M49）、圣帕德里克大教堂（M76／M77／M78／M111）、圣托马斯教堂（M105／M106／M107／M108）、圣巴特洛圣公会教堂（M81／M82／M83）、中央犹太教堂（M121／M122／M123）、纽约公共图书馆（M54／M55／M56／M57／M58）、帝国大厦（M5／M50／M51）、克莱斯勒大厦（M71）、利华大厦（M95）、花旗银行（M4）、范德比尔特一号楼（M44／M46／M63／M70）以及三幢世界最高的住宅楼：中央公园塔（M3／M86／M91）、57街西111号（M3／M87）、公园大道432号（M88／M84）等。

MIDTOWN

Midtown Manhattan spans from 14th Street to 59th Street, occupying an area similar in size to Downtown. It is from 14th Street onward that Manhattan's road structure fully transitions into a grid network, except for the Broadway meandering through. Due to a noticeable decrease in historic buildings compared to Downtown, and the widespread use of steel and new technologies, the overall height and density of buildings in Midtown far exceed those in Downtown.

The very important buildings in Midtown Manhattan include Grand Central Terminal, St. Patrick's Cathedral, Saint Thomas Church, St. Bartholomew's Episcopal Church, Central Synagogue, the New York Public Library, the Empire State Building, the Chrysler Building, the Lever House, Citibank, One Vanderbilt, and three of the world's tallest residential towers, Central Park Tower, 111 W 57 St. 432 Park Ave. etc.

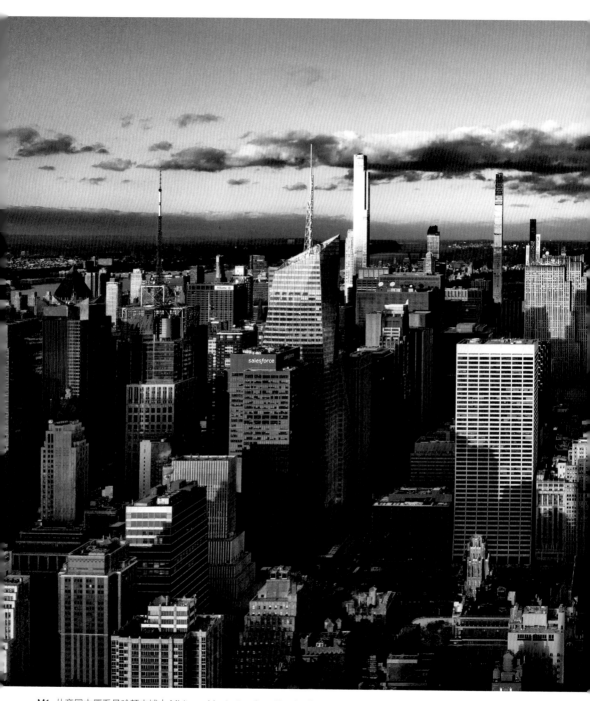

M1 从帝国大厦看曼哈顿中城 ｜ Midtown Manhattan from Empire State Building

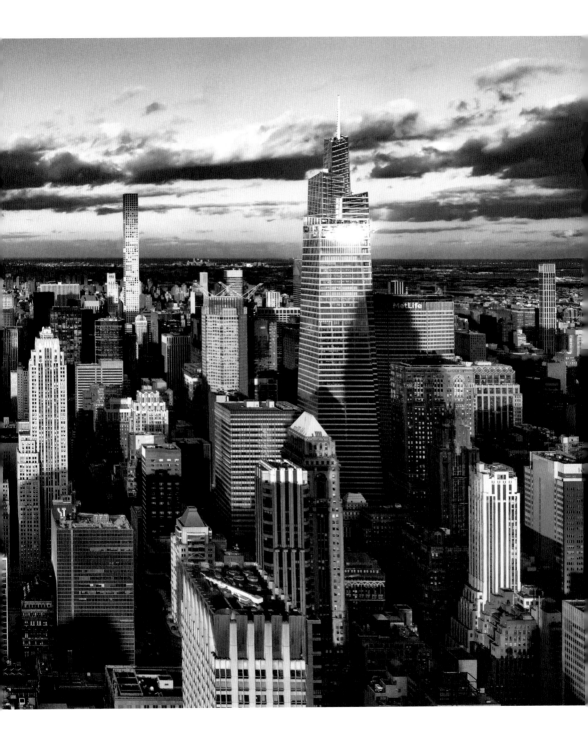

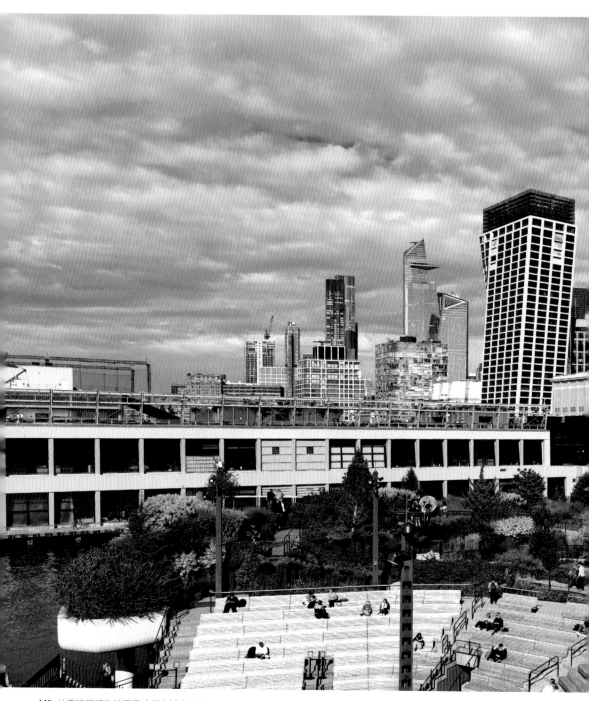

M2 从惠特尼博物馆看曼哈顿中城 | Midtown Manhattan from Whitney Museum

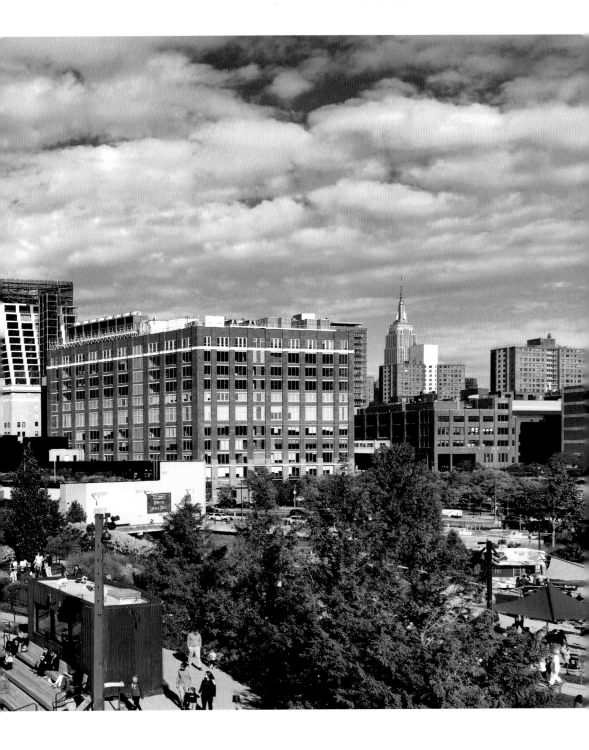

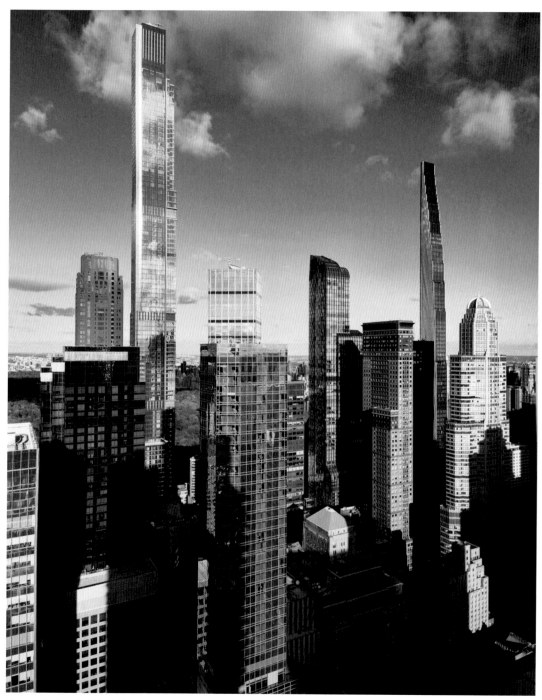

M3 从阿罗公寓看曼哈顿中城 | Midtown Manhattan from ARO

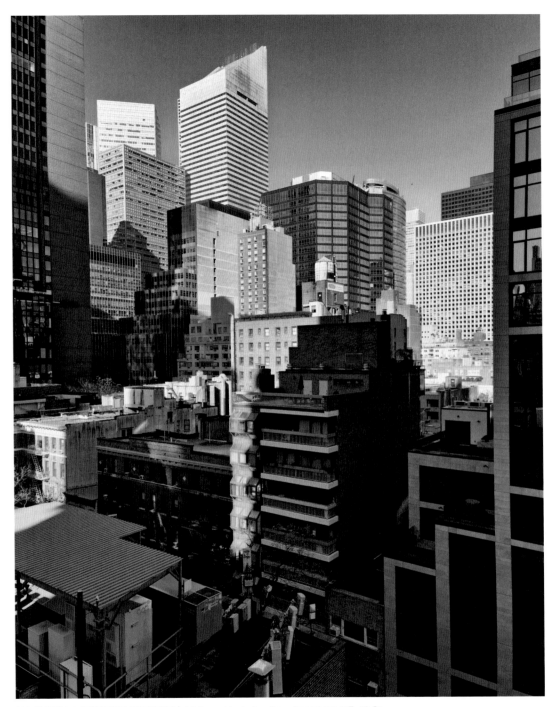

M4 从东四十九街的公寓看曼哈顿中城 | Midtown Manhattan from Apartment at E. 49 St.

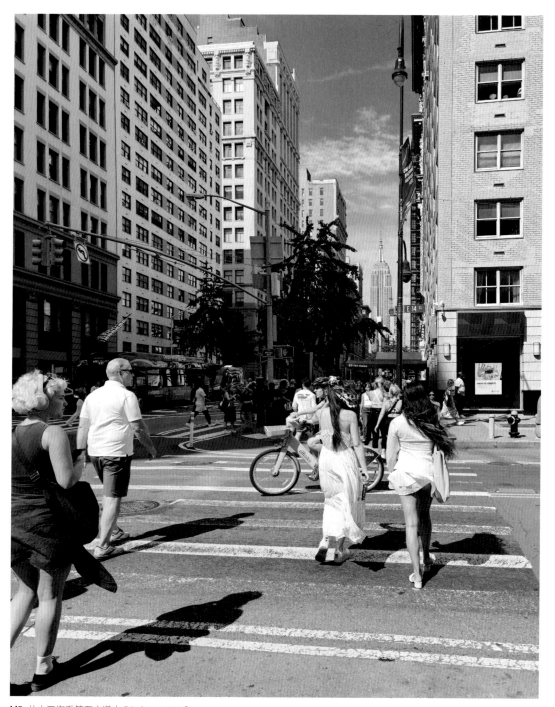

M5 从十四街看第五大道 | 5th Ave. at 14 St.

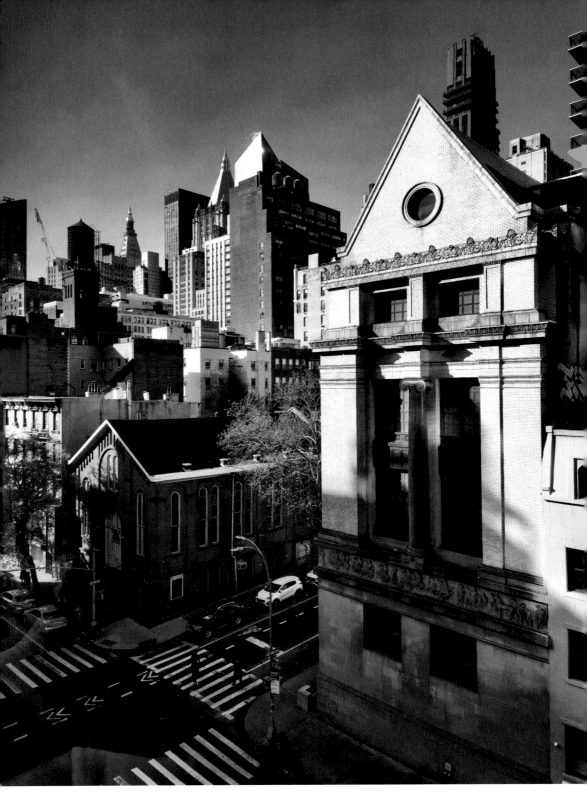

M6 从东三十街的公寓看曼哈顿中城 | Midtown Manhattan from Apartment at E. 30 St.

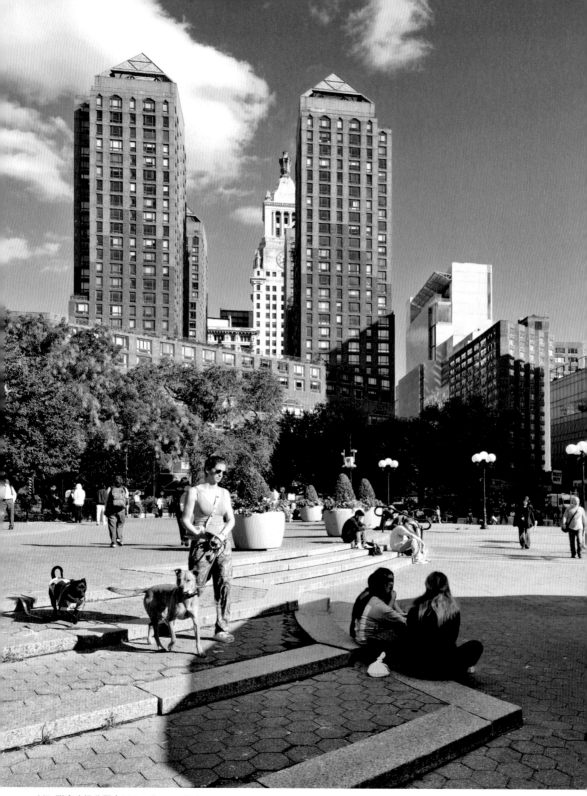

M7 联合广场公园 | Union Square Park

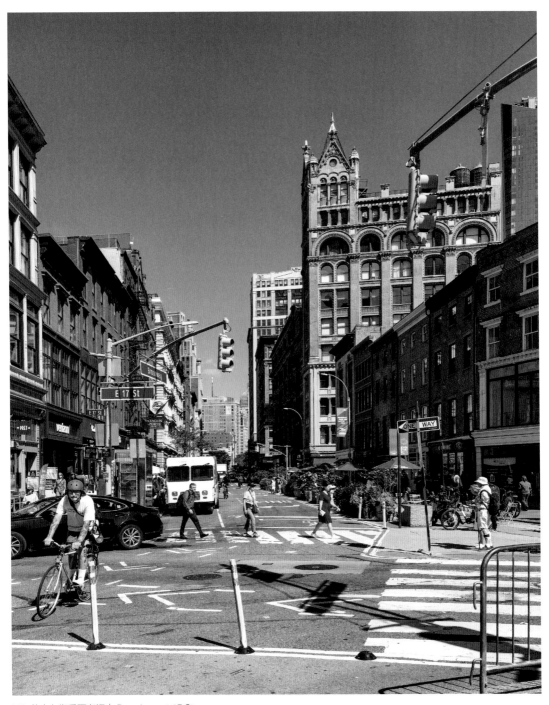

M8 从十七街看百老汇 | Broadway at 17 St.

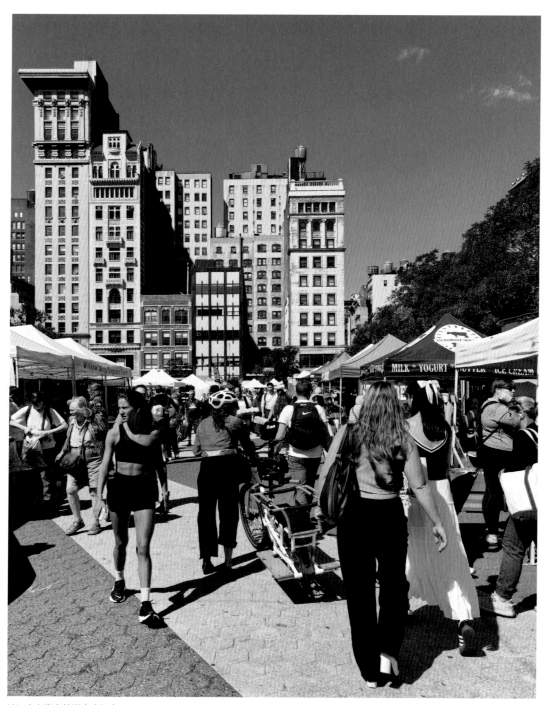

M9 十七街旁的联合广场 | Union Square by 17 St.

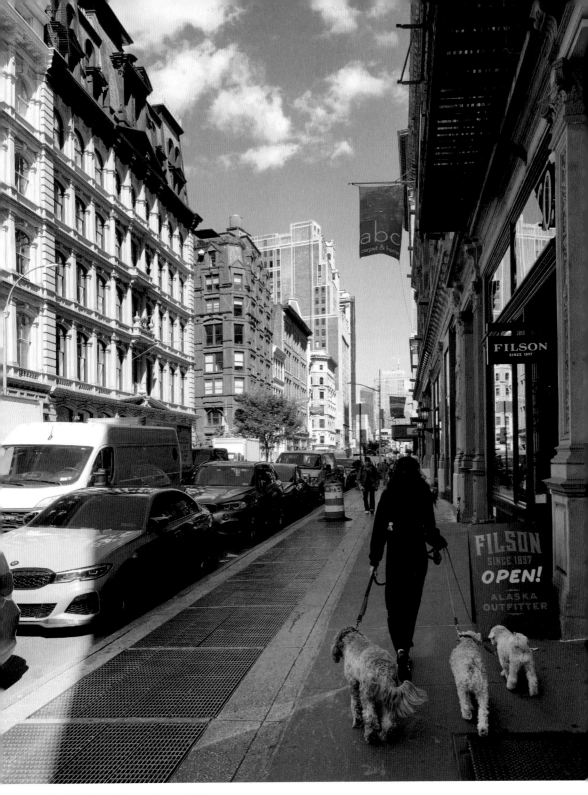

M10　从十八街看百老汇　|　Broadway at 18 St.

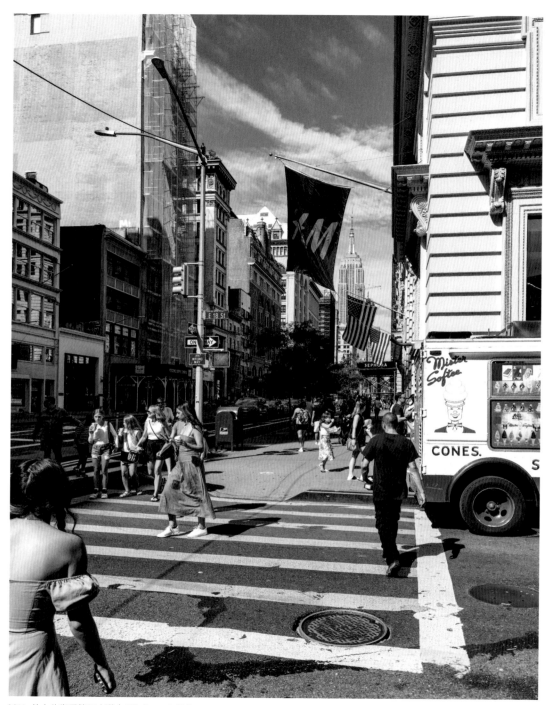

M11　从十八街看第五大道 ｜ 5th Ave. at 18 St.

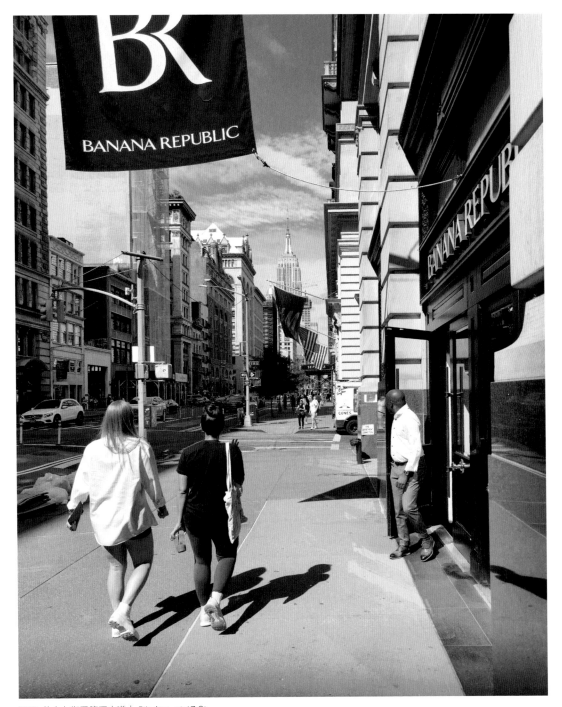

M12 从十七街看第五大道 | 5th Ave. at 17 St.

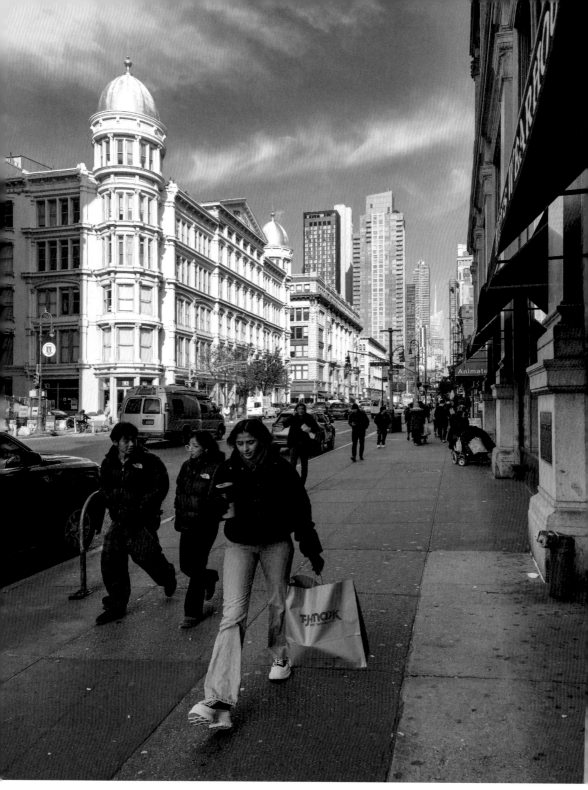

M13 从十九街看第六大道 | 6th Ave. at 19 St.

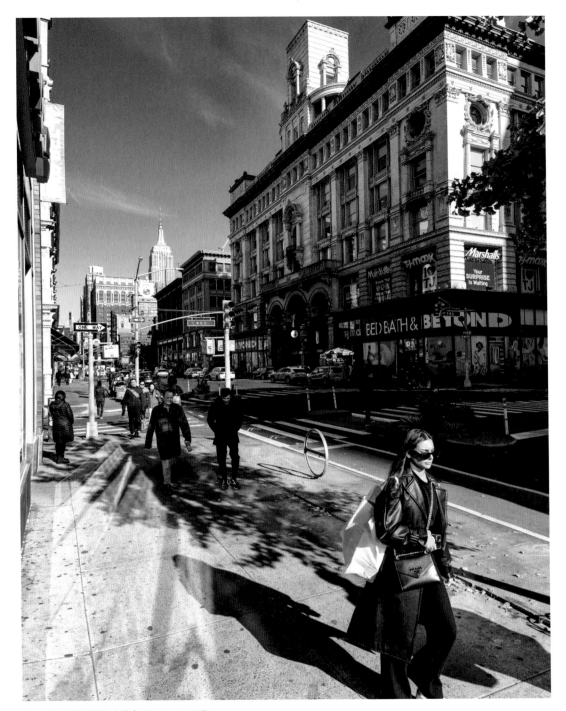

M14 从十八街看第六大道 | 6th Ave. at 18 St.

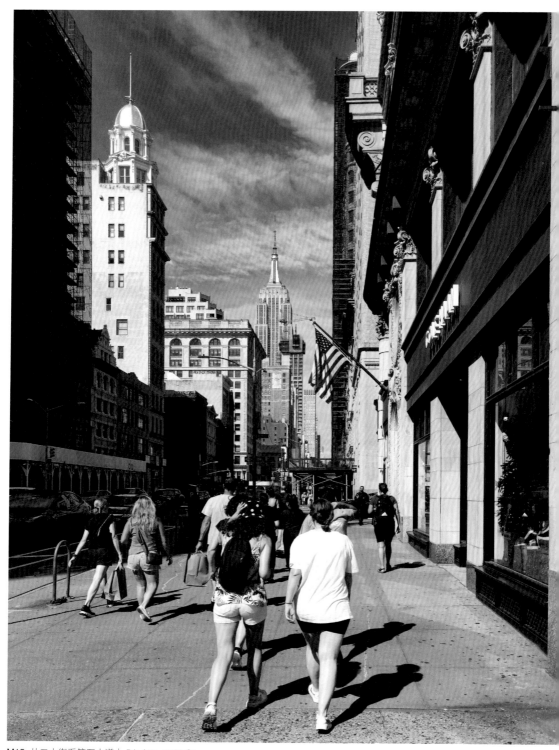

M15　从二十街看第五大道 ｜ 5th Ave. at 20 St.

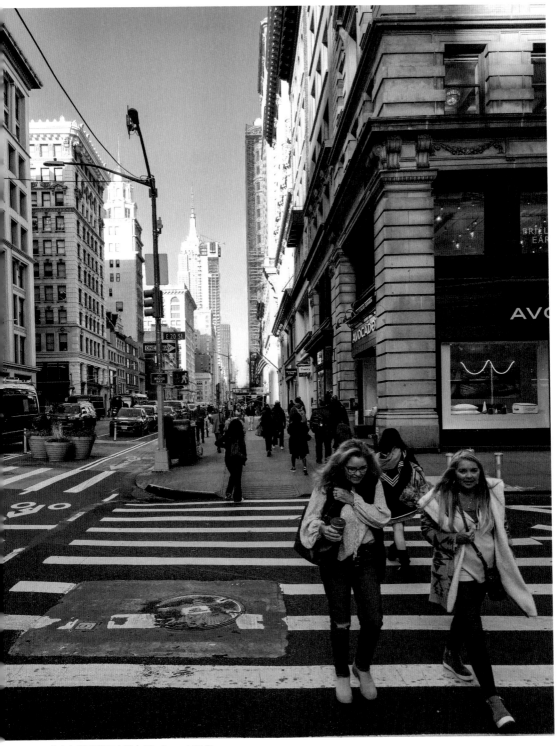

M16 从十九街看第五大道 | 5th Ave. at 19 St.

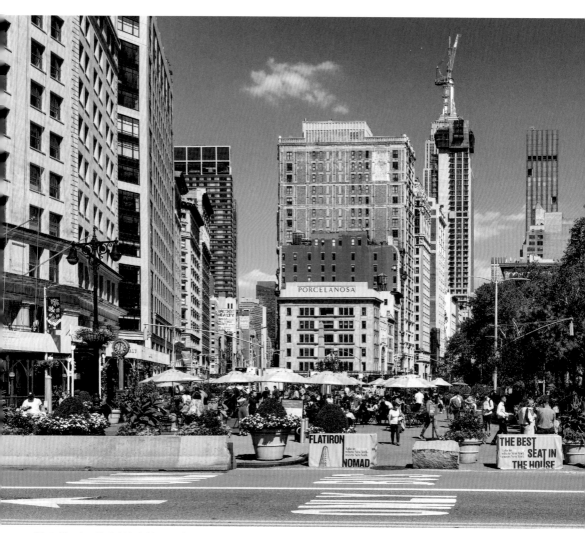

M17 从二十三街看麦迪逊广场公园 | Madison Square Park at 23 St.

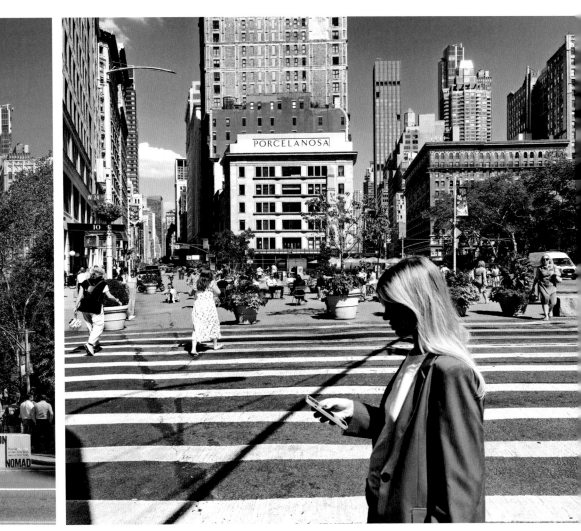

M18 从二十四街看沃斯广场 | Worth Square at 24 St.

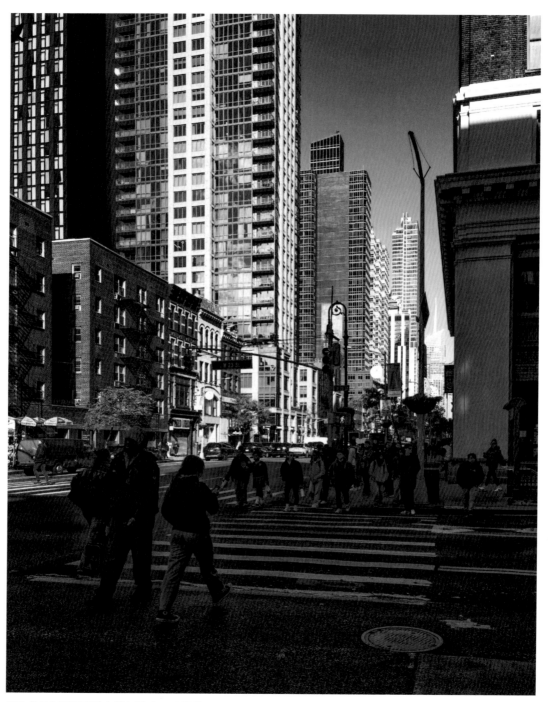

M19 从二十三街看第六大道 | 6th Ave. at 23 St.

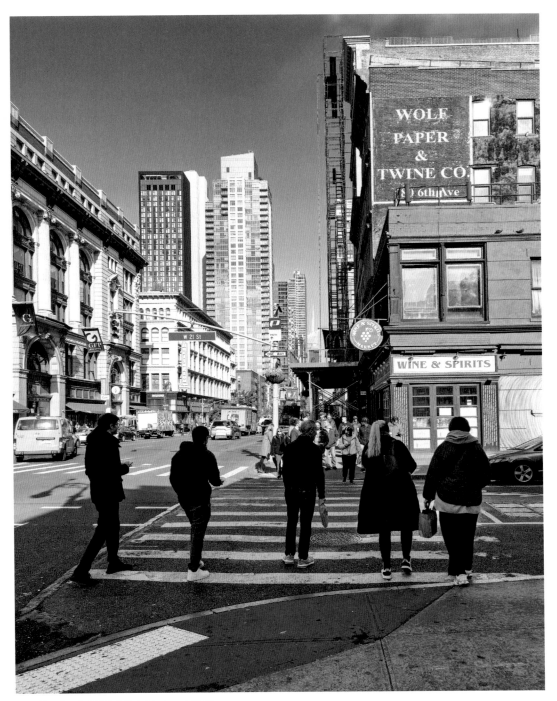

M20 从二十一街看第六大道 | 6th Ave. at 21 St.

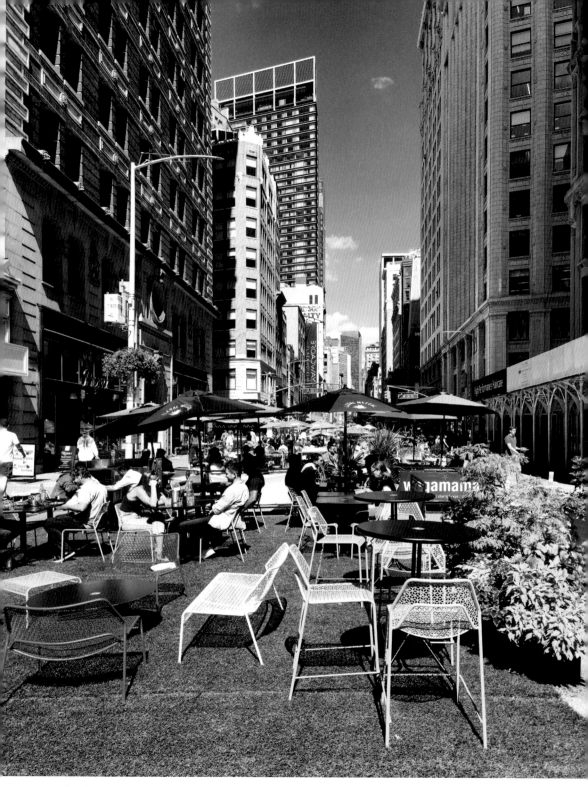

M21　从二十五街看百老汇 | Broadway at 25 St.

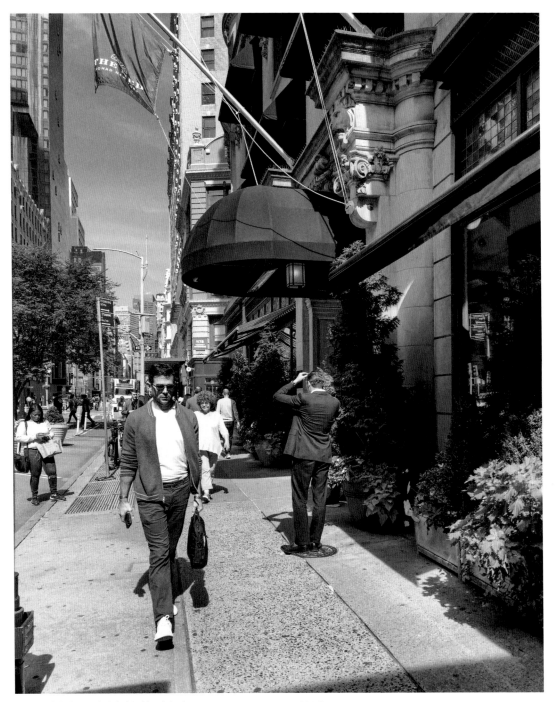

M22 二十七街至二十八街之间的百老汇 | Broadway between 27 and 28 St.

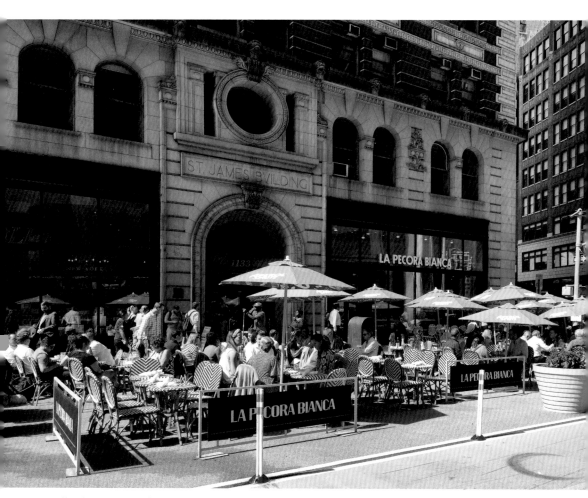

M23 从二十六街看百老汇 | Broadway at 26 St.

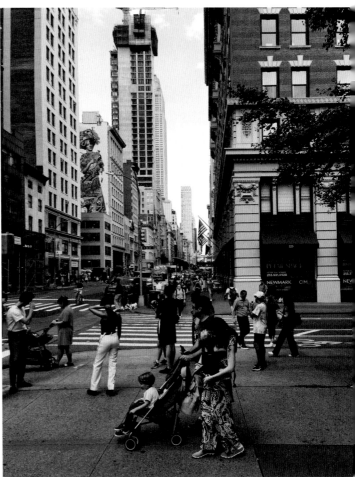

M24 从二十六街看第五大道 | 5th Ave. at 26 St.

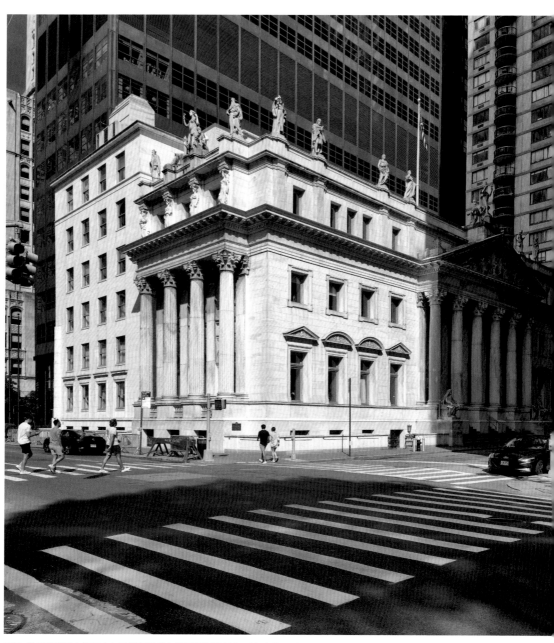

M25 位于麦迪逊大街二十七号的纽约州上诉最高法院 | New York State Appellate Division of the Supreme Court at 27 Madison Ave.

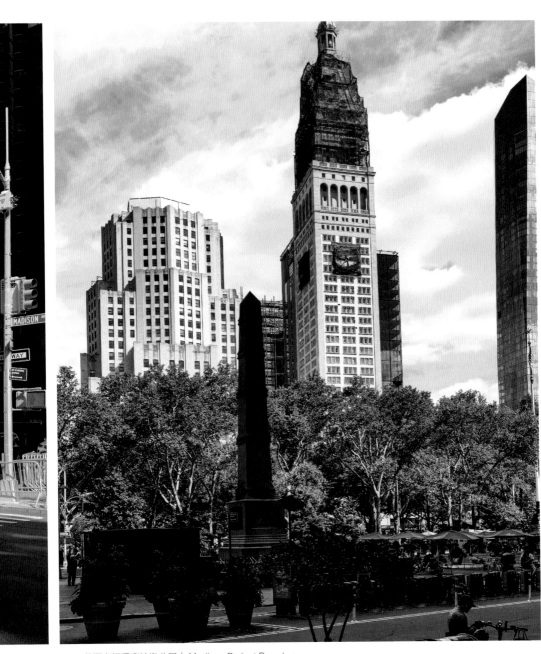

M26 从百老汇看麦迪逊公园 | Madison Park at Broadway

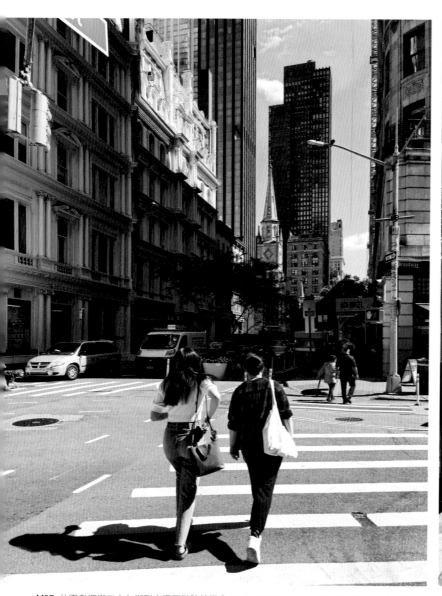

M27 从百老汇街二十九街到大理石学院教堂 | 29 St. at Broadway to Marble Collegiate Church

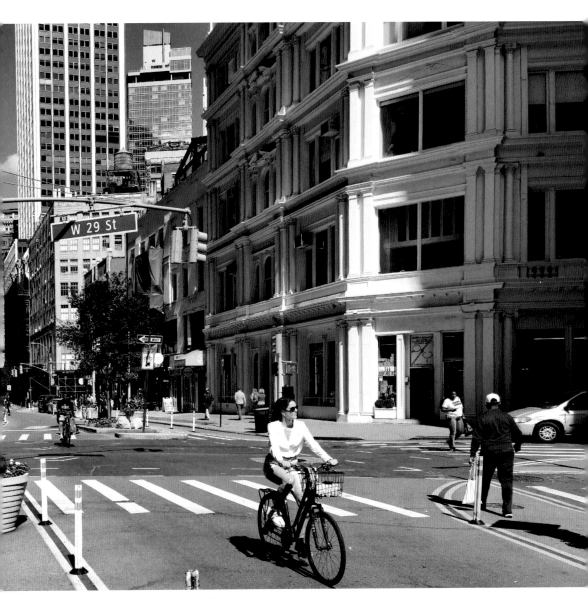

M28 从二十九街看百老汇 | Broadway at 29 St.

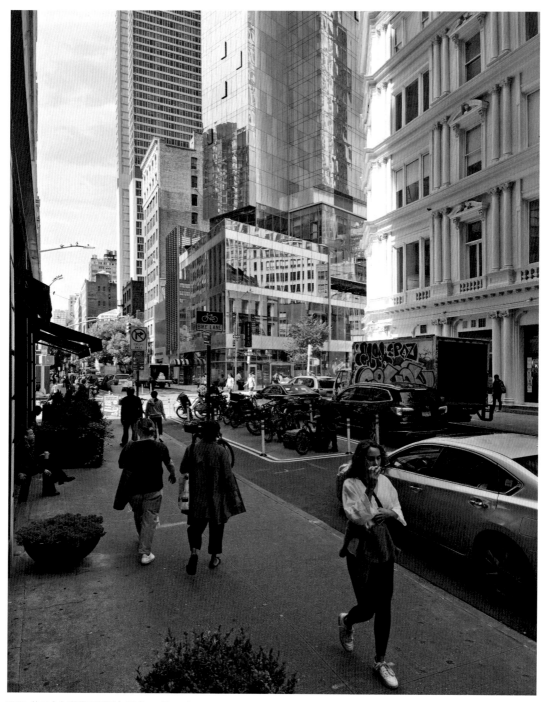

M29 从二十九街到百老汇 | 29 St. to Broadway

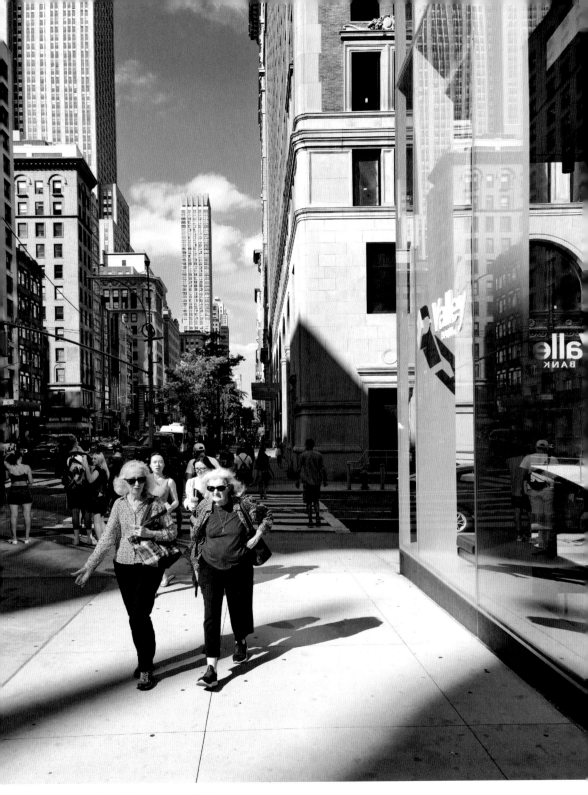

M30 从三十街看第五大道 | 5th Ave. at 30 St.

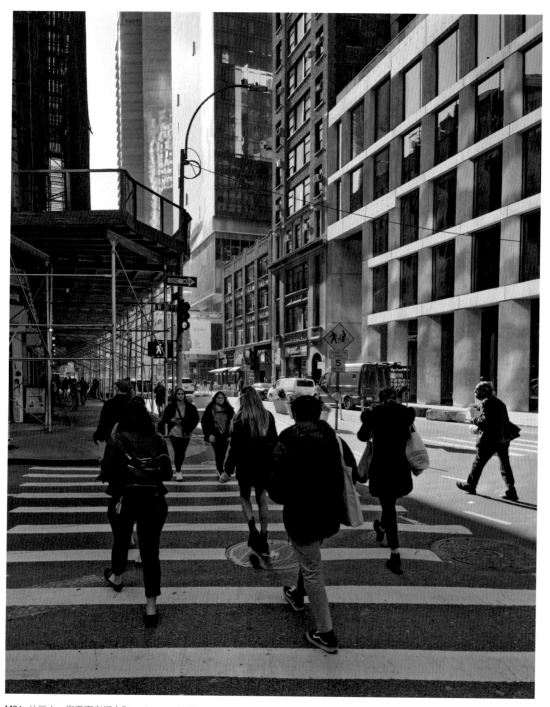

M31 从三十一街看百老汇 | Broadway at 31 St.

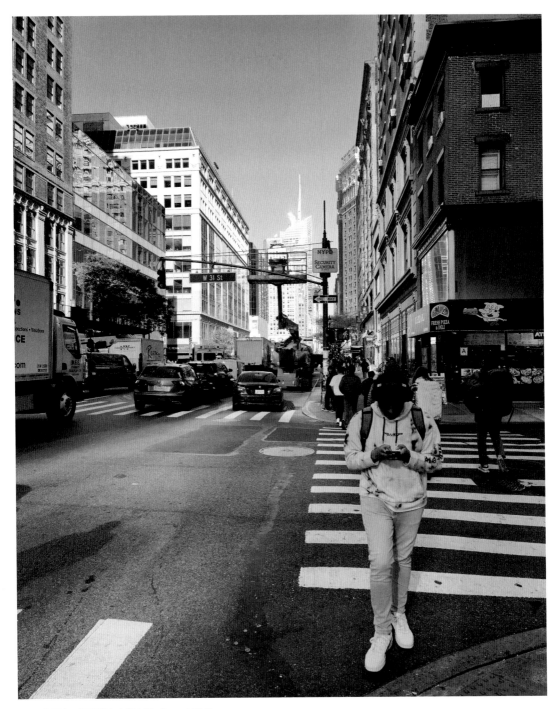

M32　从三十一街看第六大道 | 6th Ave. at 31 St.

M33 从三十三街看第八大道 | 8th Ave. at 33 St.

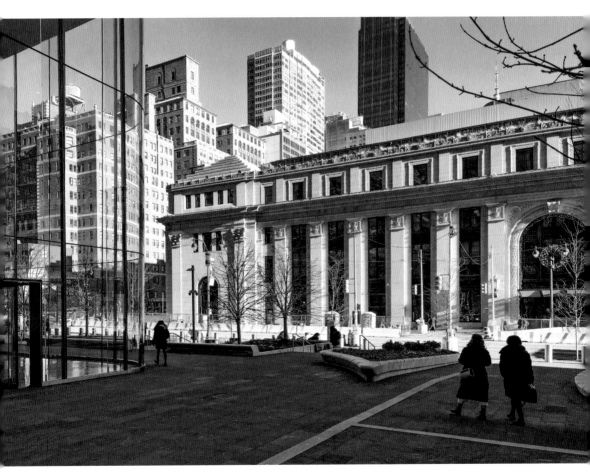

M34 宾州车站的莫伊尼汉火车大厅 | Moynihan Train Hall at Penn Station

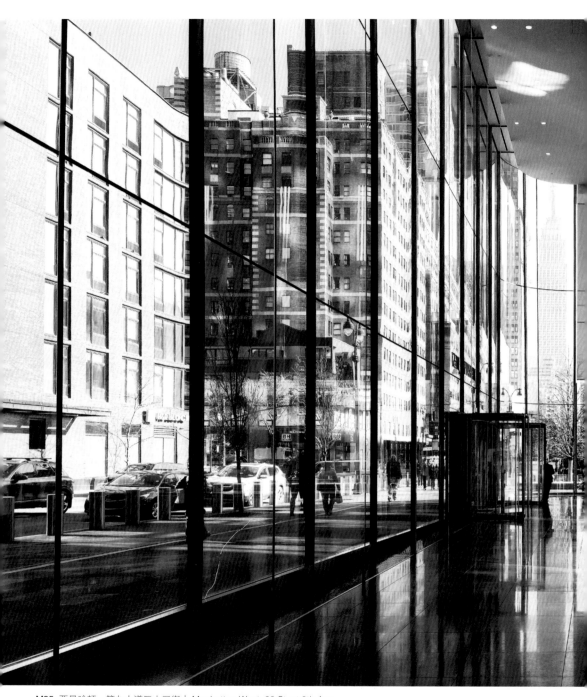

M35 西曼哈顿，第九大道三十三街 | Manhattan West, 33 St. at 9th Ave.

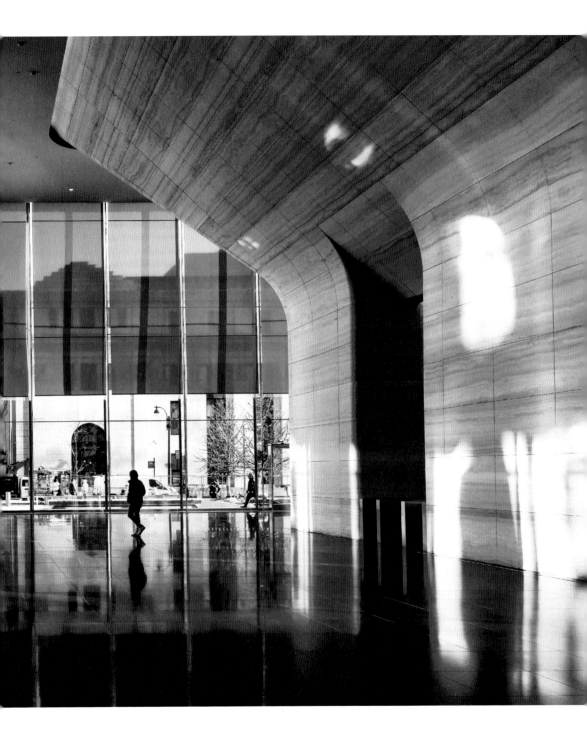

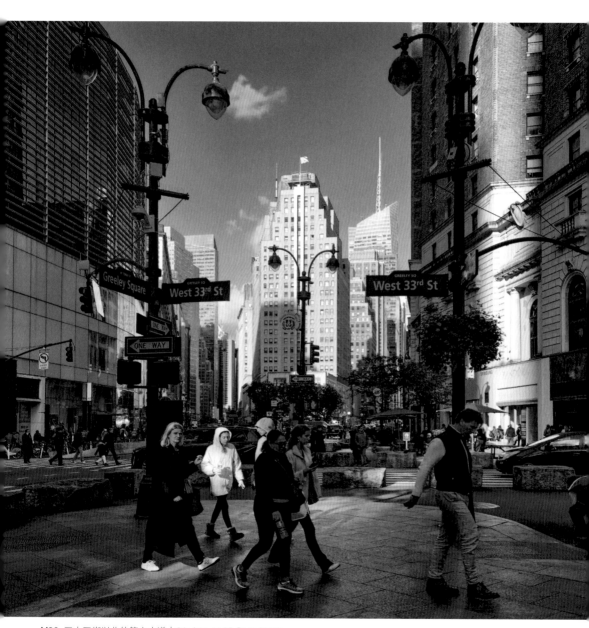

M36 三十三街以北的第六大道 | 6th Ave. at 33 St. to North

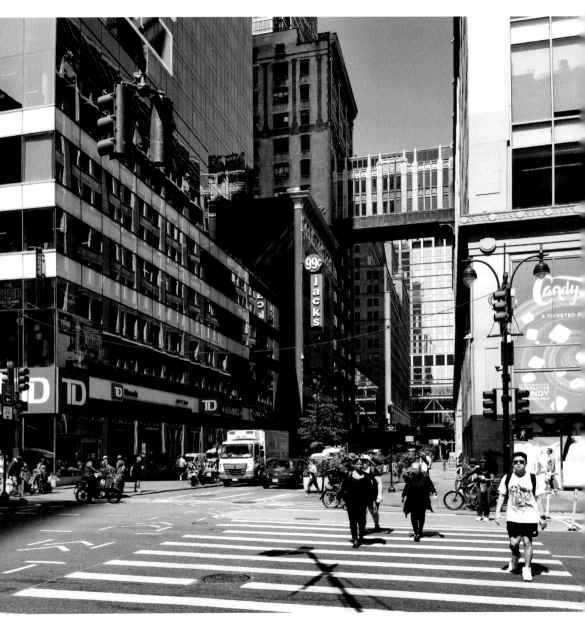

M37　第六大道至宾州火车站之间的三十二街 | 32 St. at 6th Ave. to Penn Station

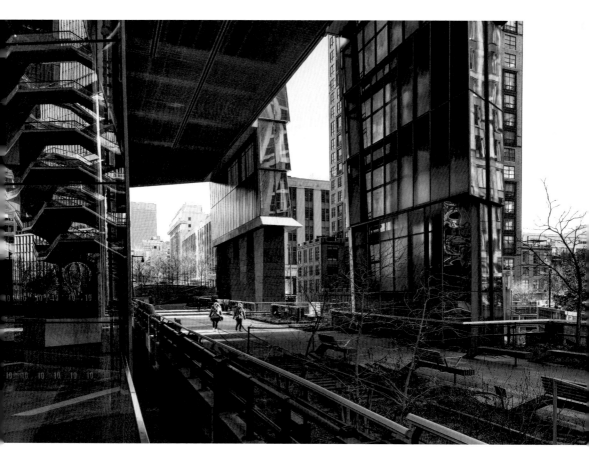

M38 哈德孙广场的高线公园 | The High Line at Hudson Yards

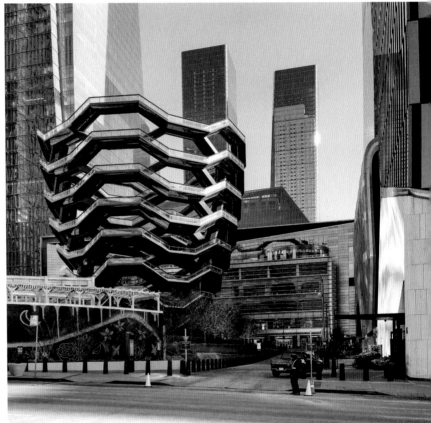

M39 哈德孙广场,第十一大道的三十三街 | Hudson Yards, 33 St. at 11 th Ave.

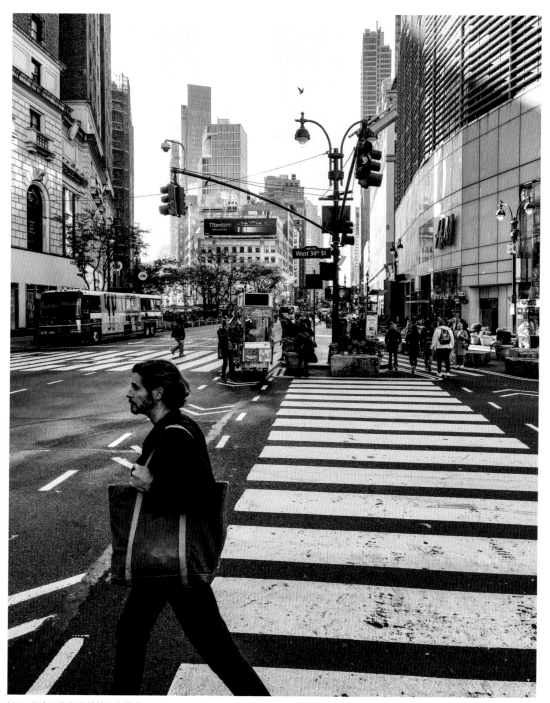

M40 三十四街以南的第六大道 | 6th Ave. at 34 St. to South

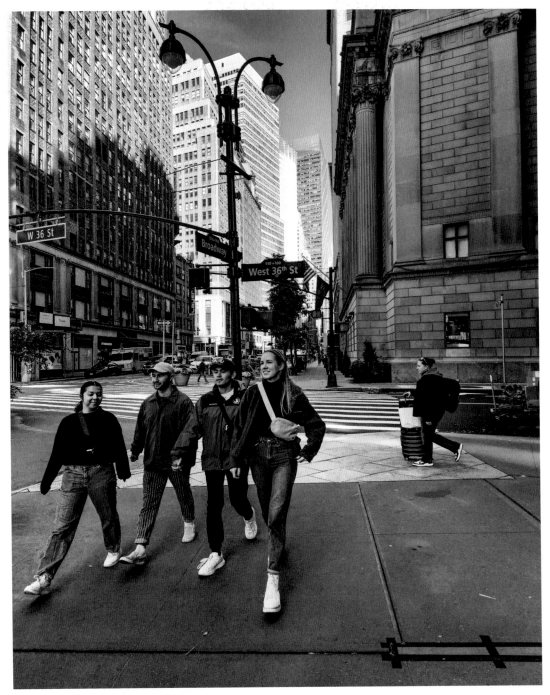

M41　从三十六街看百老汇 ｜ Broadway at 36 St.

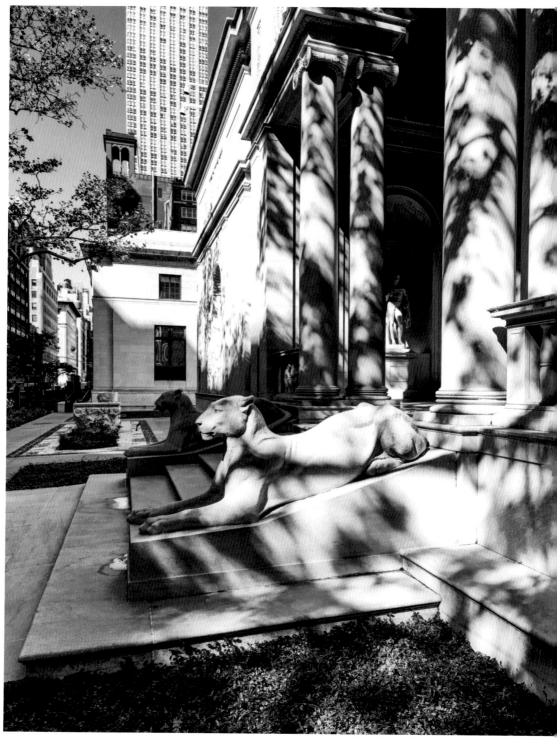

M42 从三十六街看摩根图书馆和博物馆 | The Morgan Library & Museum at 36 St.

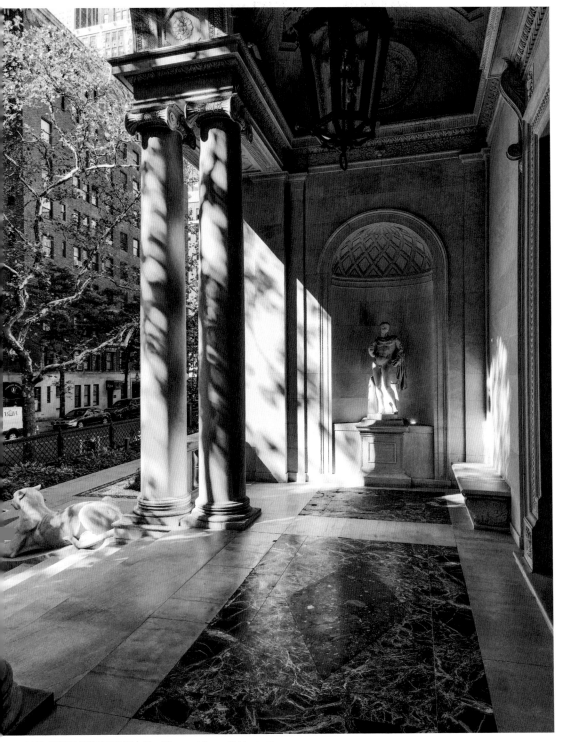

M43 摩根图书馆和博物馆 | The Morgan Library & Museum

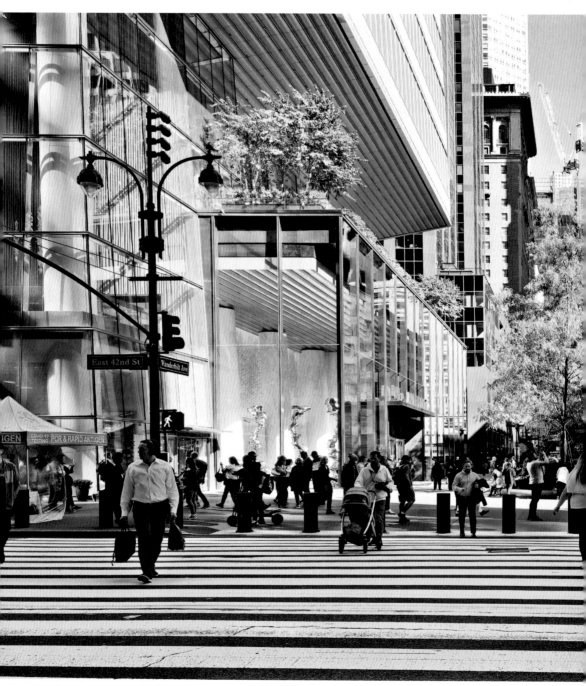

M44 从四十二街看范德比尔特大街 | Vanderbilt Ave. at 42 St.

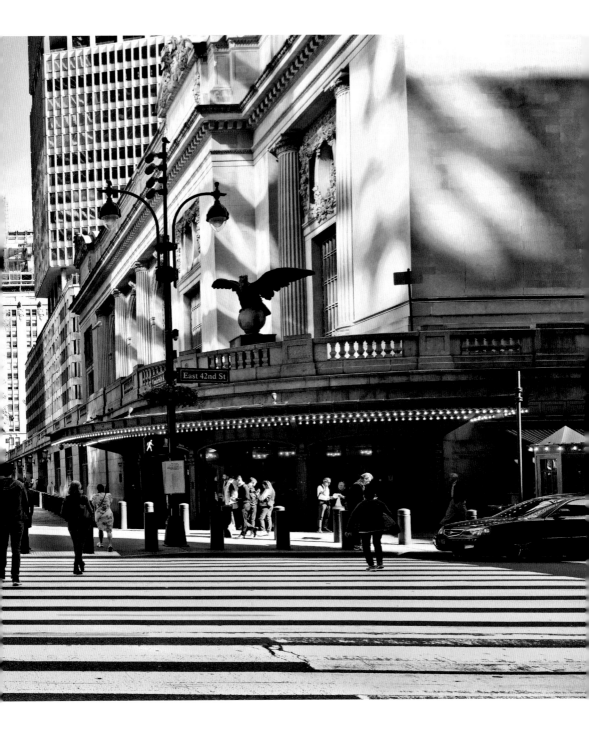

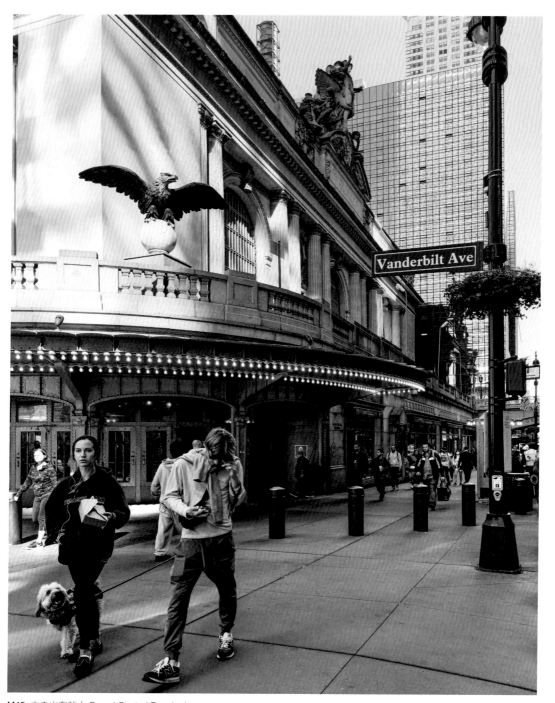

M45 中央火车站 | Grand Central Terminal

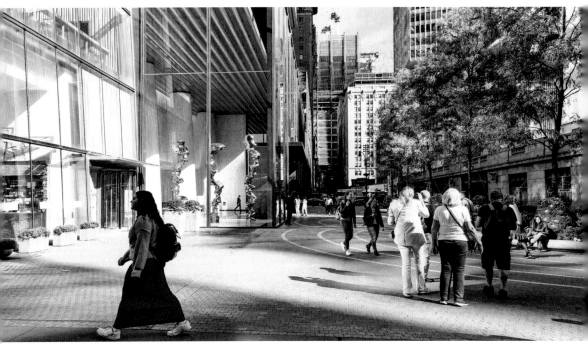

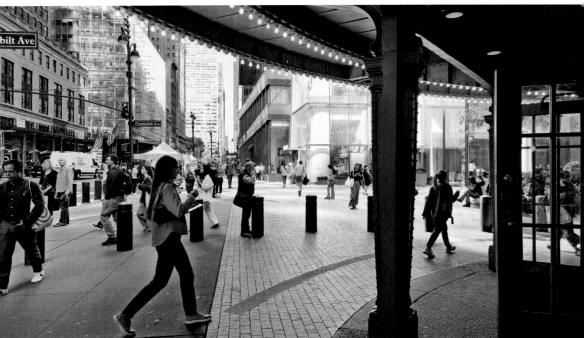

M46 范德比尔特一号 | One Vanderbilt / M47 中央火车站入口 | Entrance of Grand Central Terminal

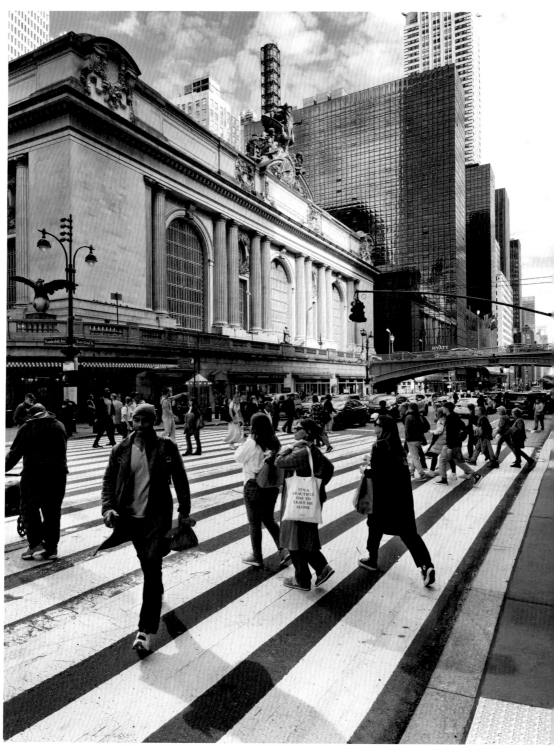

M48 从四十二街看中央火车站 | Grand Central Terminal at 42 St.

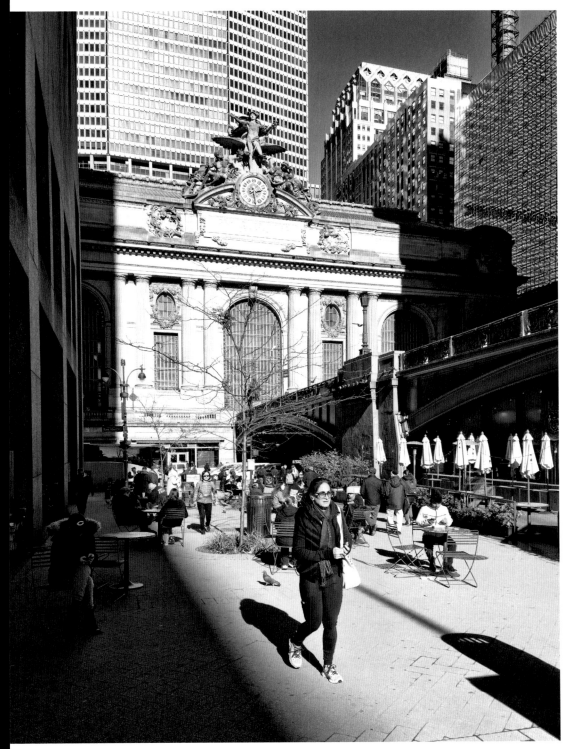

M49 从公园大道看中央火车站 | Grand Central terminal at Park Ave.

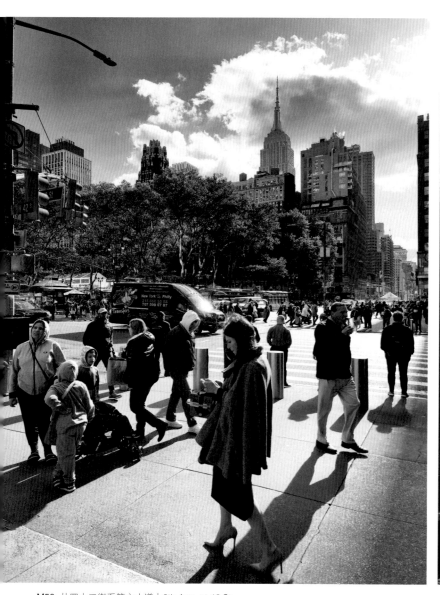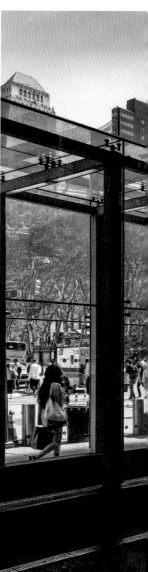

M50 从四十二街看第六大道 | 6th Ave. at 42 St.

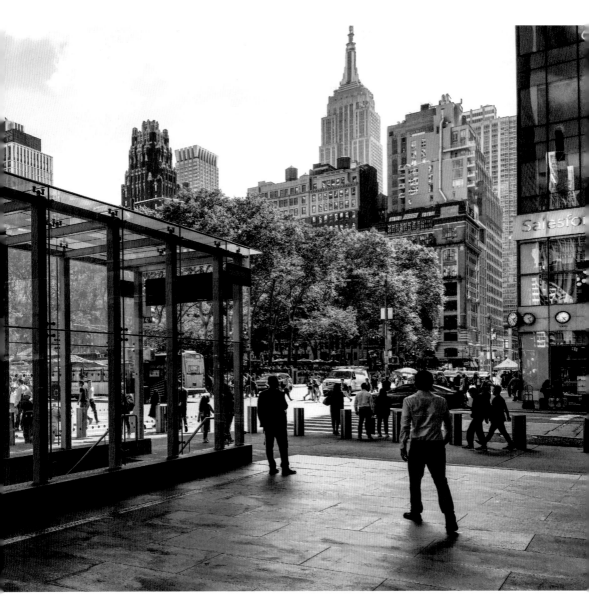

M51 布莱恩特公园地铁 | Subway of Bryant Park

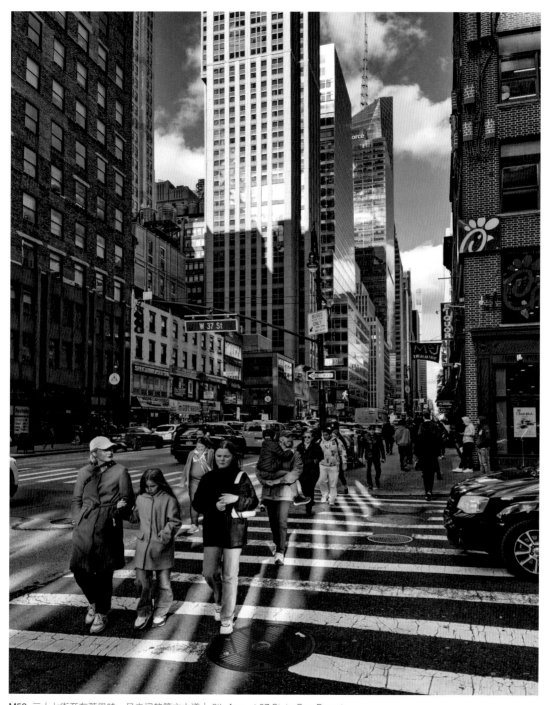

M52 三十七街至布莱恩特一号之间的第六大道 | 6th Ave. at 37 St. to One Bryant

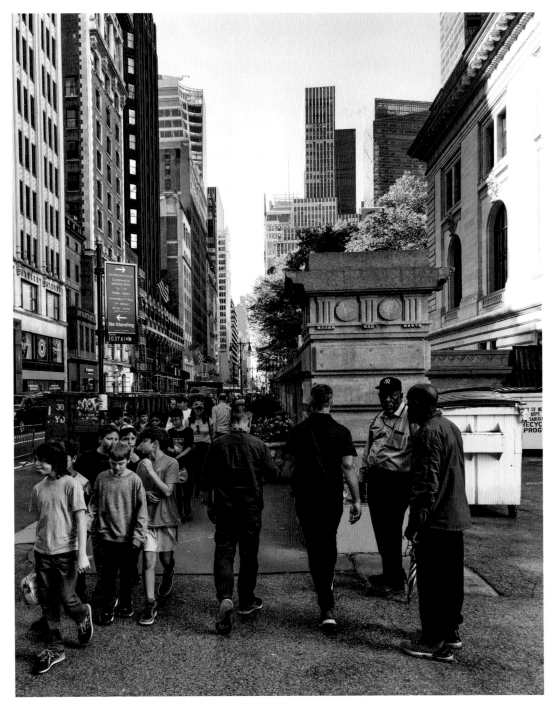

M53 纽约公共图书馆旁边的四十街 | 40 St. by New York Public Library

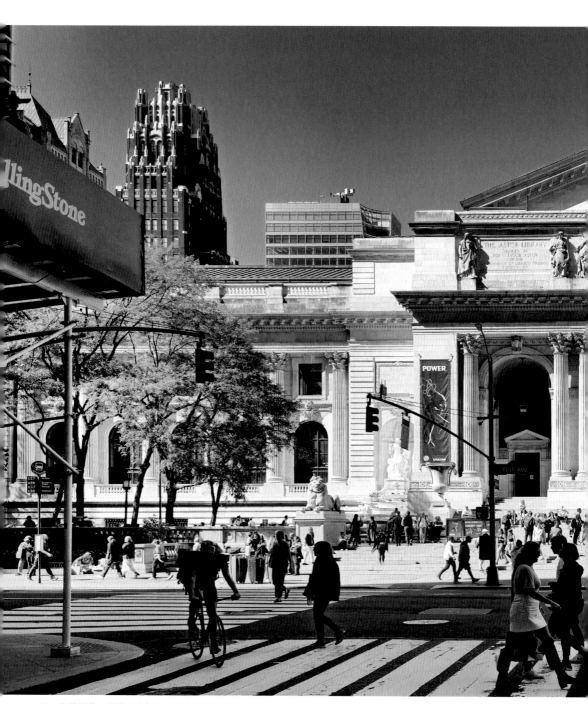

M54 纽约公共图书馆（1） | New York Public Library (1)

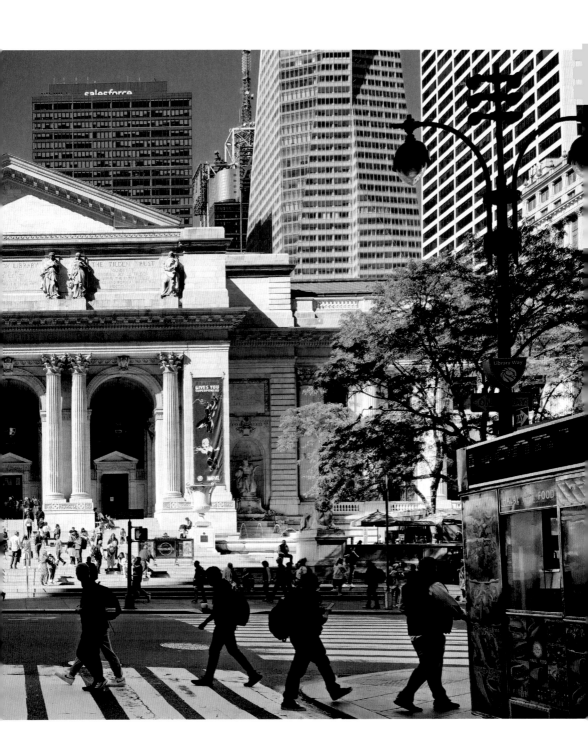

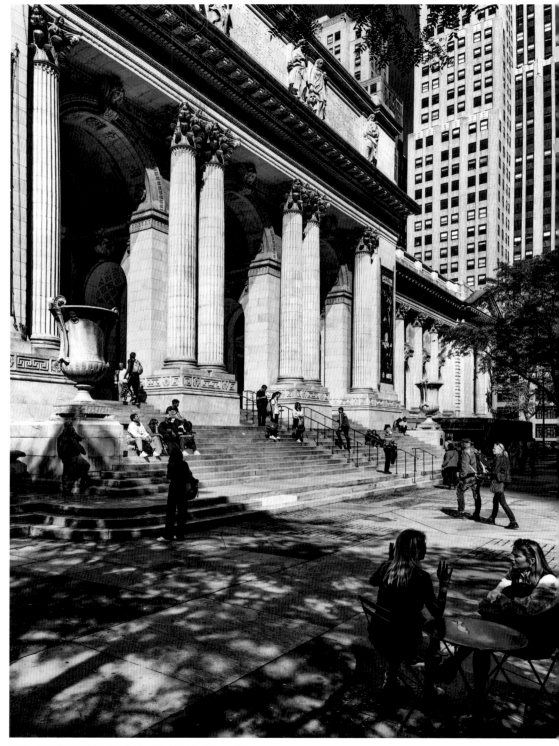

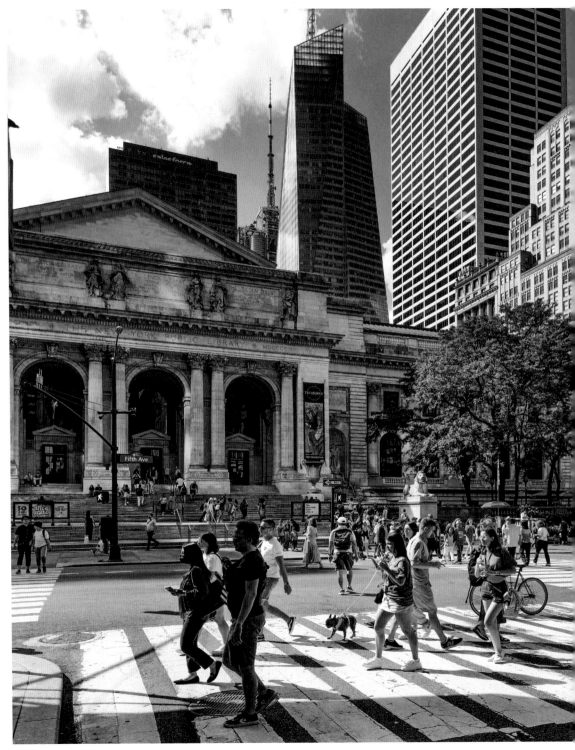

M56 纽约公共图书馆（3）| New York Public Library (3)

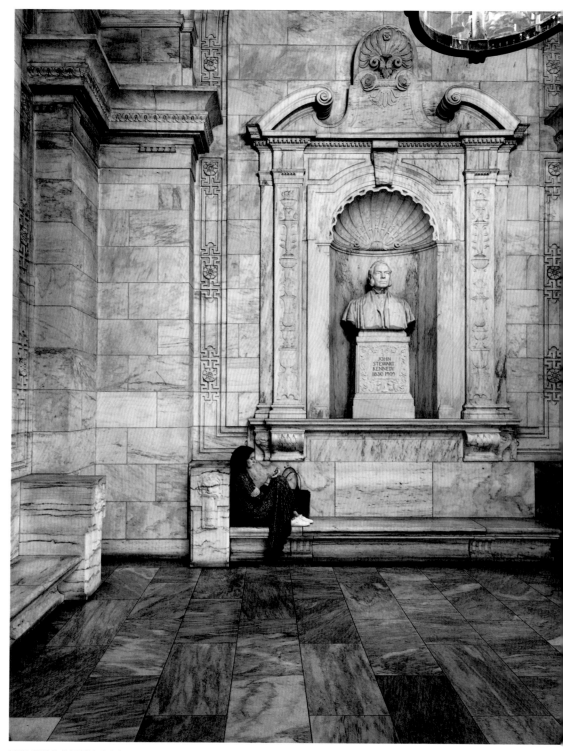

M57 纽约公共图书馆（4）| New York Public Library (4)

M58 纽约公共图书馆 (5) | New York Public Library (5)

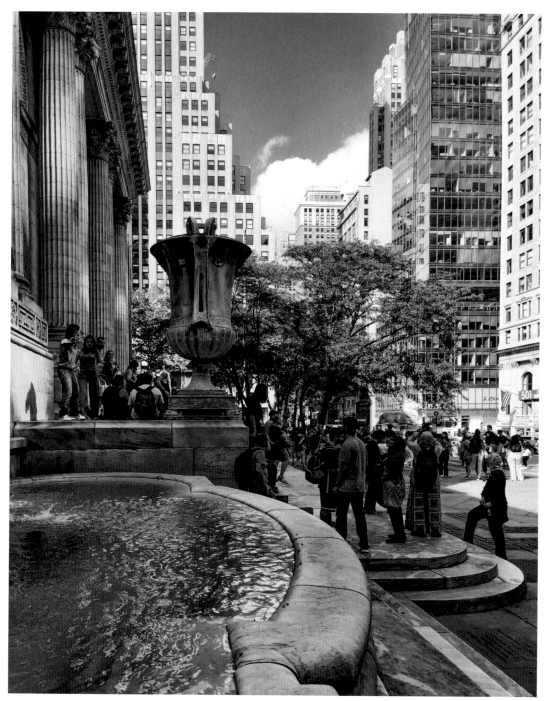

M59 从第五大道看纽约公共图书馆 | New York Public Library at 5th Ave.

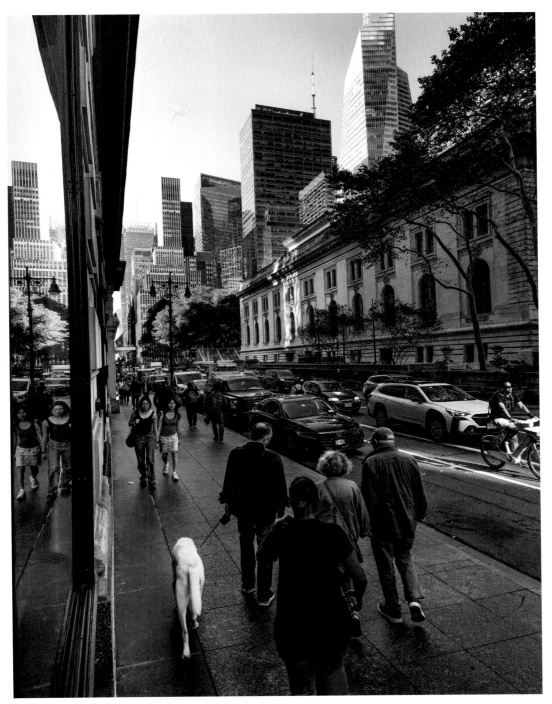

M60 纽约公共图书馆旁的四十街 | 40 St. by New York Public Library

中城 | MIDTOWN

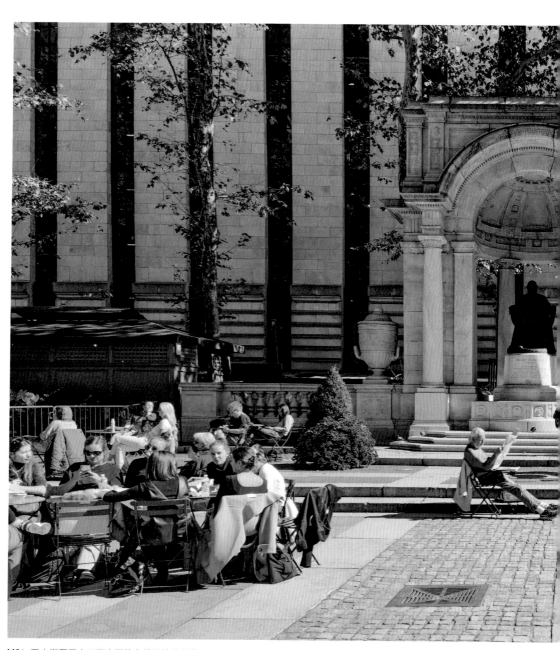

M61　四十街至四十二街之间的布莱恩特公园 ｜ Bryant Park between 40 & 42 St.

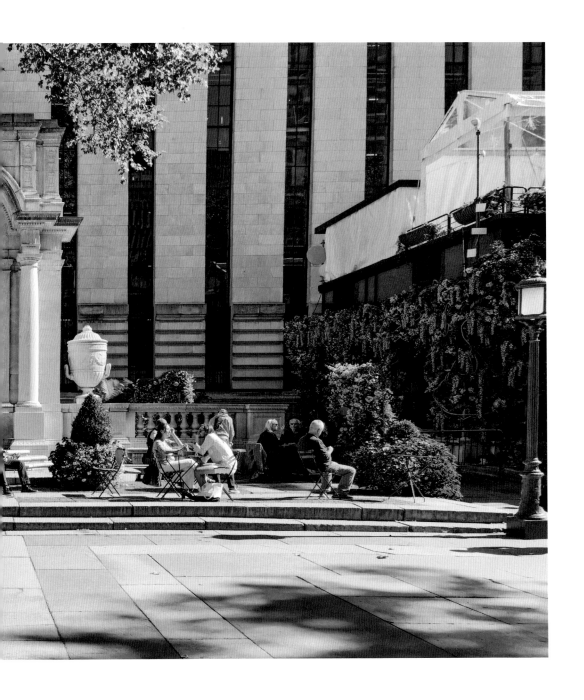

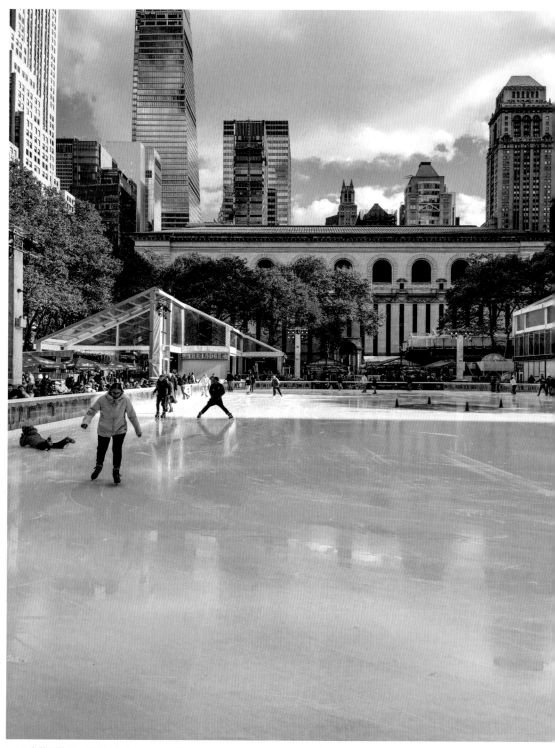

M62 布莱恩特公园滑冰场 | Bryant Park Skating

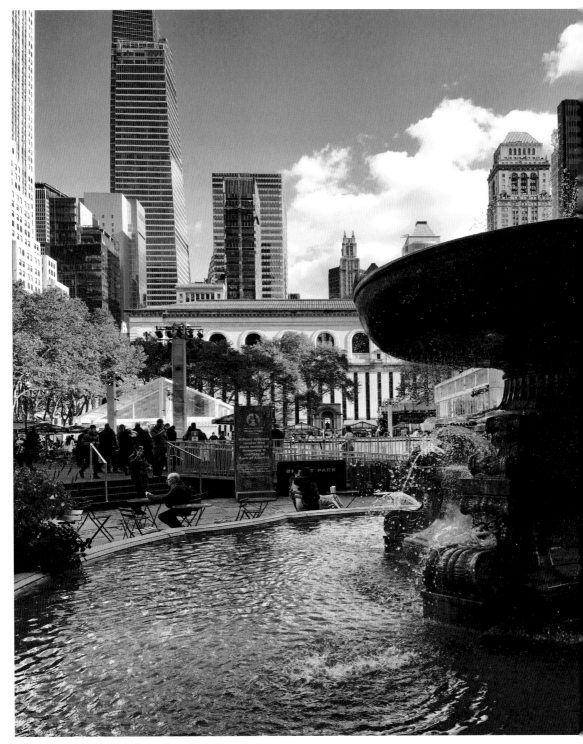

M63 布莱恩特公园喷水池 | Bryant Park Fountain

M64　从第六大道看四十二街 | 42 St. at 6th Ave.

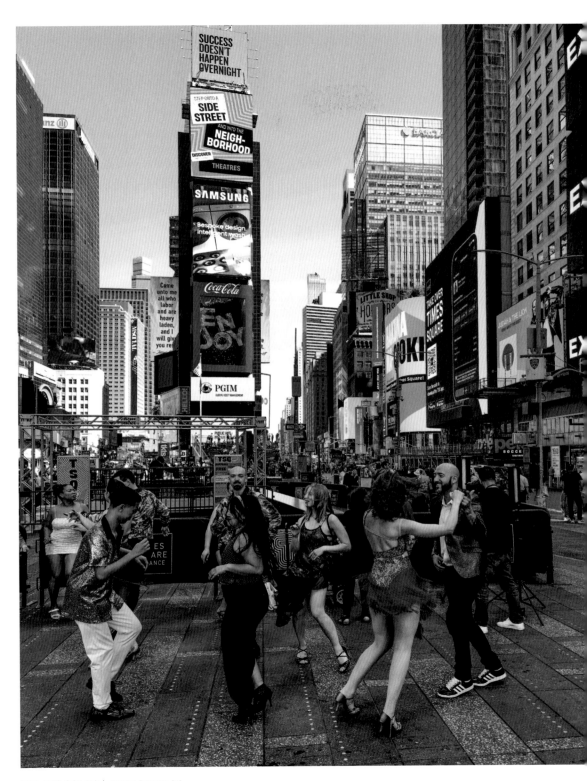

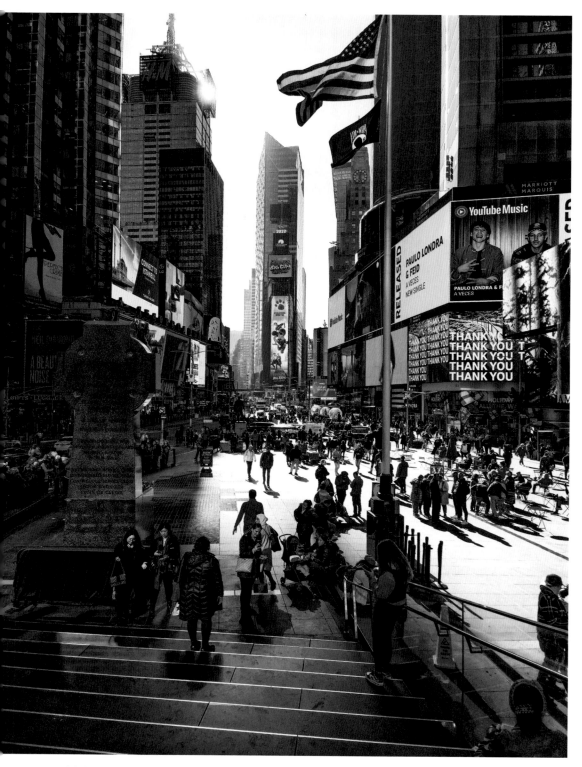

M68 从第七大道看四十二街 | 42 St. at 7th Ave.

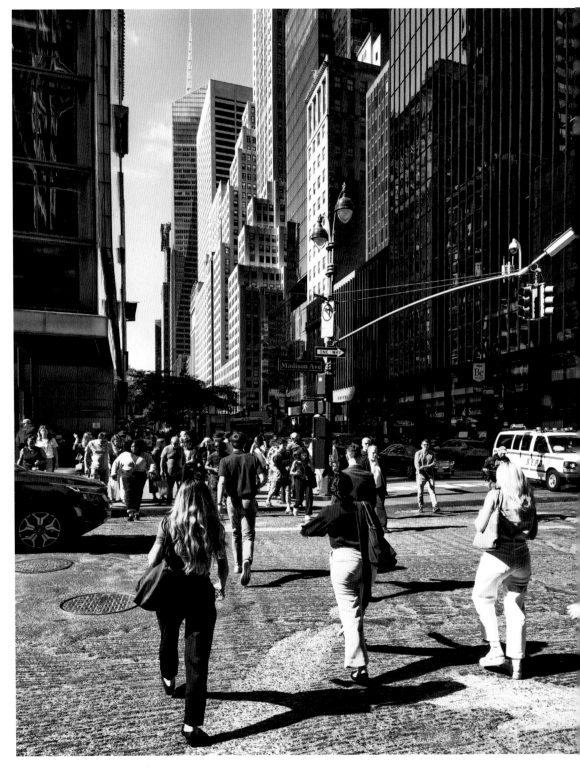

M69 从麦迪逊大道看四十二街 | 42 St. at Madison Ave.

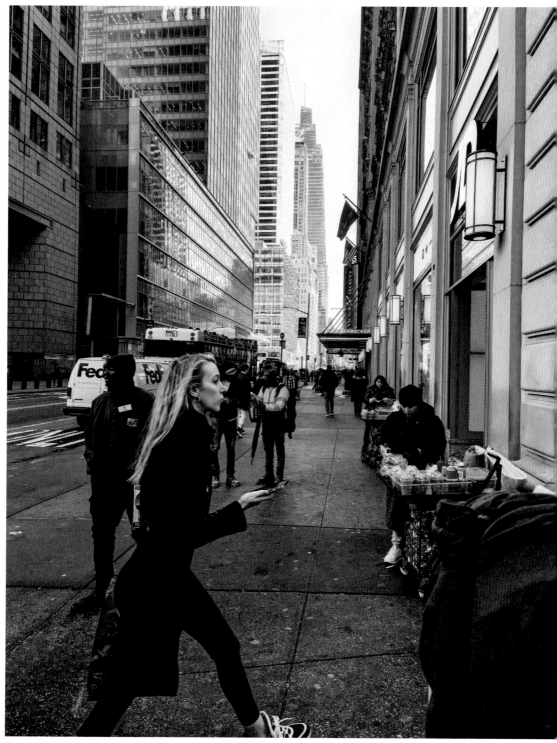

M70　从四十二街到范德比尔特一号 ｜ 42 St. to One Vanderbilt

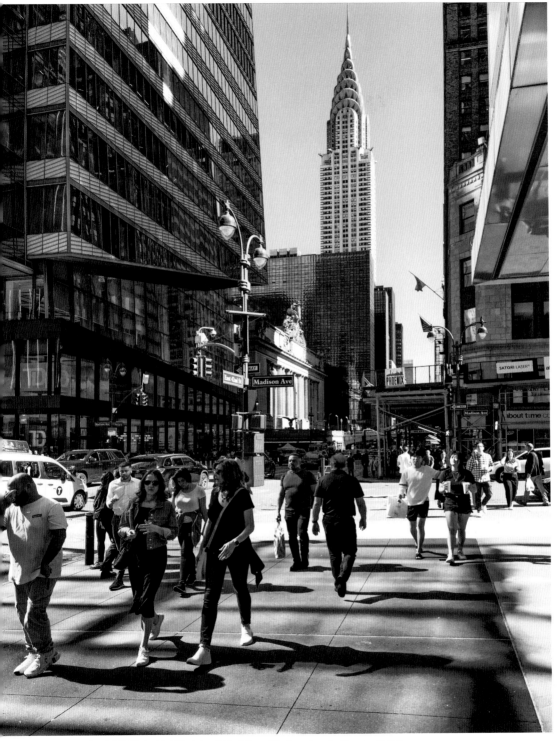

M71 麦迪逊大道至克莱斯勒大厦之间的四十二街 | 42 St. at Madison Ave. to Chrysler Building

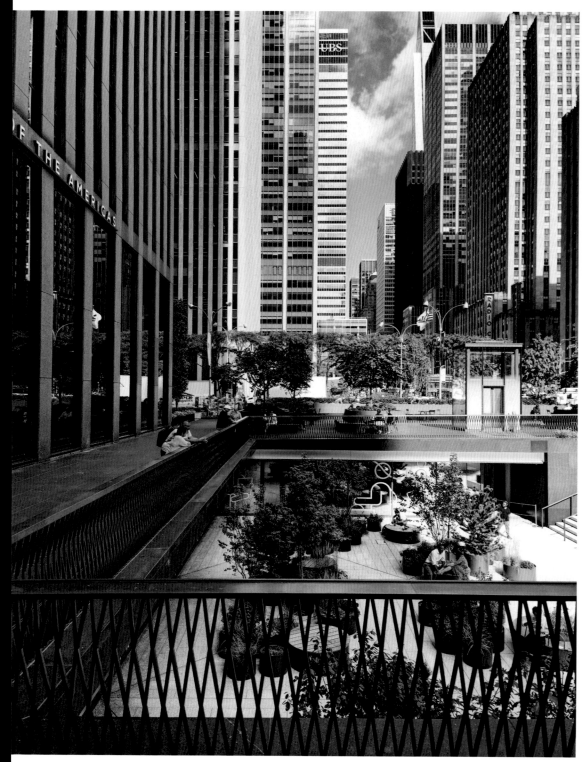

M72 从四十八街看第六大道 | 6th Ave. at 48 St.

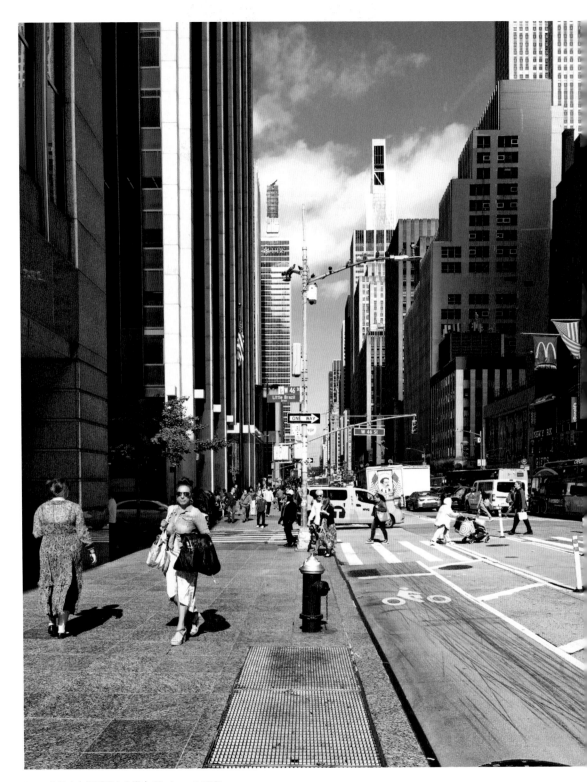

M73 从四十六街看第六大道 | 6th Ave. at 46 St.

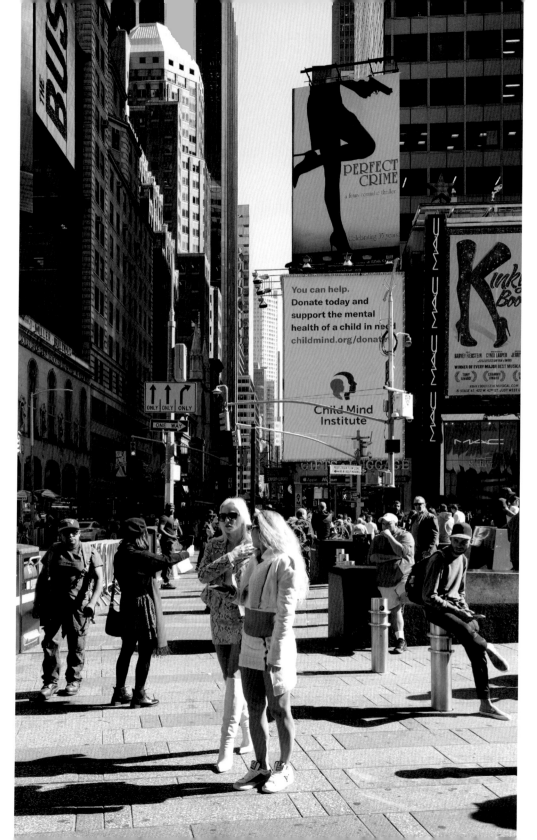

M74 从百老汇看四十六街 | 46 St. at Broadway

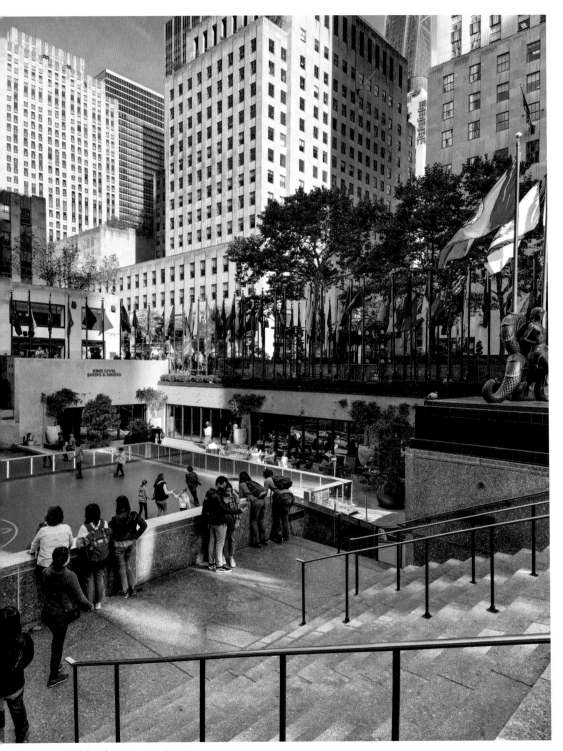

M75 洛克菲勒中心 | Rockefeller Center

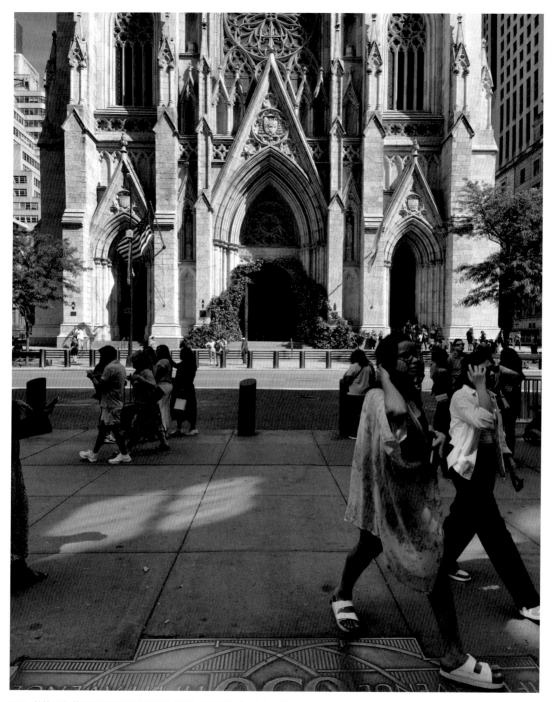

M76 从第五大道看圣帕特里克大教堂 | St. Patrick's Cathedral at 5th Ave.

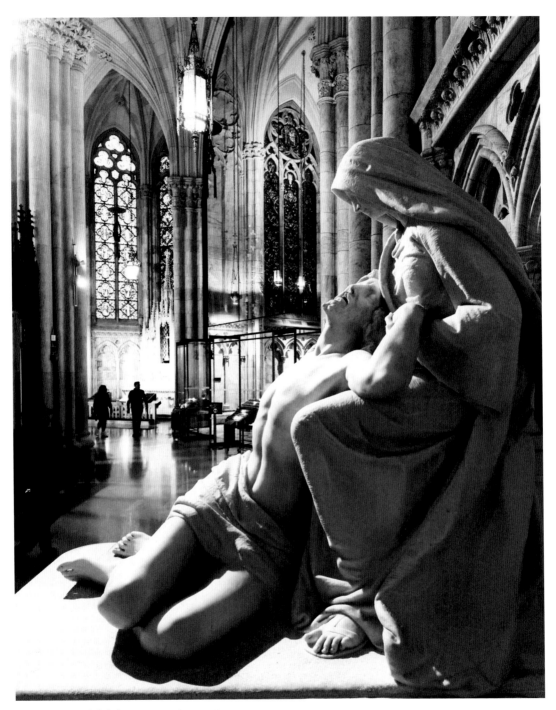

M77 圣帕特里克大教堂 | St. Patrick's Cathedral

M78 从四十九街看第五大道 | 5th Ave. at 49 St.

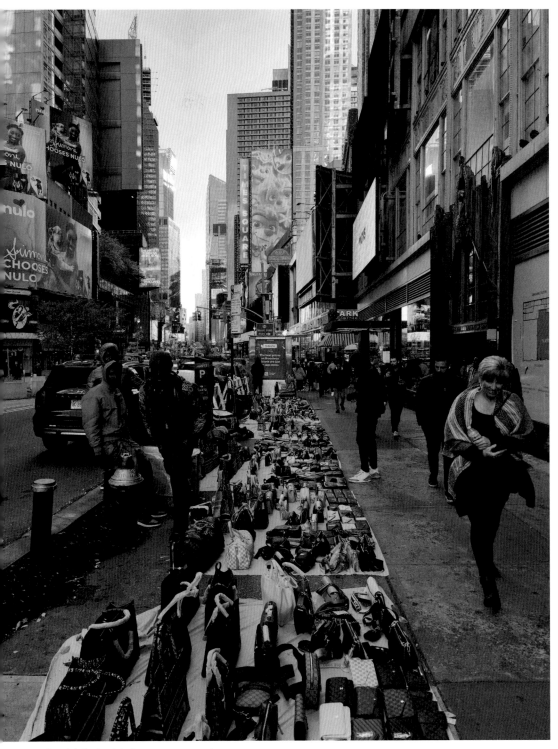

M79 从四十九街看百老汇 | Broadway at 49 St.

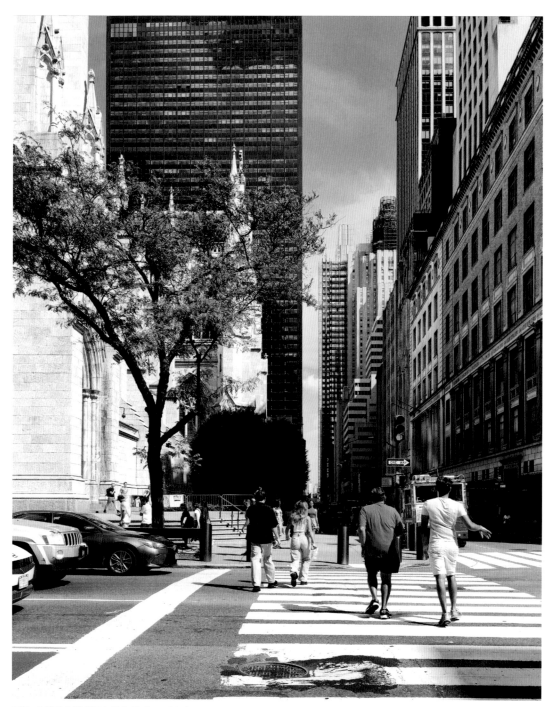

M80 从第五大道看五十街 ｜ 50 St. at 5th Ave.

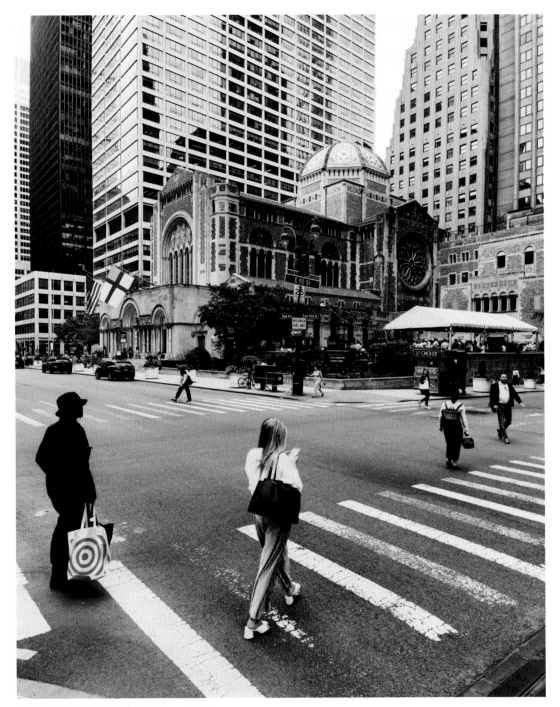

M81 从五十街看公园大道 | Park Ave. at 50 St.

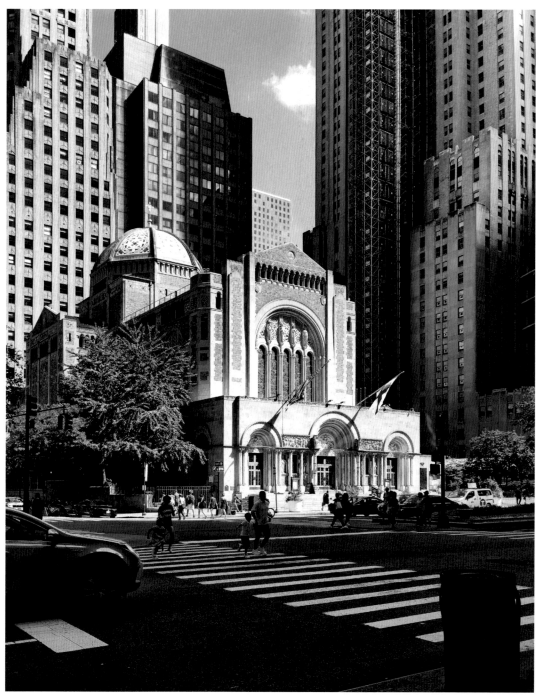

M82 从五十一街公园大道看圣巴特洛圣公会教堂 | St. Bartholomew's Episcopal Church at 51 St. Park Ave.

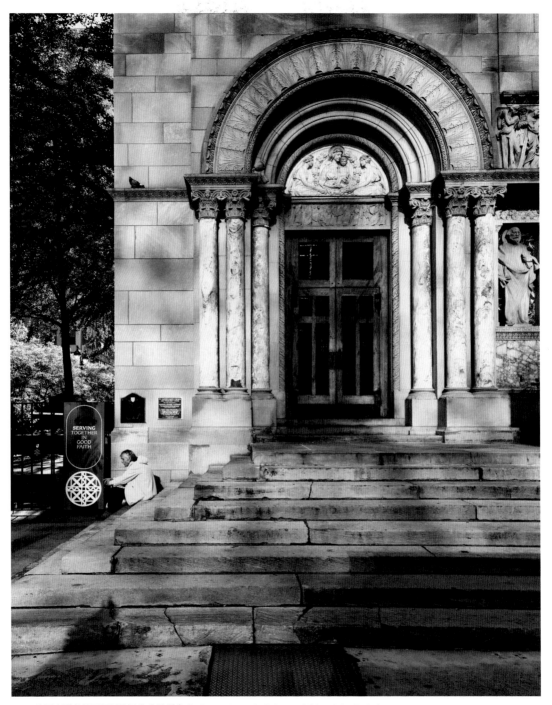

M83 公园大道旁的圣巴特洛圣公会教堂 | St. Bartholomew's Episcopal Church by Park Ave.

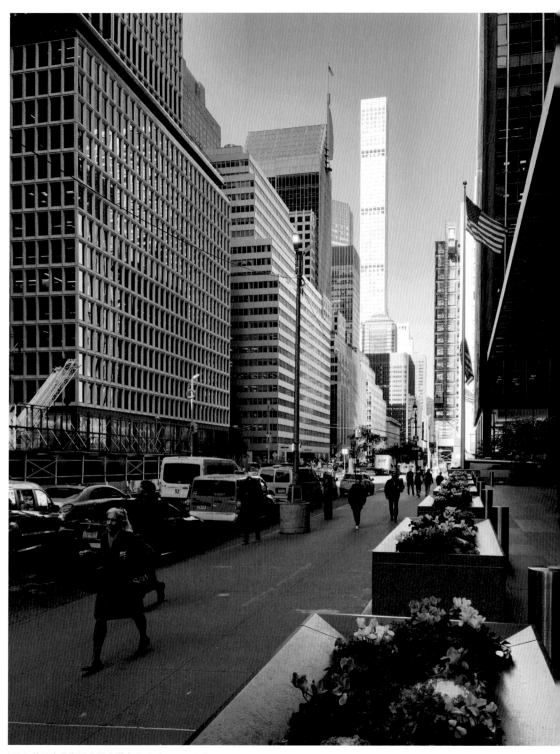

M84 从四十八街看公园大道 | Park Ave. at 48 St.

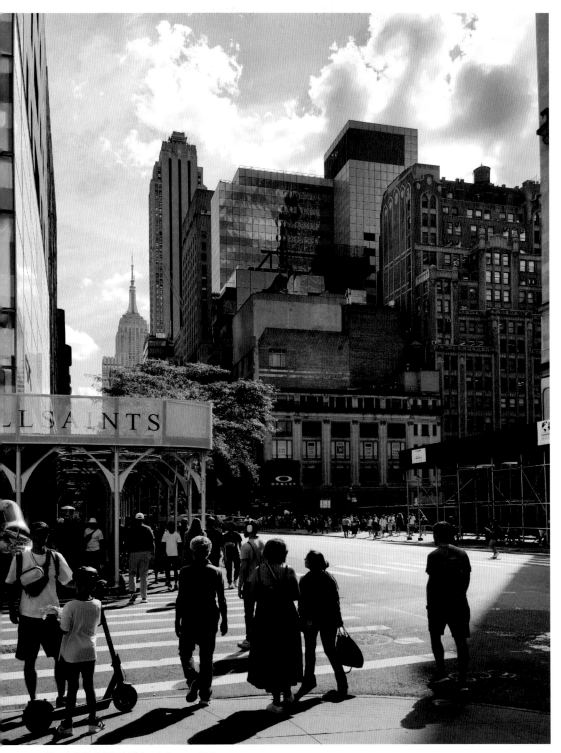

M85　从四十七街看第五大道 | 5th Ave. at 47 St.

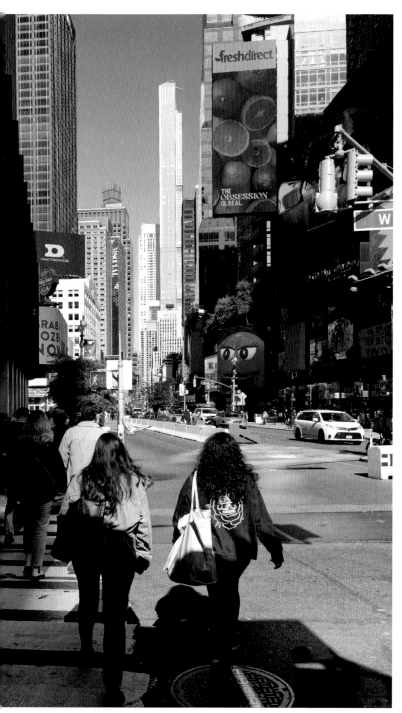

M86 从四十七街至中央公园塔（住宅）的百老汇
Broadway at 47 St. to Central Park Tower (residential)

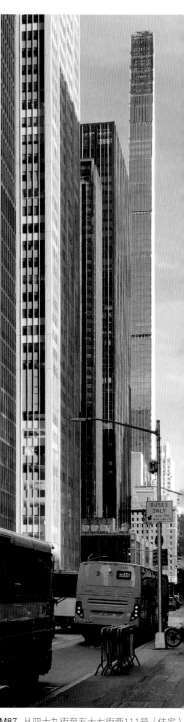

M87 从四十九街至五十七街西111号（住宅）的第六大道
6th Ave. at 49 St. to 111 W. 57 St. (residential

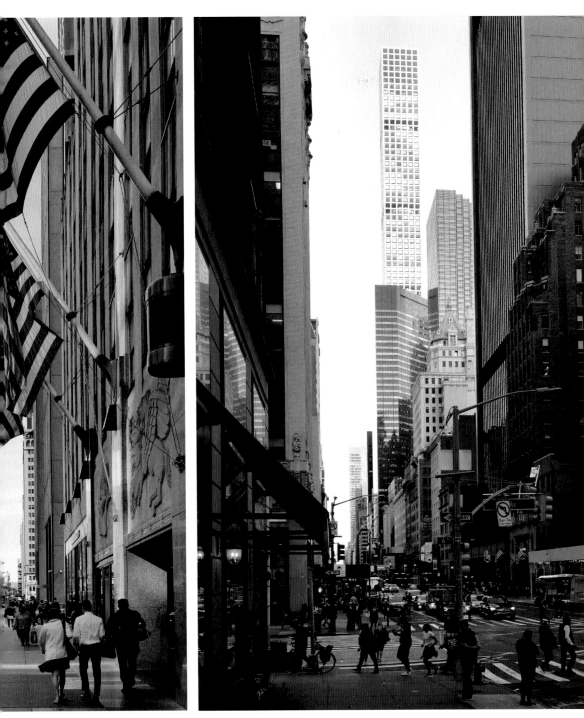

M88 从第六大道至公园大道432号（住宅）之间的五十七街
57 St. at 6th Ave. to 432 Park Ave. (residential)

M89 从四十九街看第十一大道 | 11th Ave. at 49 St.

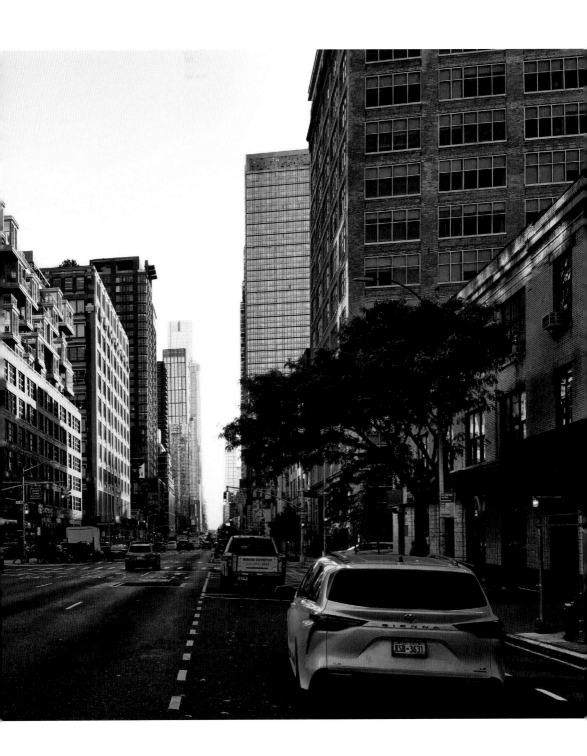

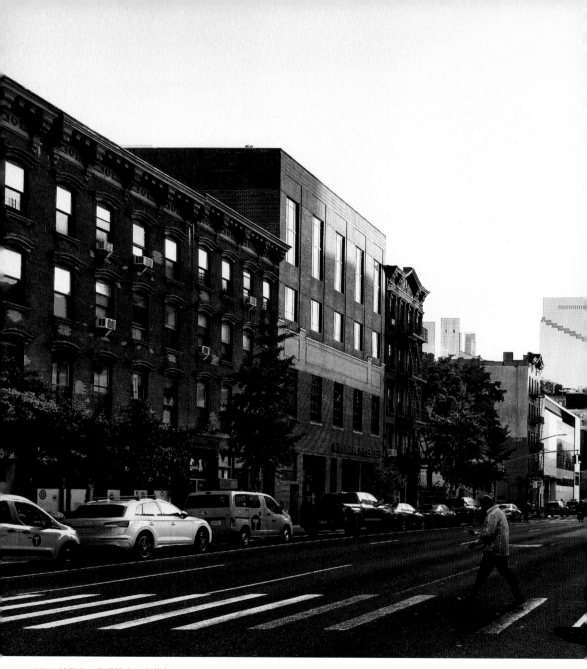

M90　从五十二街看第十一大道 | 11th Ave. at 52 St.

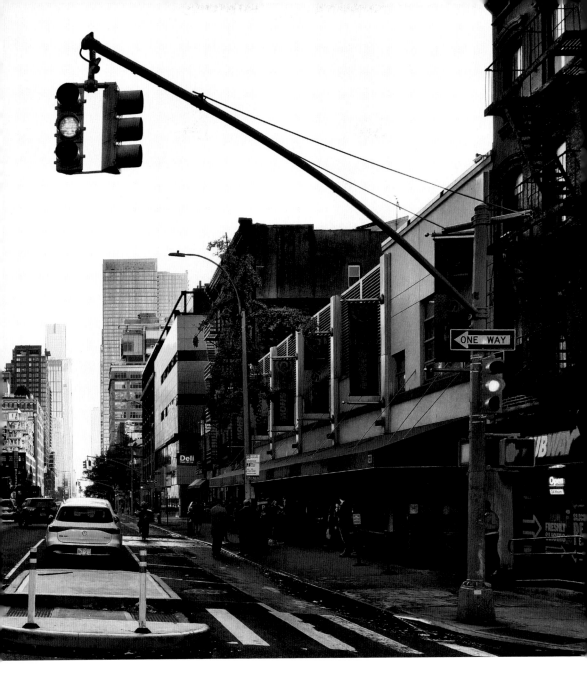

中城 | MIDTOWN

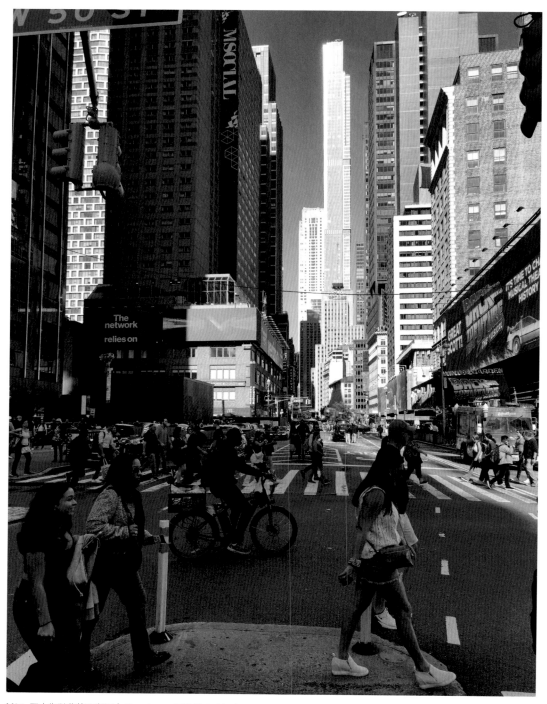

M91 五十街以北的百老汇 | Broadway at 50 St. to North

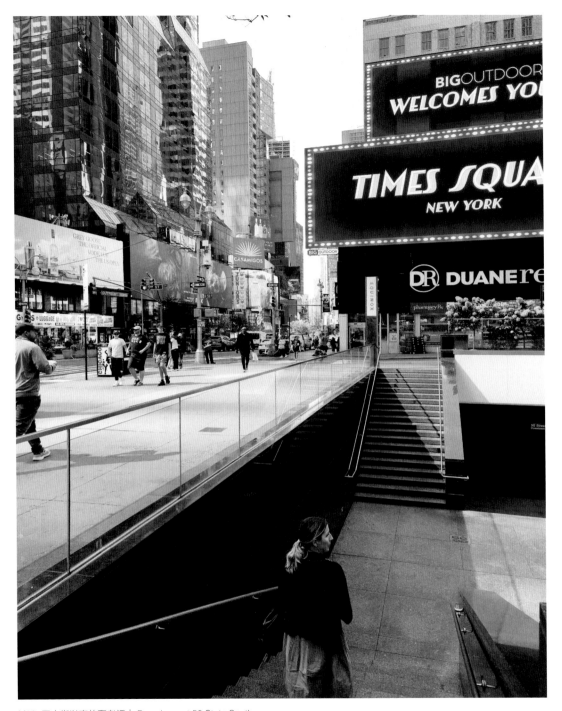

M92 五十街以南的百老汇 | Broadway at 50 St. to South

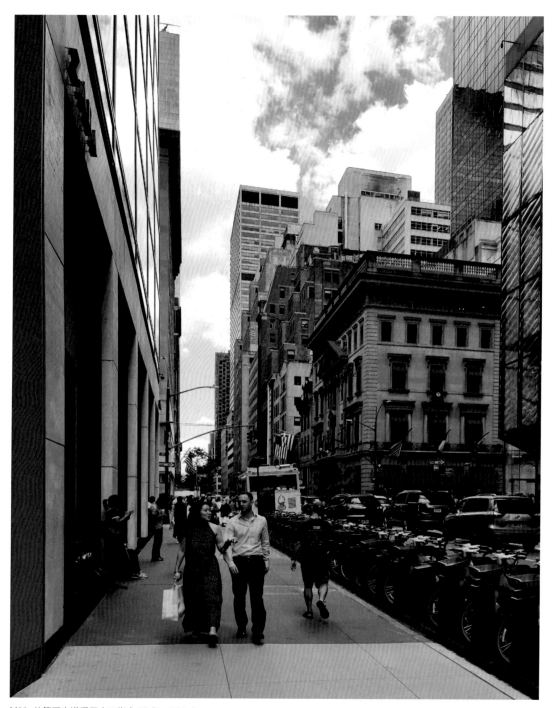

M93 从第五大道看五十二街 | 52 St. at 5th Ave.

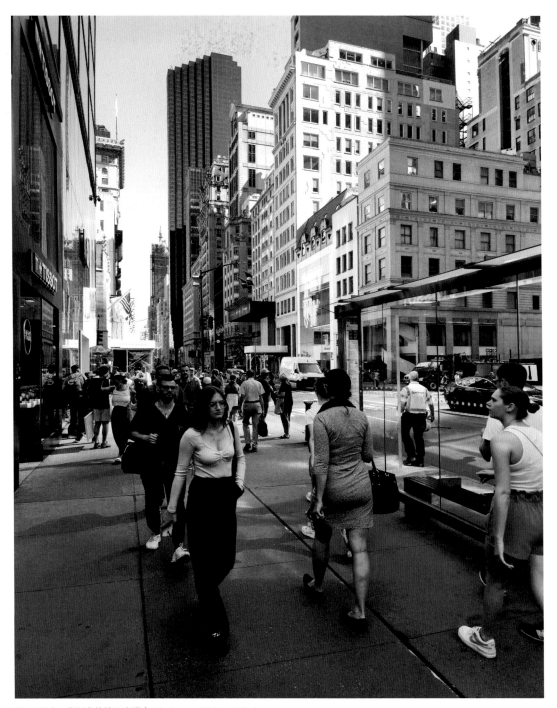

M94　五十二街以北的第五大道　｜　5th Ave. at 52 St. to North

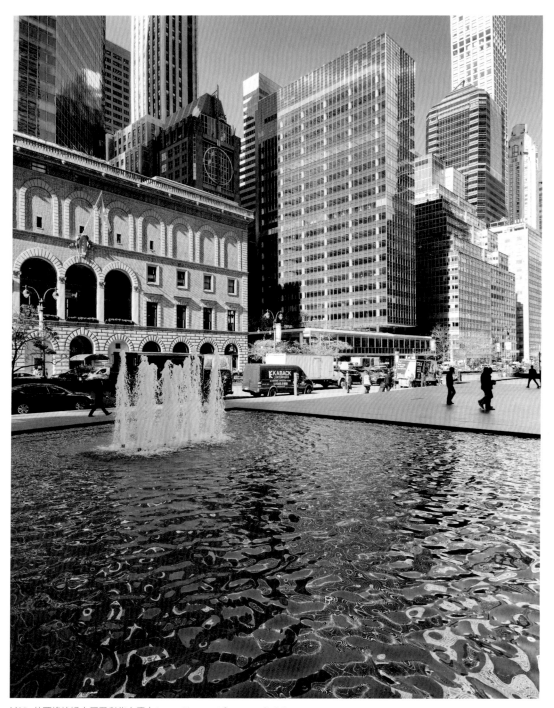

M95 从西格拉姆大厦看利华大厦 | Lever House at Seagram Building

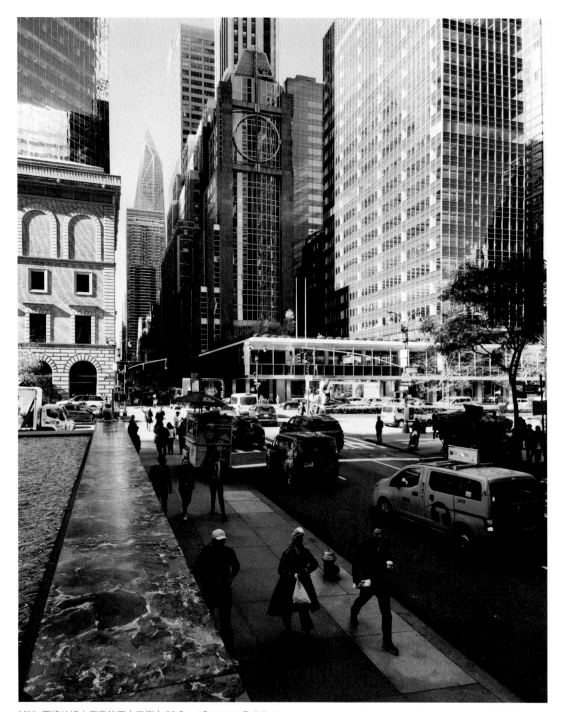

M96 西格拉姆大厦旁的五十三街 | 53 St. at Seagram Building

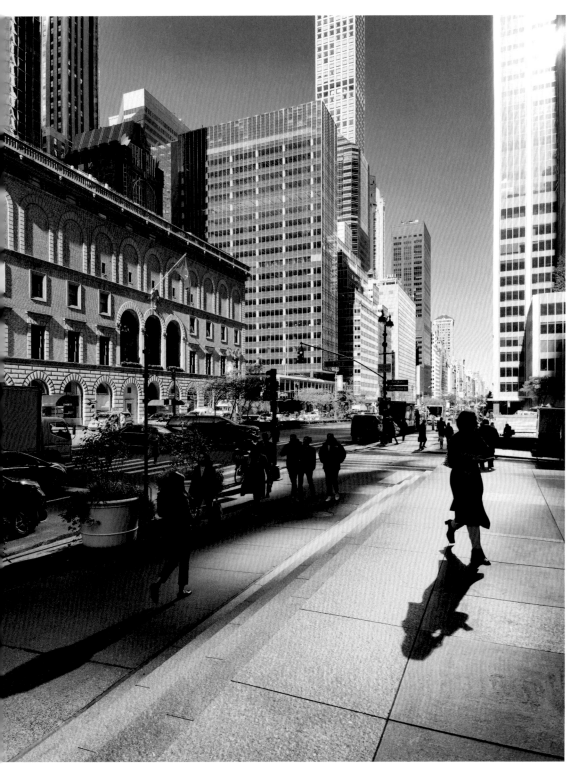

M97 公园大道旁的网球俱乐部 | Racquet and Tennis Club by Park Ave.

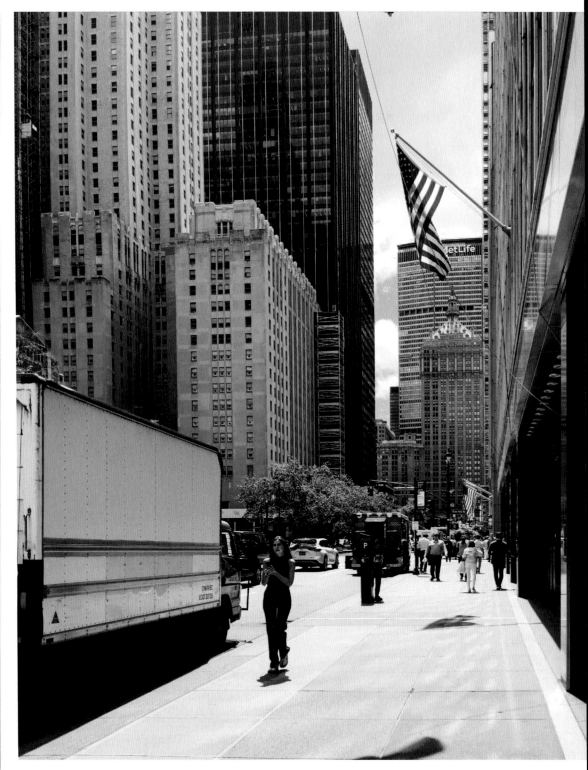

M98 从五十二街至中央车站之间的公园大道 | Park Ave. at 52 St. to Grand Central Terminal

M99 从第六大道看五十二街 | 52 St. at 6th Ave.

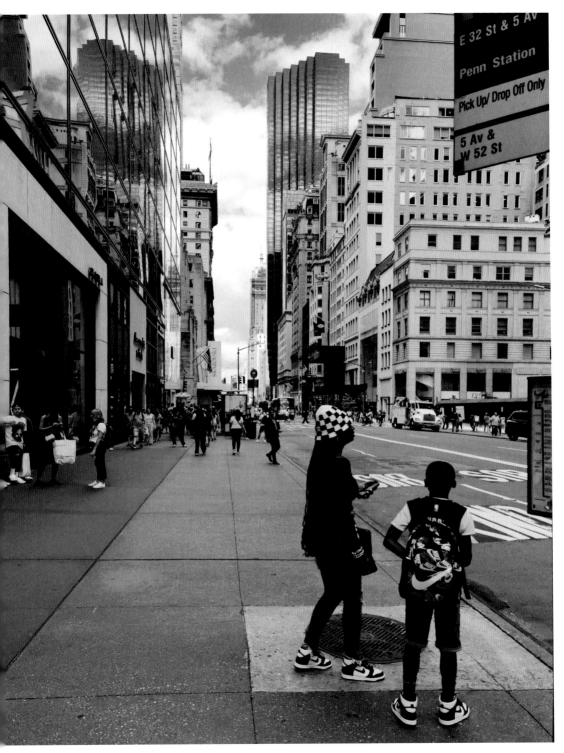

M100 从五十二街看第五大道 | 5th Ave. at 52 St.

M101 五十三街的 MOMA 窗景 | Window View of MOMA at 53 St.

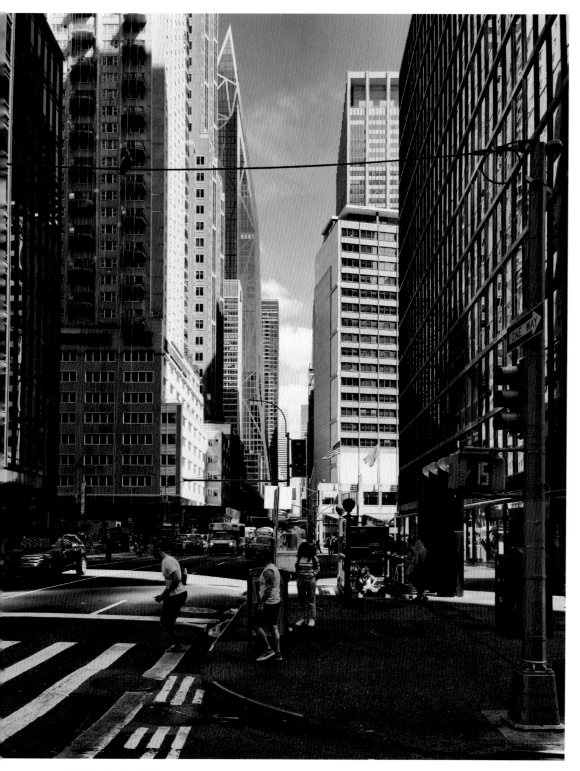

M102　从百老汇看五十三街　|　53 St. at Broadway

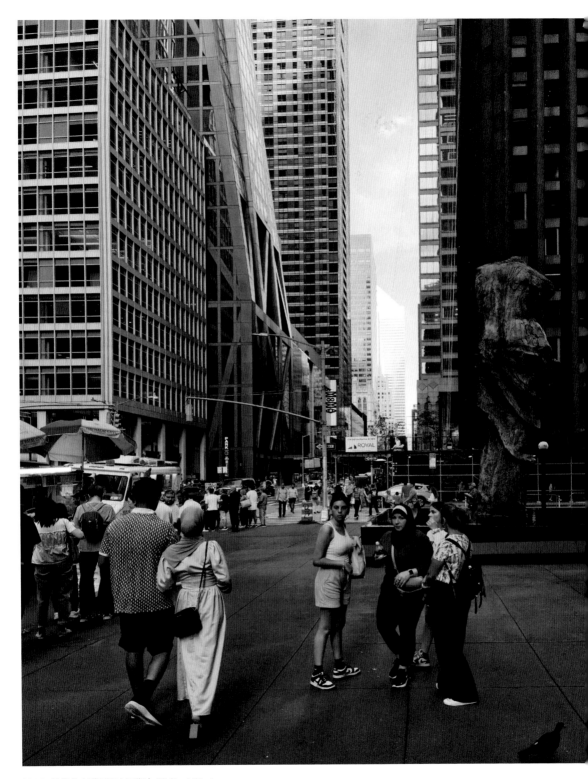

M103 从第六大道看五十三街 | 53 St. at 6th Ave.

M104 从第五大道看五十三街 | 53 St. at 5th Ave.

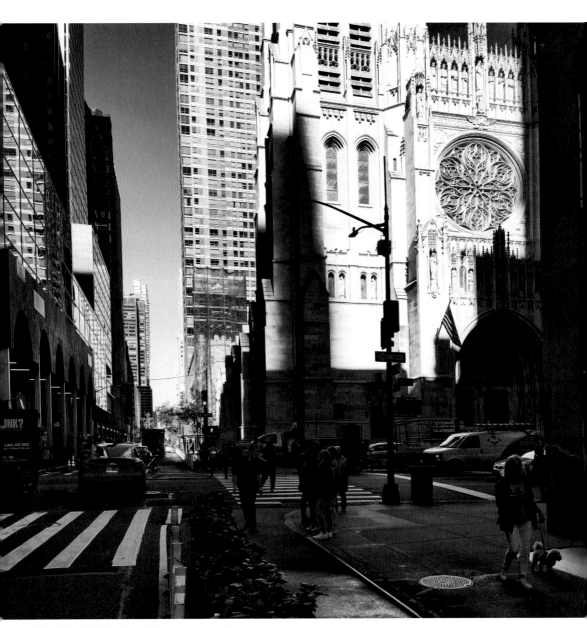

M105 圣托马斯教堂（1）| St. Thomas Church (1)

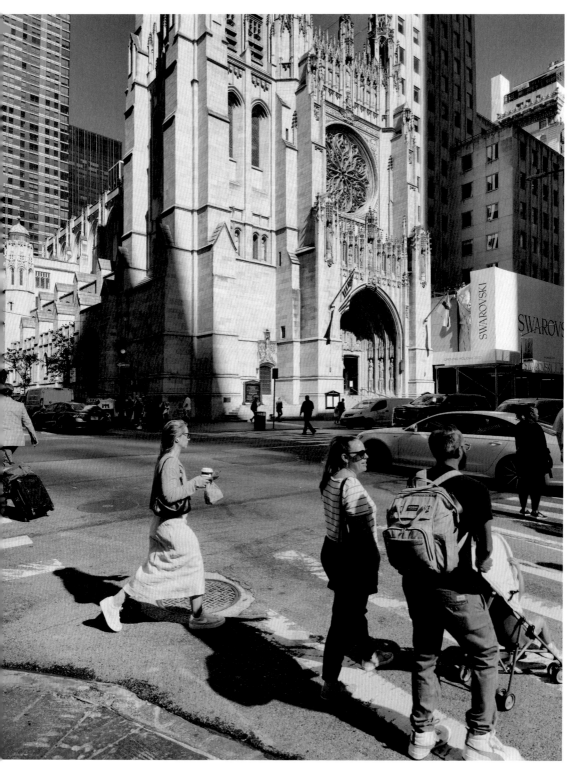

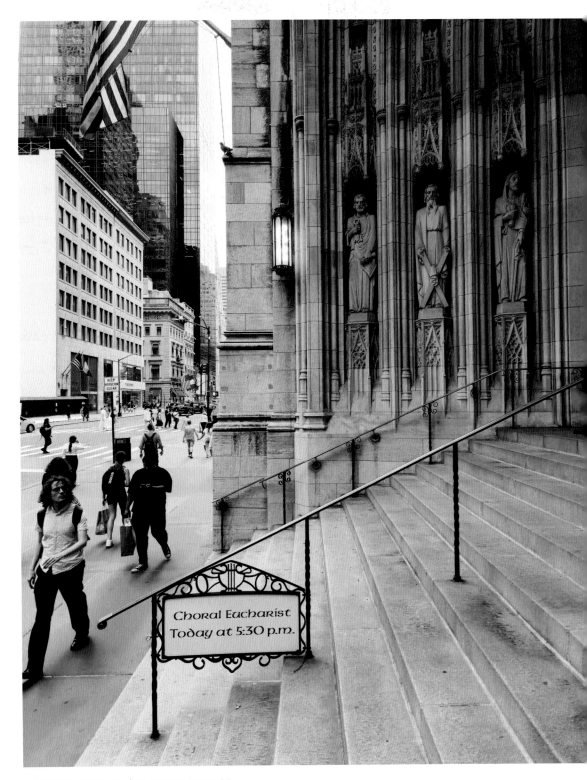

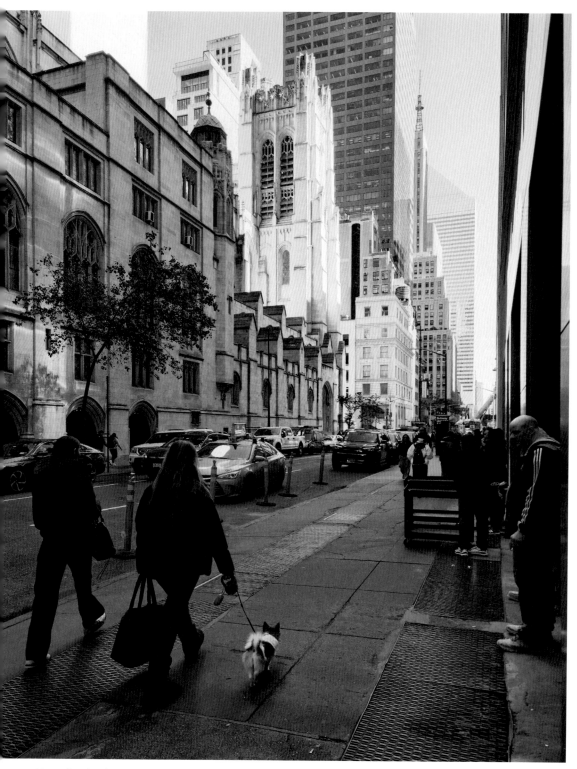

M108　从五十三街看圣托马斯教堂　|　St. Thomas Church at 53 St.

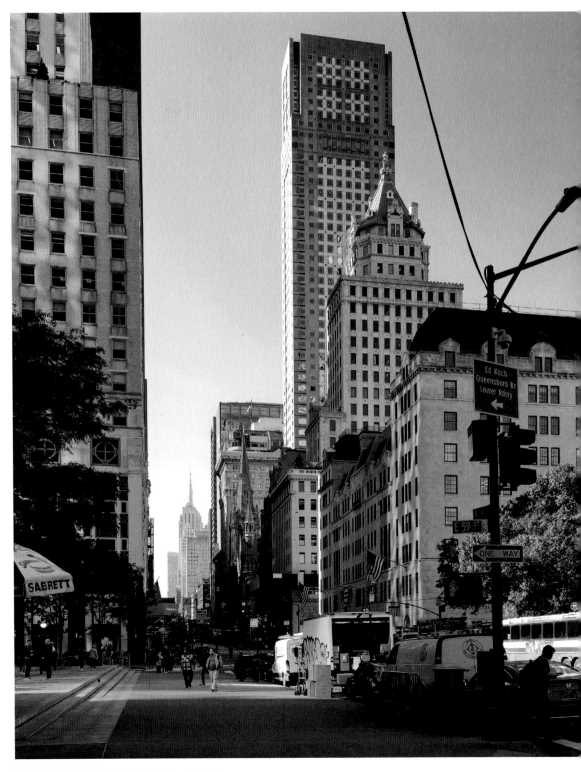

M109 从五十九街看第五大道 | 5th Ave. at 59 St.

M110 从五十三街看第六大道 | 6th Ave. at 53 St.

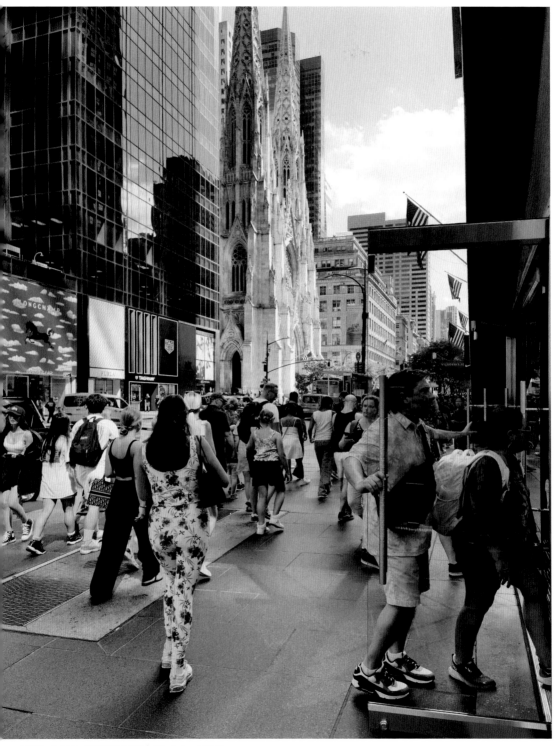

M111　从五十三街看第五大道 ｜ 5th Ave. at 53 St.

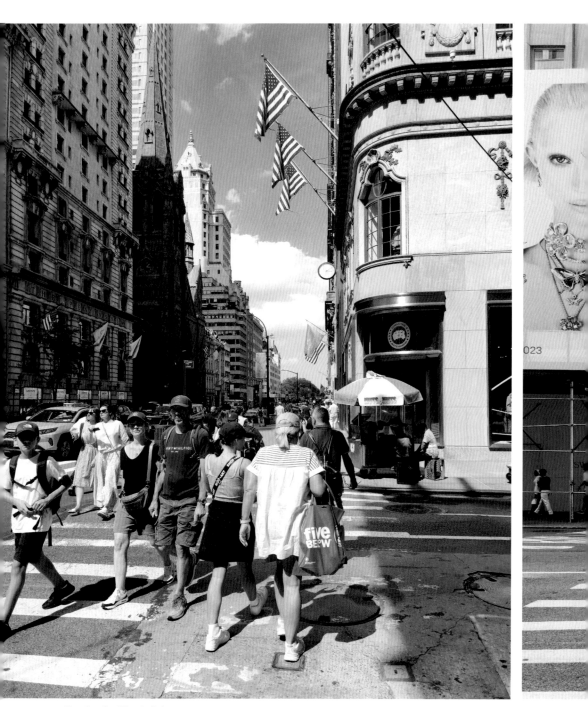

M112 从五十四街看第五大道 | 5th Ave. at 54 St.

M113 从第五大道看五十四街 | 54 St. at 5th Ave.

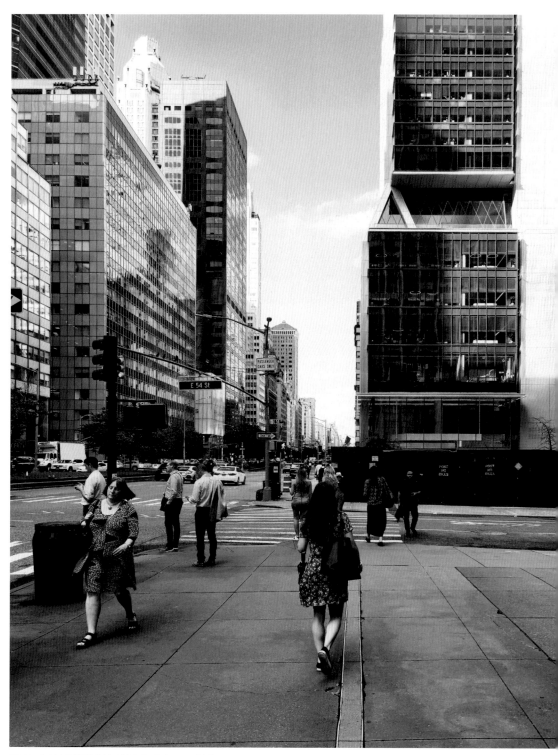

M114 从五十四街看公园大道 | Park Ave. at 54 St.

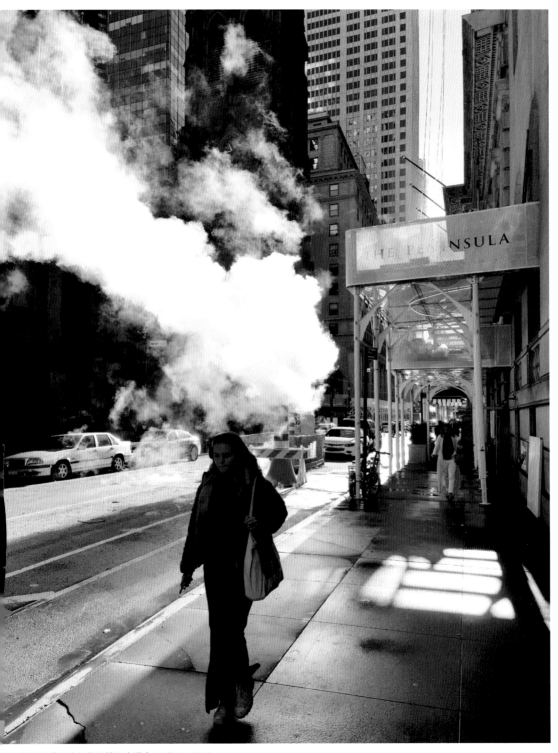

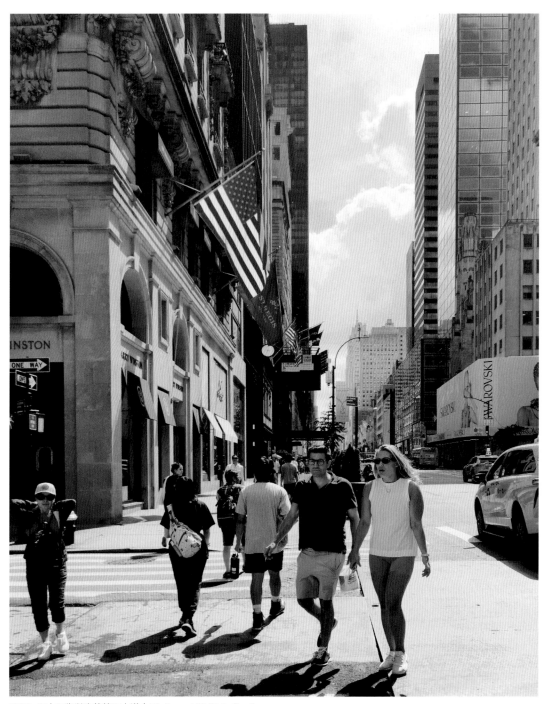

M116 五十五街以南的第五大道 | 5th Ave. at 55 St. to South

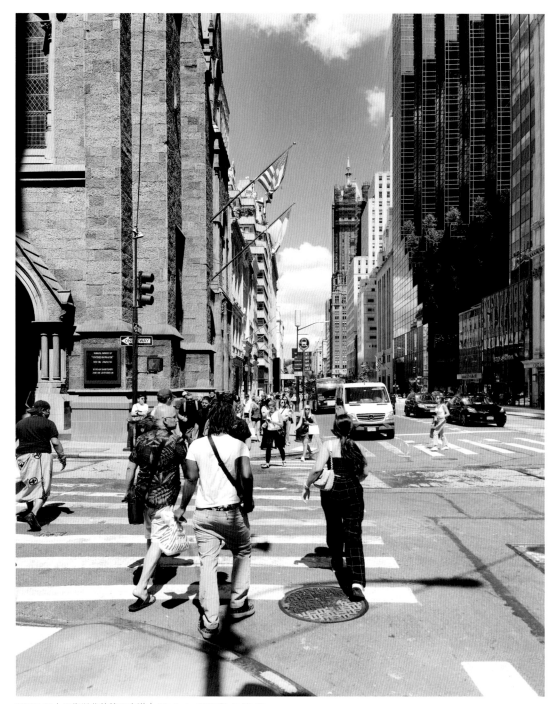

M117 五十五街以北的第五大道 | 5th Ave. at 55 St. to North

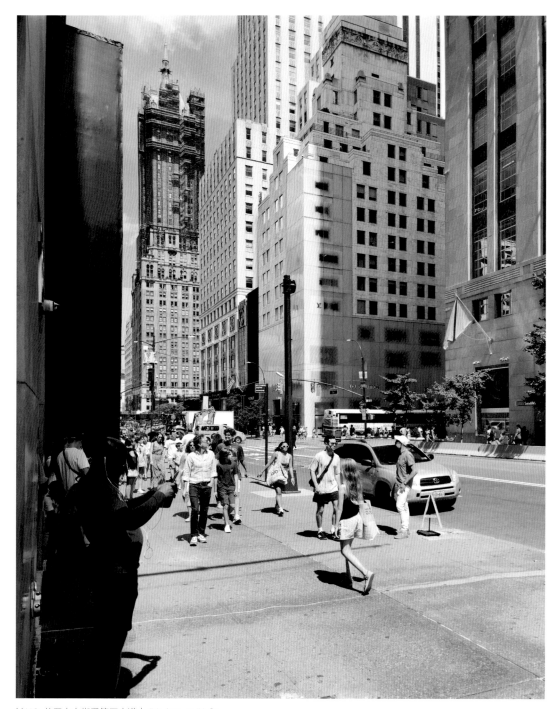

M118 从五十六街看第五大道 | 5th Ave. at 56 St.

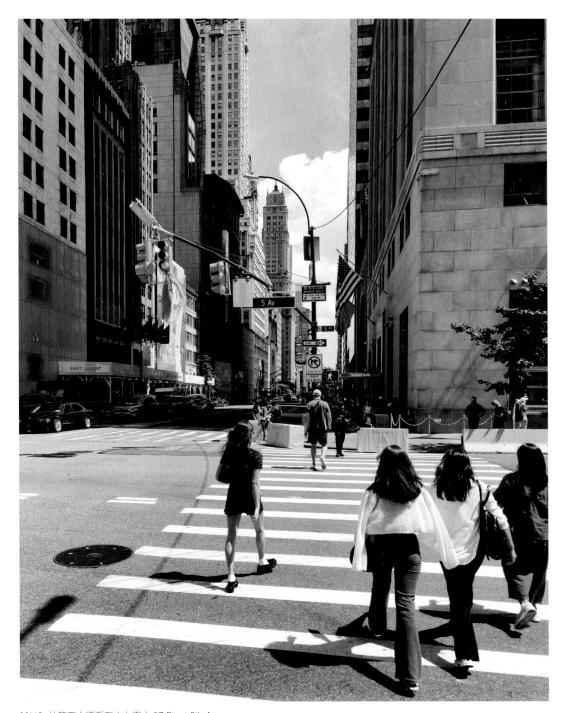

M119 从第五大道看五十七街 | 57 St. at 5th Ave.

M120 从第五大道看长老会教堂 | Presbyterian Church at Fifth Ave.

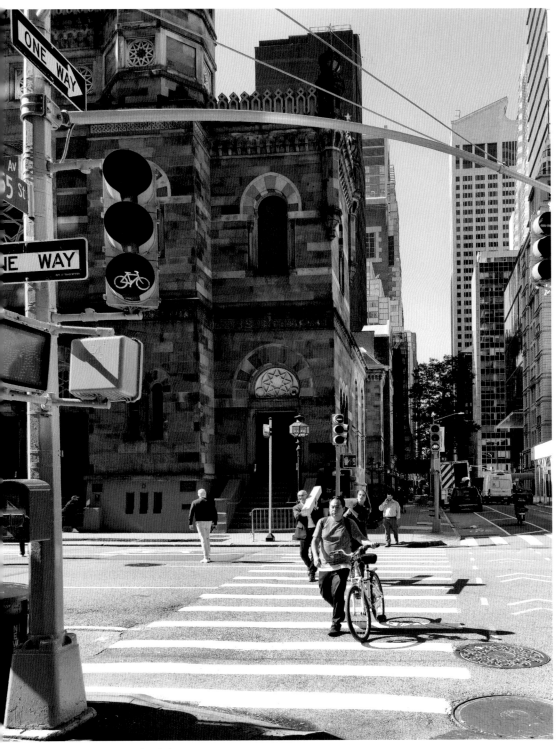

M121 从列克星敦大道看五十五街 | 55 St. at Lexington Ave.

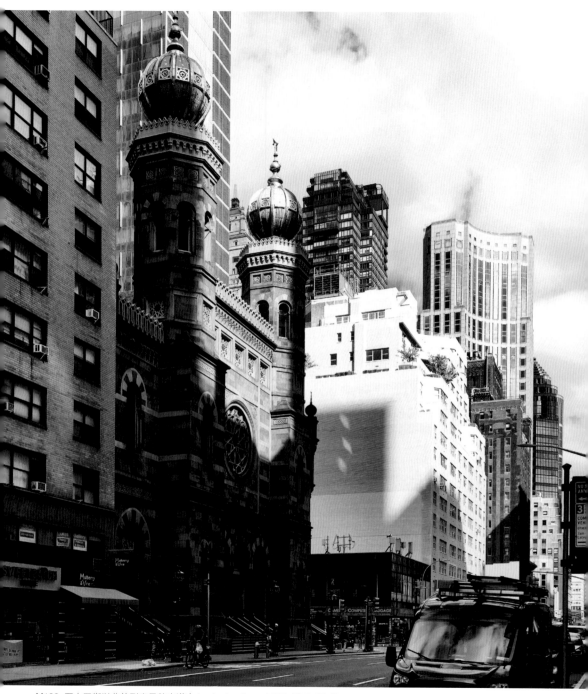

M122　五十四街以北的列克星敦大道 ｜ Lexington Ave. at 54th St. to North

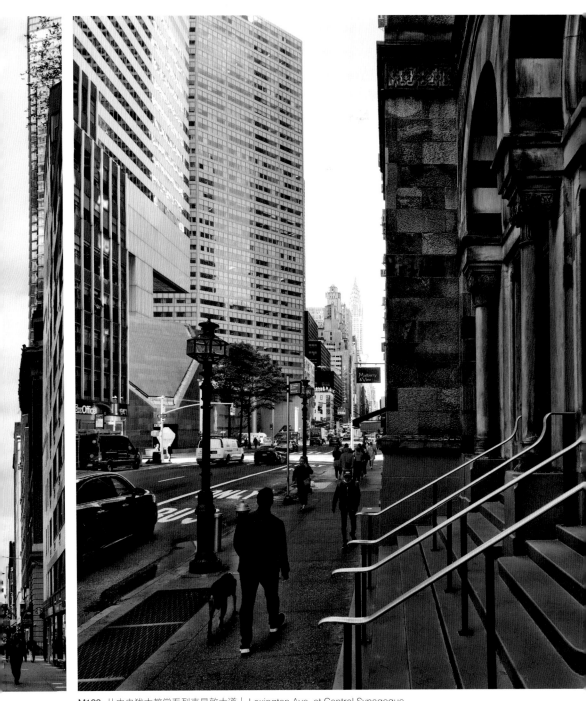

M123 从中央犹太教堂看列克星敦大道 | Lexington Ave. at Central Synagogue

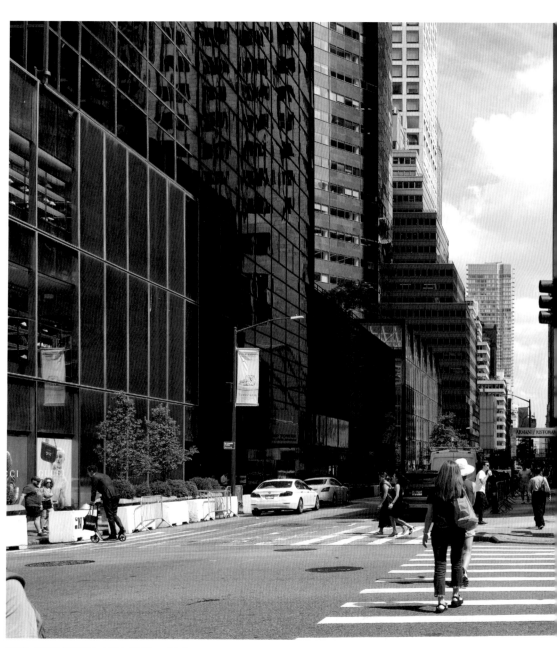

M124 第五大道的五十六街 | 56 St. at 5th Ave.

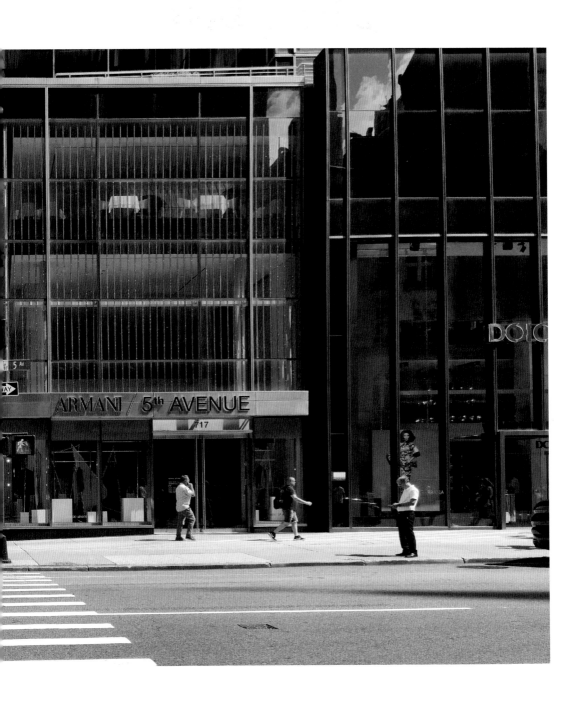

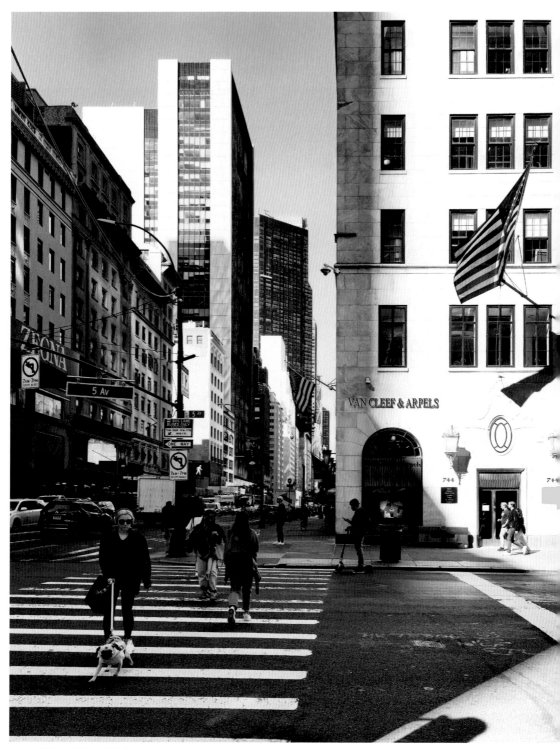

M125 从第五大道看五十七街 | 57 St. at 5th Ave.

M126 从第六大道看五十五街 | 55 St. at 6th Ave.

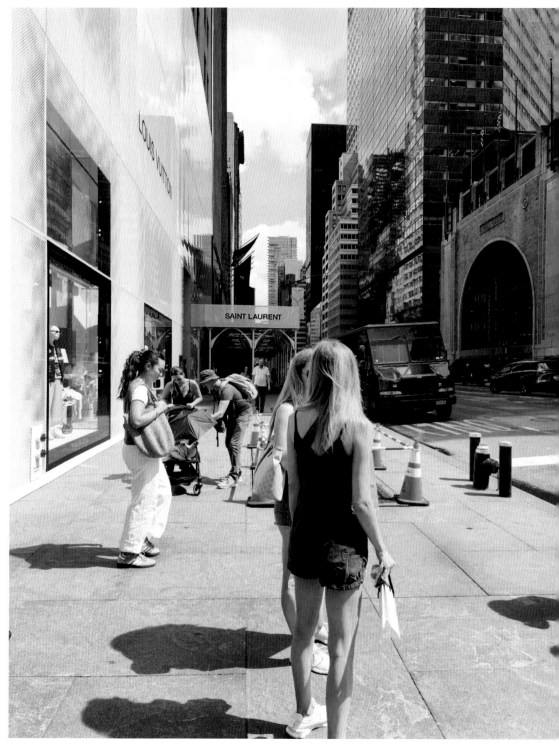

M127 从五十七街到麦迪逊大道 | 57 St. to Madison Ave.

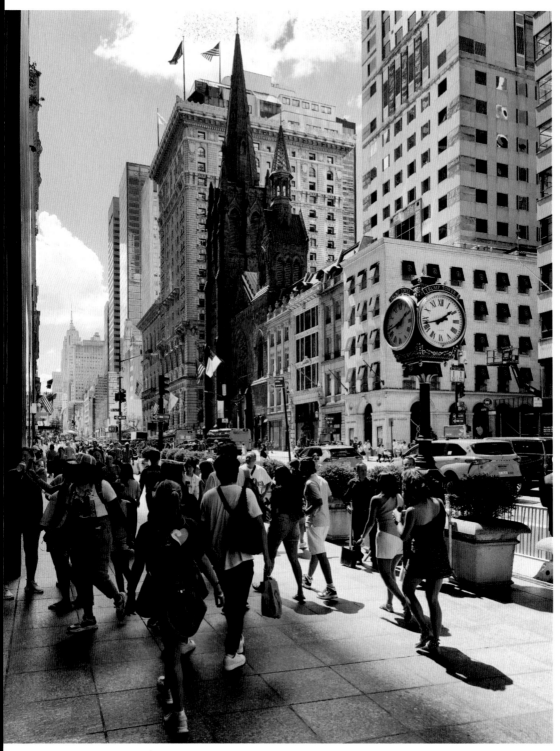

M128 从五十七街看第五大道 | 5th Ave. at 57 St.

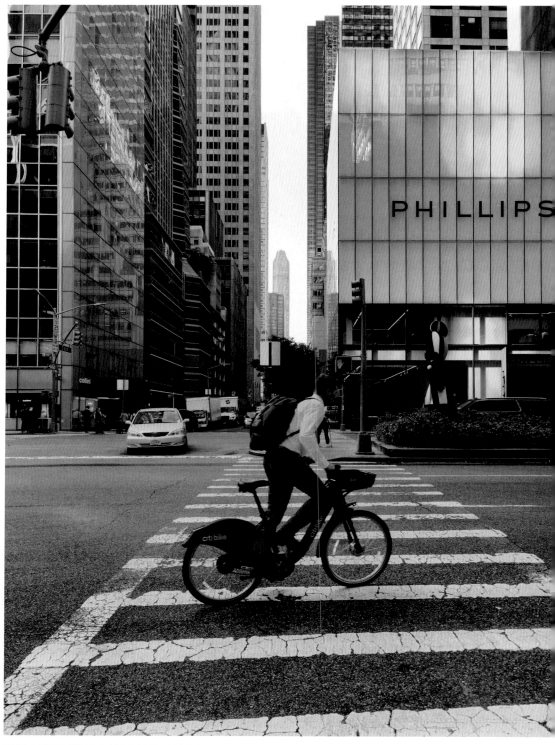

M129 从公园大道看五十六街 | 56 St. at Park Ave.

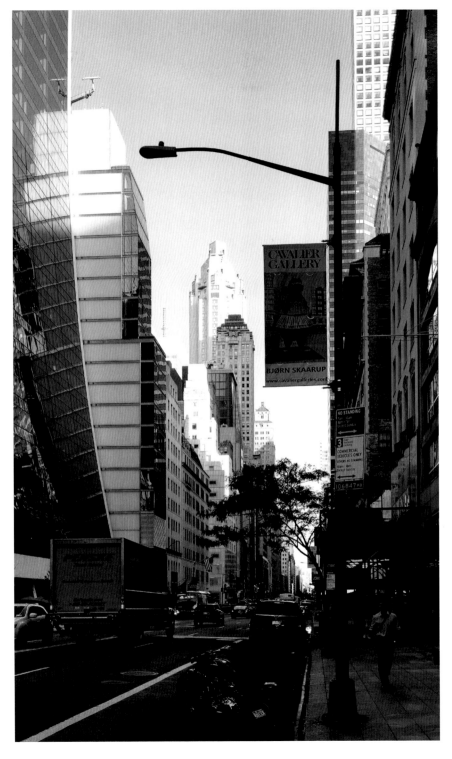

M130 从第五大道看五十七街 | 57 St. at 5th Ave.

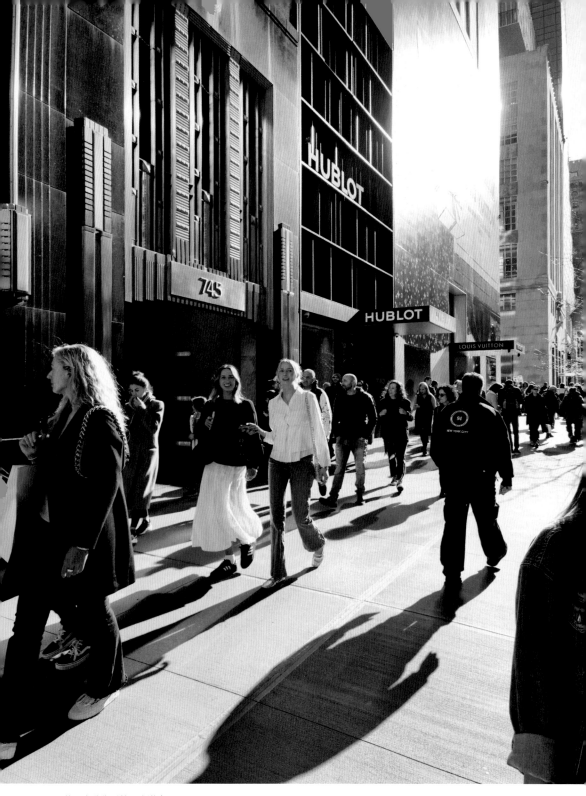

M131 从五十八街看第五大道 | 5th Ave. at 58 St.

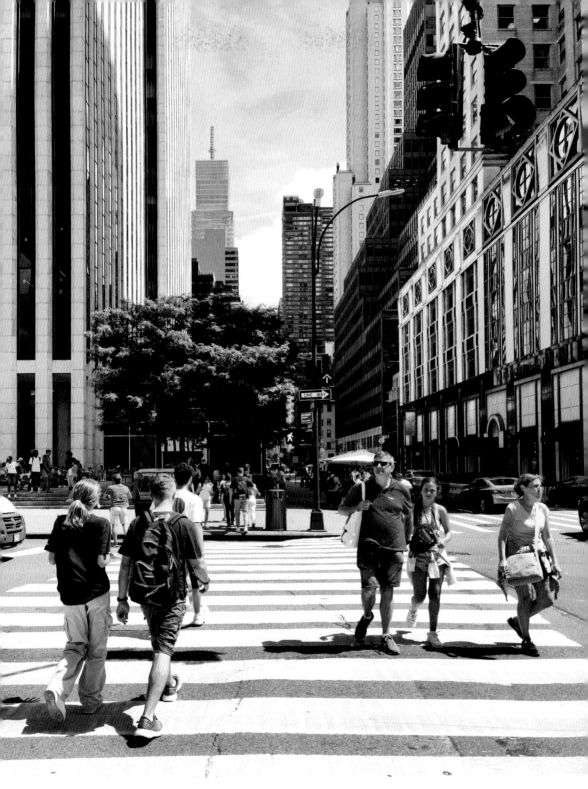

M132 从第五大道看五十八街 | 58 St. at 5th Ave.

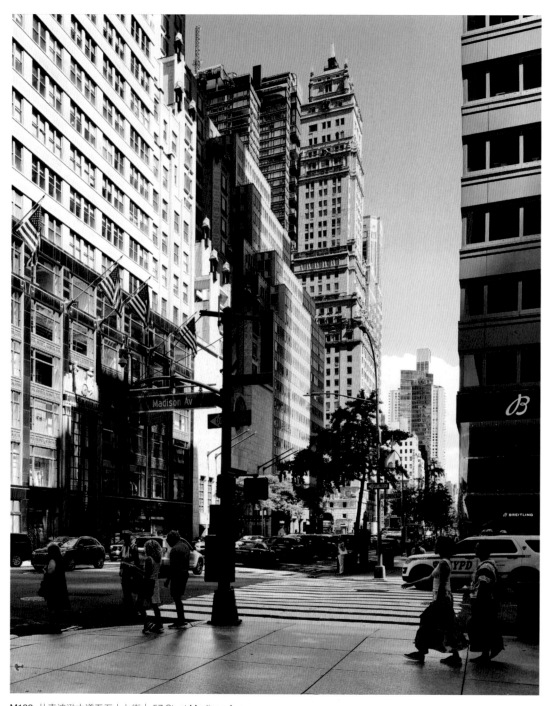

M133 从麦迪逊大道看五十七街 | 57 St. at Madison Ave.

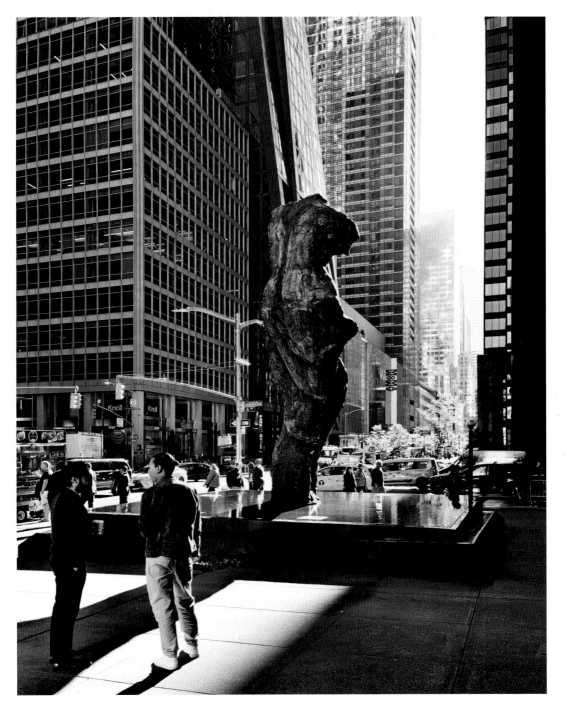

M134 从第六大道看五十三街 | 53 St. at 6th Ave.

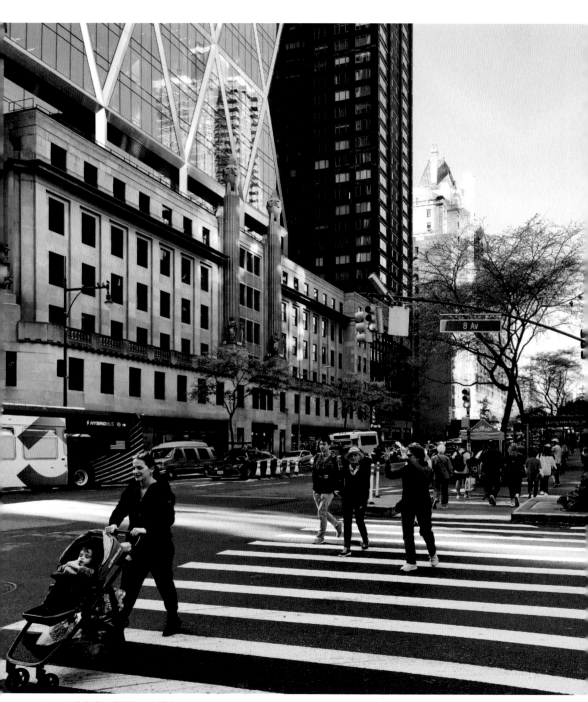

M135 五十六街以北的第八大道 | 8th Ave. at 56 St. to North

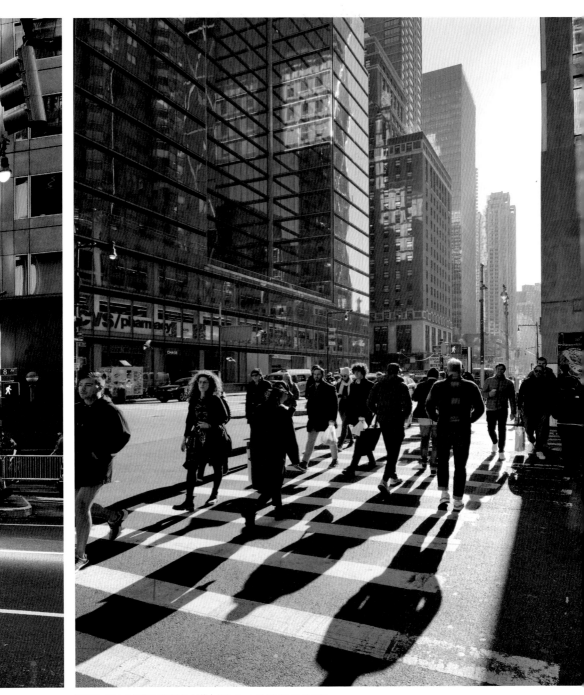

M136 五十八街以南的第八大道 | 8th Ave. at 58 St. to South

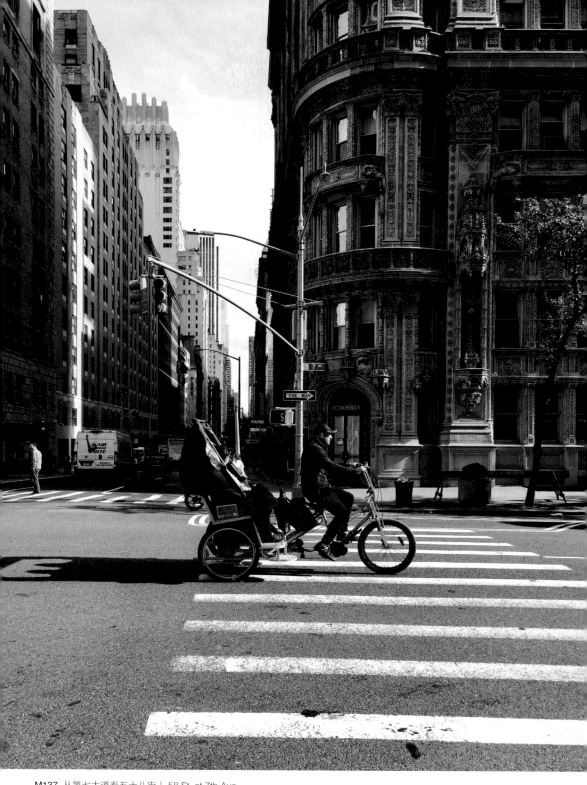

M137 从第七大道看五十八街 | 58 St. at 7th Ave.

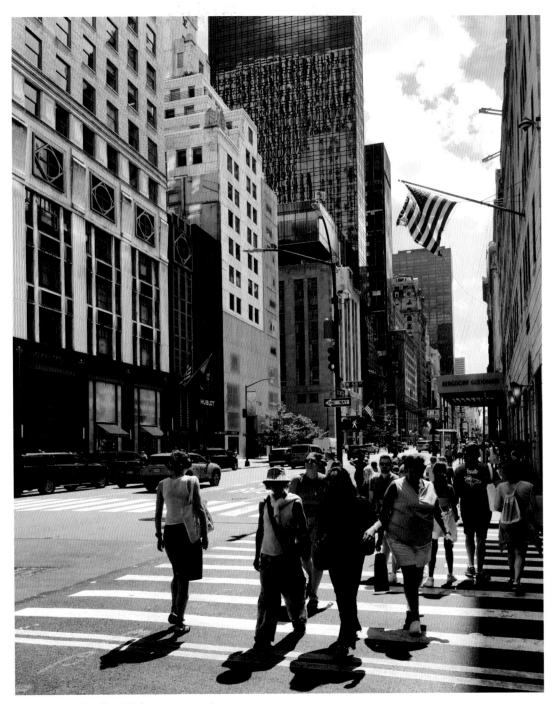

M138 从五十九街看第五大道 | 5th Ave. at 59 St.

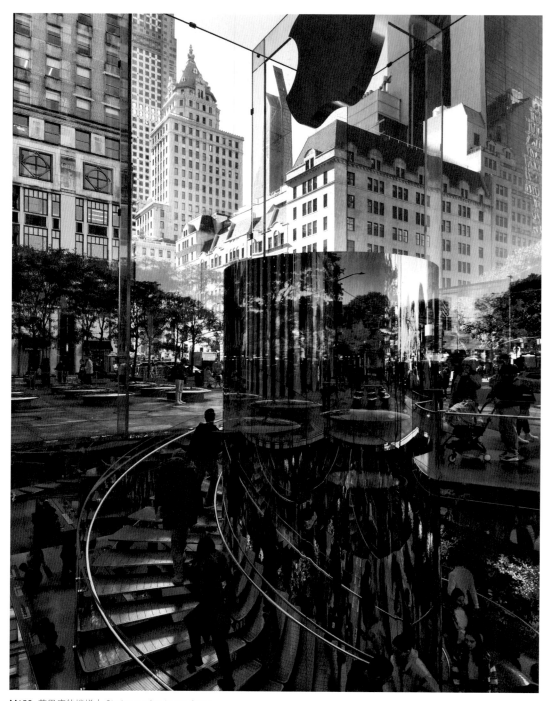

M139 苹果店的楼梯 | Skaircase for Apple Store

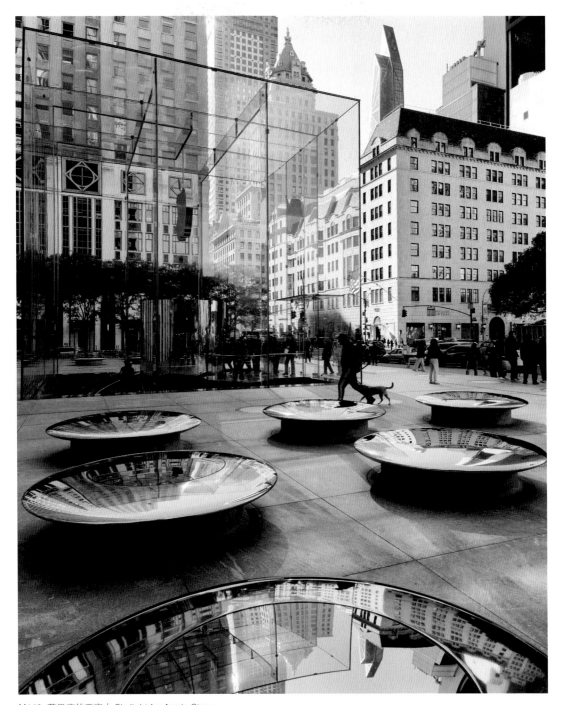

M140 苹果店的天窗 | Skylight for Apple Store

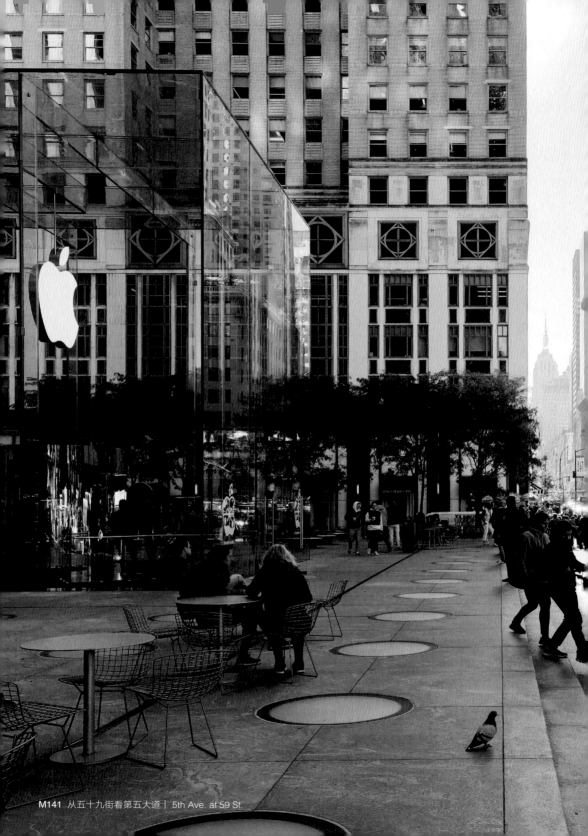

M141 从五十九街看第五大道 | 5th Ave. at 59 St.

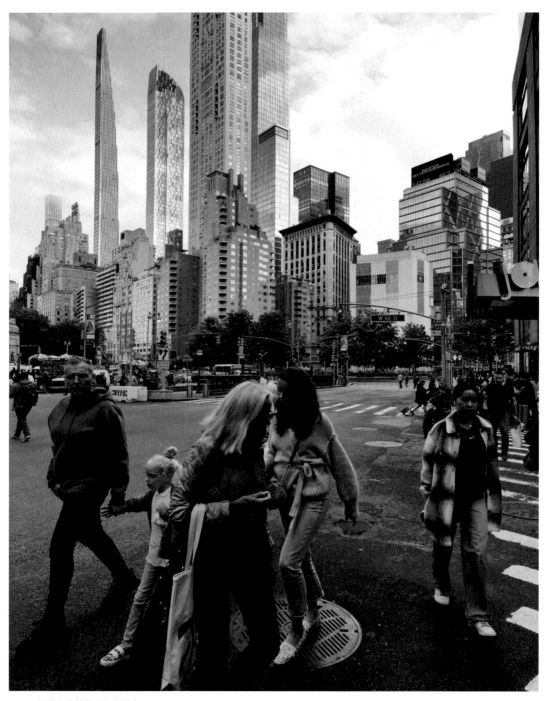

M142 哥伦布圈的曼哈顿中城 | Midtown Manhattan at Columbus Circle

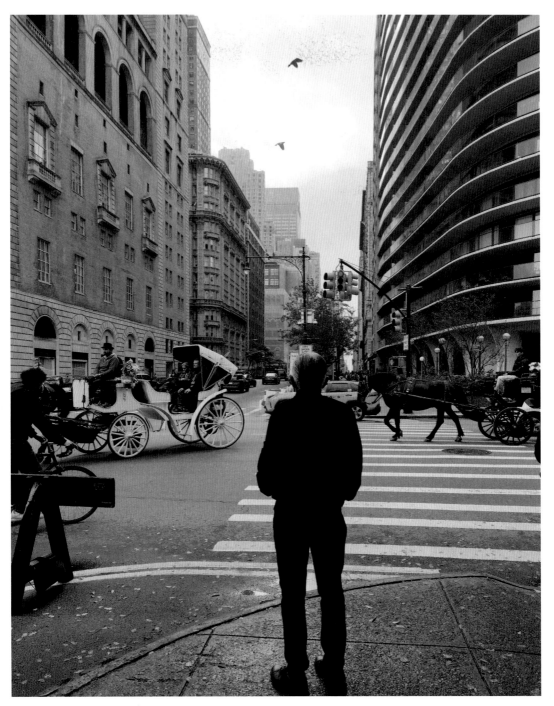

M143 从五十九街看第七大道 | 7th Ave. at 59 St.

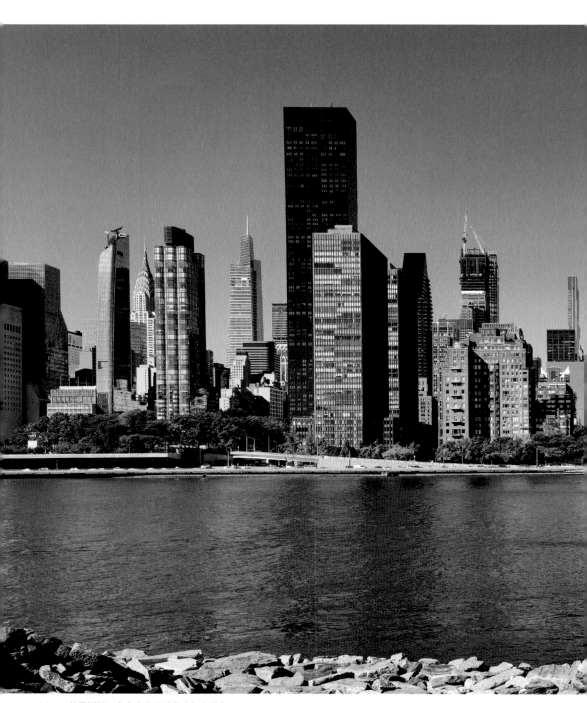

M144 从罗斯福四大自由公园看曼哈顿中城 | Midtown Manhattan from FDR. Four Freedoms Park

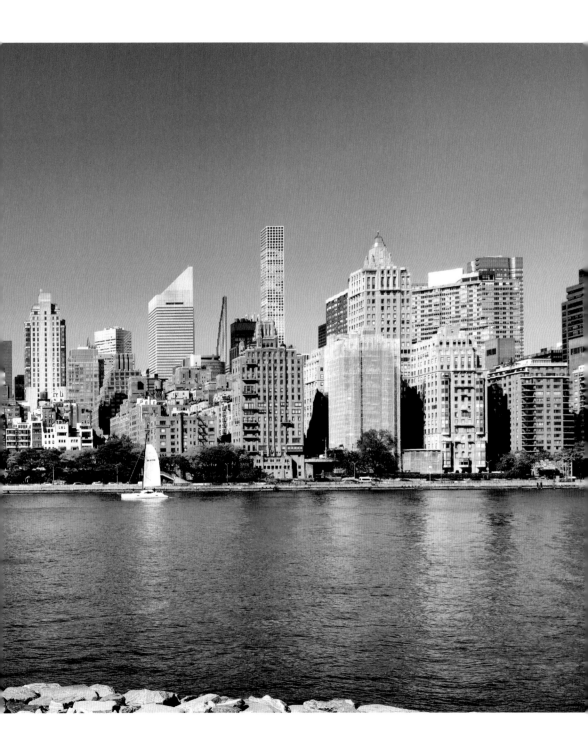

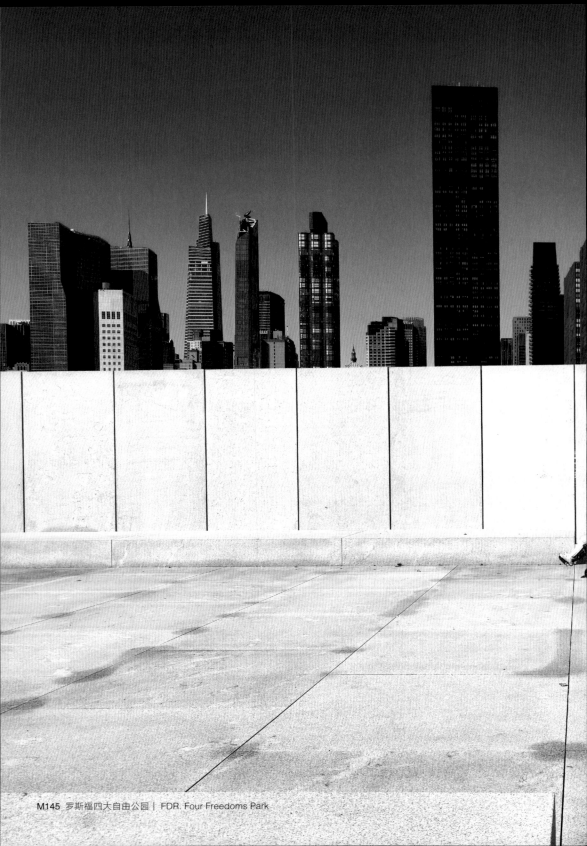

M145 罗斯福四大自由公园 | FDR. Four Freedoms Park

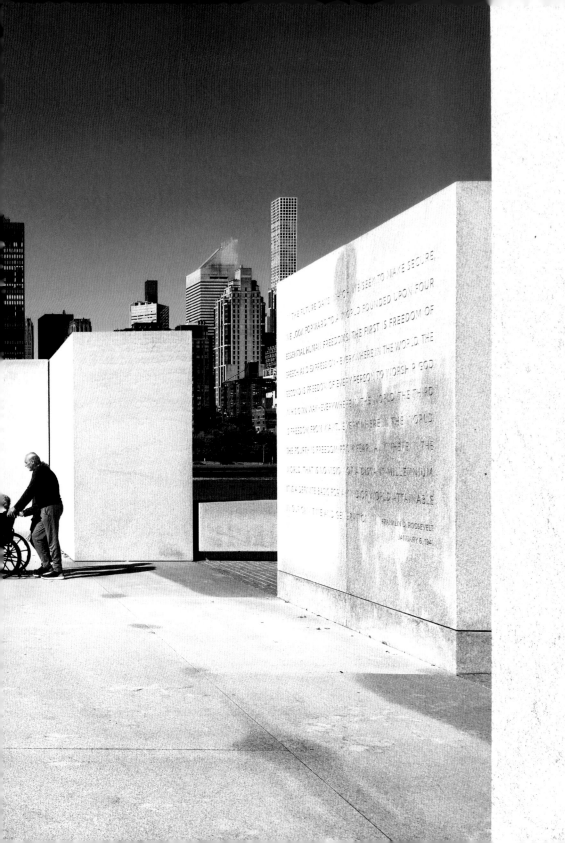

上城

曼哈顿上城是从五十九街往北到百老汇大桥的区域，占地面积大约是下城与中城之和，即曼哈顿的一半。从整体感觉上判断，上城的建筑密度不及中城和下城的一半，若算上大约5000亩的纽约中央公园，估计也就是三分之一左右。

上城重要的建筑有：大都会博物馆（U24／U25／U26／U27）、佛里克收藏馆（U23）、古根海姆美术馆（U28）、以马内利会堂（U14／U15）、乌克兰研究院（U29）、大都会歌剧院（U18／U19／U20／U21）、圣约翰大教堂（U45／U46／U47／U48）、基督教科学派第一教堂（U56）、哥伦比亚大学（U49／U50／U51）、修道院博物馆（U52／U53／U54／U55）和水线广场（住宅）（U10／U11／U12）等。

UPTOWN

Uptown Manhattan extends from 59th Street northward to the Broadway Bridge, covering an area approximately equivalent to the sum of Downtown and Midtown, roughly half of Manhattan. Judging from the overall feeling, Uptown Manhattan's architectural density is less than half that of Midtown and Downtown. If we include the Central Park, which covers about 5,000 acres, it is likely to be around 1/3.

The very important buildings in Uptown Manhattan include the Metropolitan Museum of Art, the Frick Collection, the Solomon R. Guggenheim Museum, Temple Emanu-El, the Ukrainian Institute, the Metrcpolitan Opera House, the Cathedral Church of Saint John the Divine, the First Church of Christ Scientist, Columbia University, the Cloisters Museum of Art and Waterline Square (residential), etc.

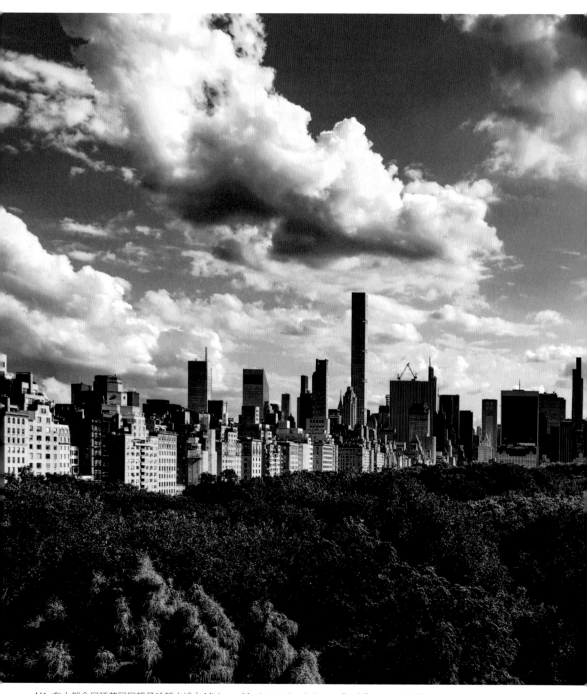

U1 在大都会屋顶花园回望曼哈顿中城 ｜ Midtown Manhattan backview at Roof Garden of MET.

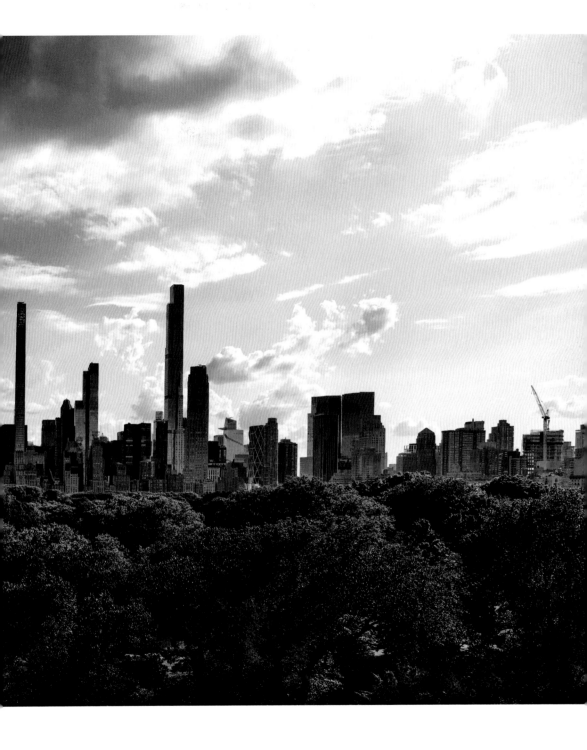

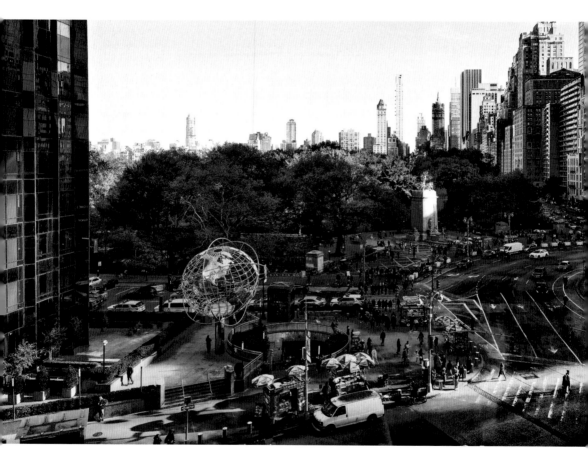

U2 从哥伦布环岛看中央公园 | Central Park at Columbus Cirale

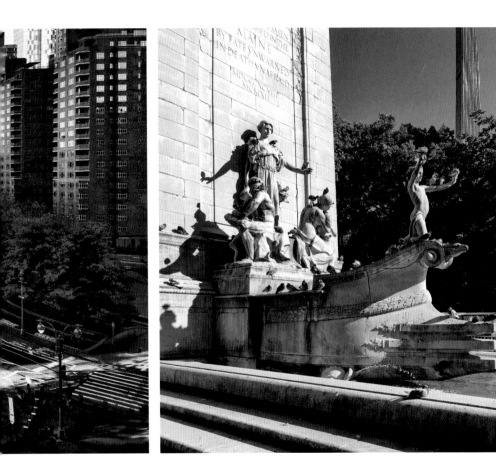

U3 缅因州纪念碑 | Maine Monument

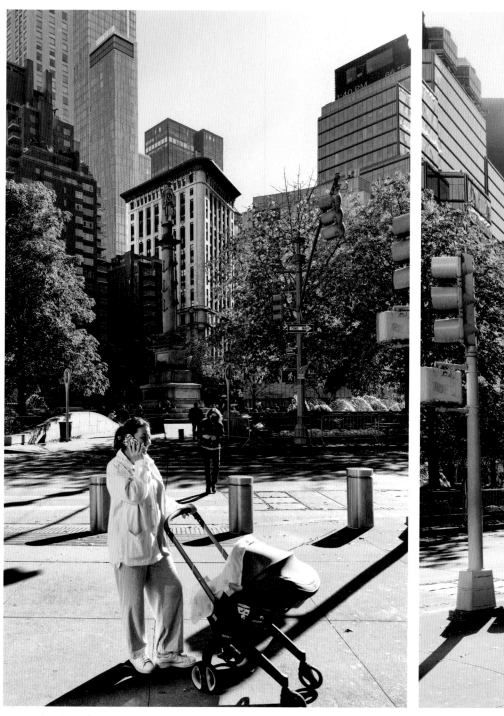

U4 哥伦布环岛（1）| Columbus Circle (1)

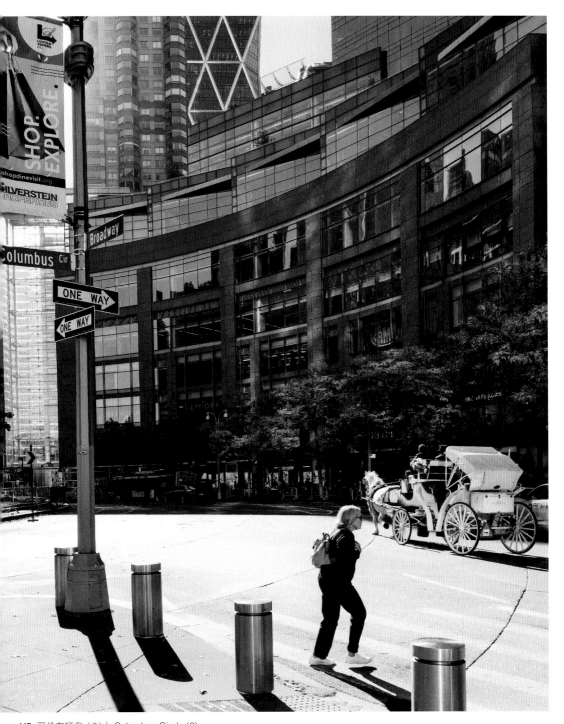

U5 哥伦布环岛（2）| Columbus Circle (2)

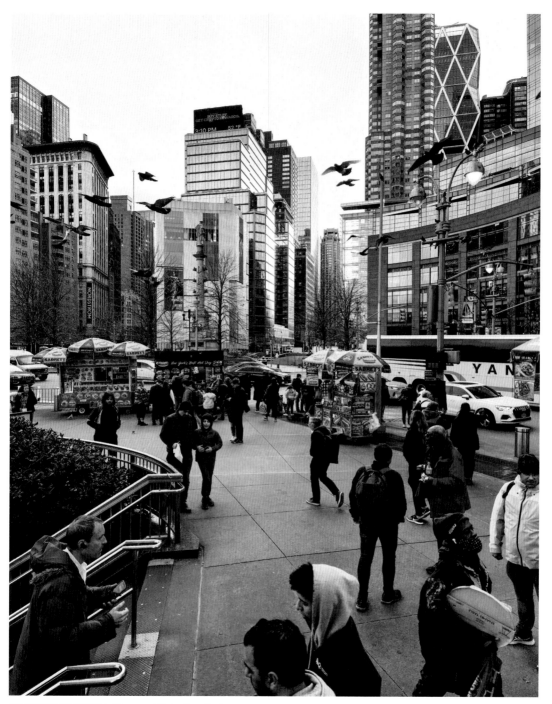

U6 哥伦布环岛的地铁 | Subway at Columbus Circle

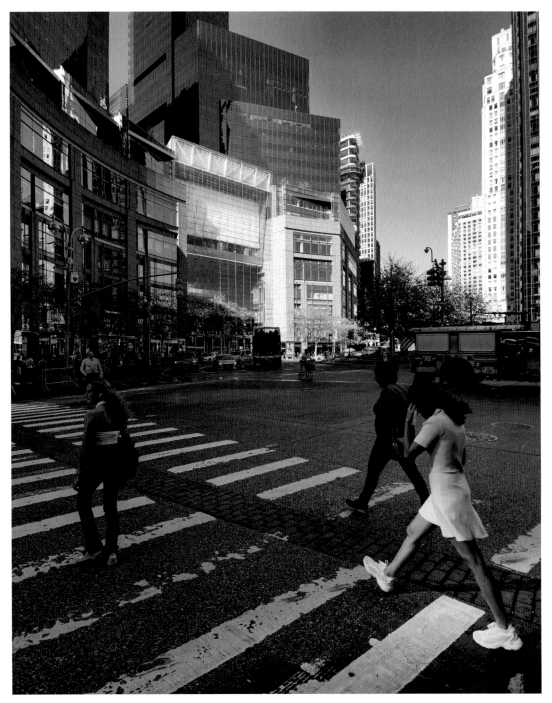

U7 从哥伦布环岛看百老汇 | Broadway at Columbus Circle

U8 从六十街看百老汇 | Broadway at 60 St.

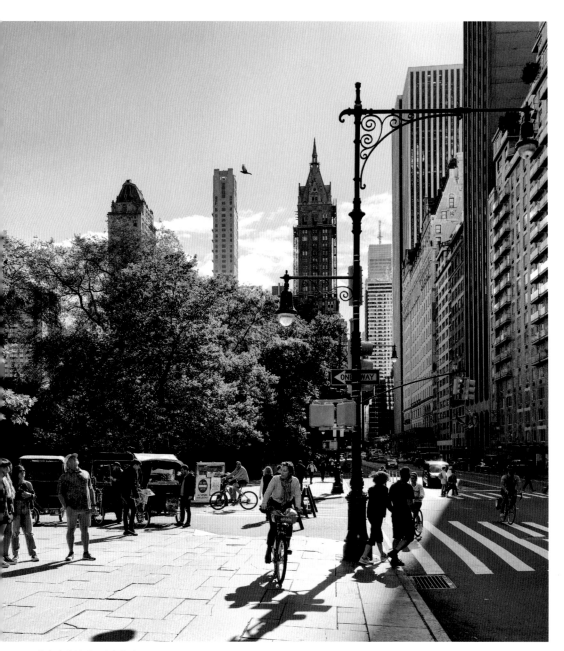

U9 从中央公园看五十九街 | 59 St. at Central Park

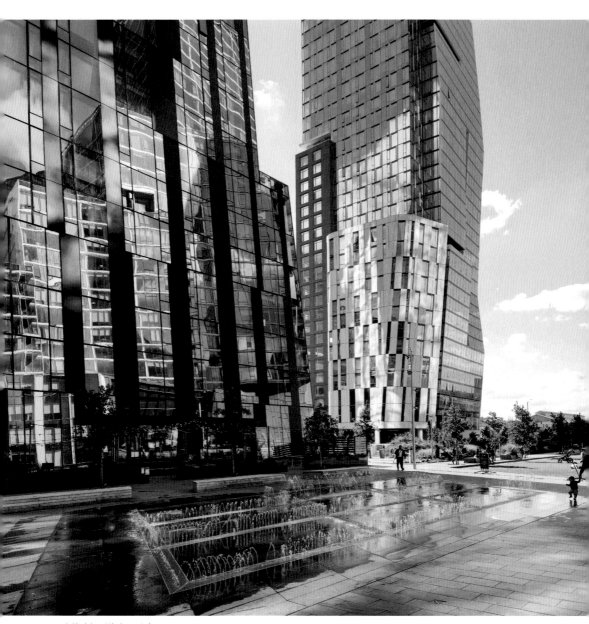

U10 水线广场（住宅，1） | Waterline Square (residential, 1)

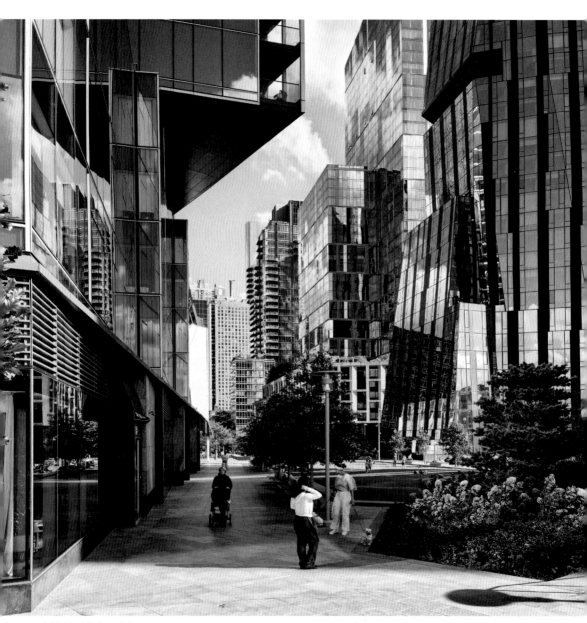

U11 水线广场（住宅，2）| Waterline Square (residential, 2)

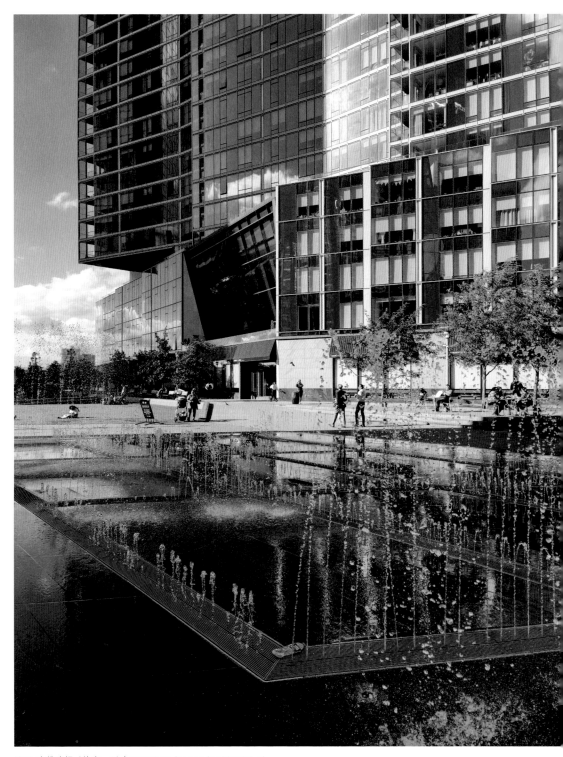

U12 水线广场(住宅,3) | Waterline Square (residential, 3)

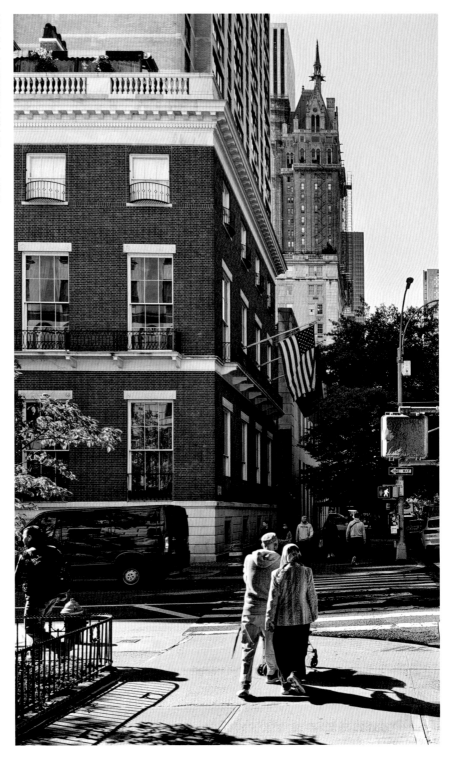

U13 从六十二街看第五大道 | 5th Ave. at 62 St.

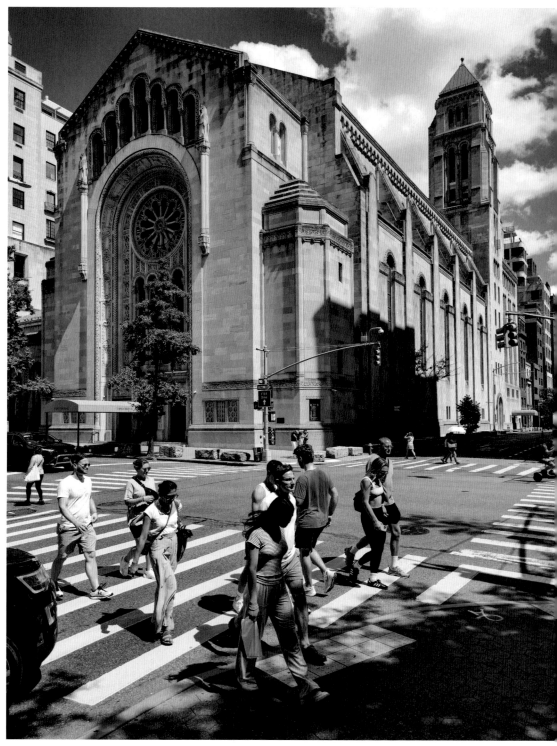

U14 从第五大道看以马内利会堂 | Temple Emanu-El at 5th Ave.

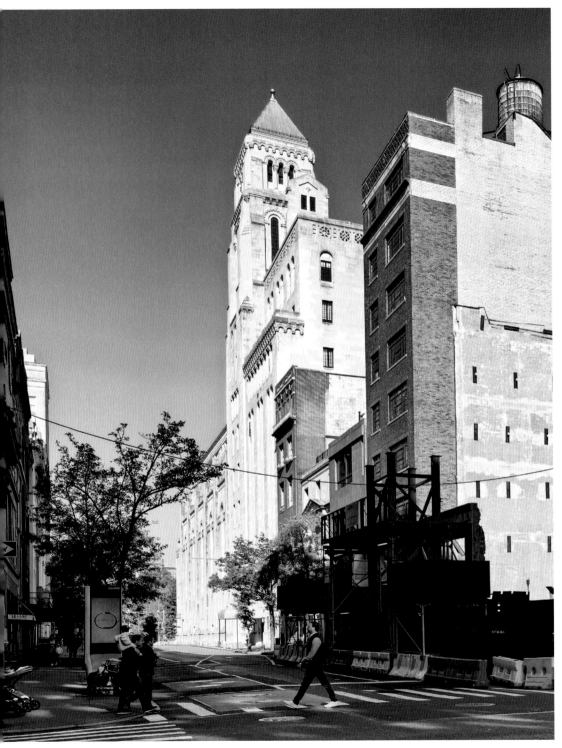

U15 从六十五街看以马内利会堂 | Temple Emanu-El at 65 St.

U16 从百老汇看阿姆斯特丹大道 | Amsterdam Ave. at Broadway

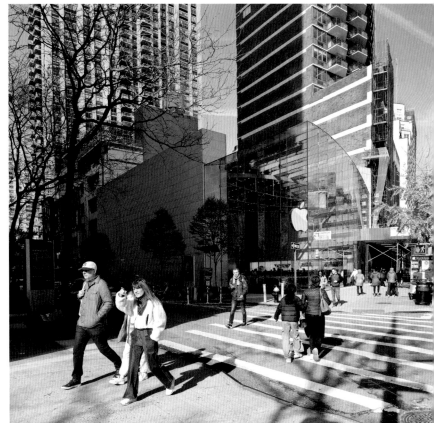

U17 从六十七街看百老汇 | Broadway at 67 St.

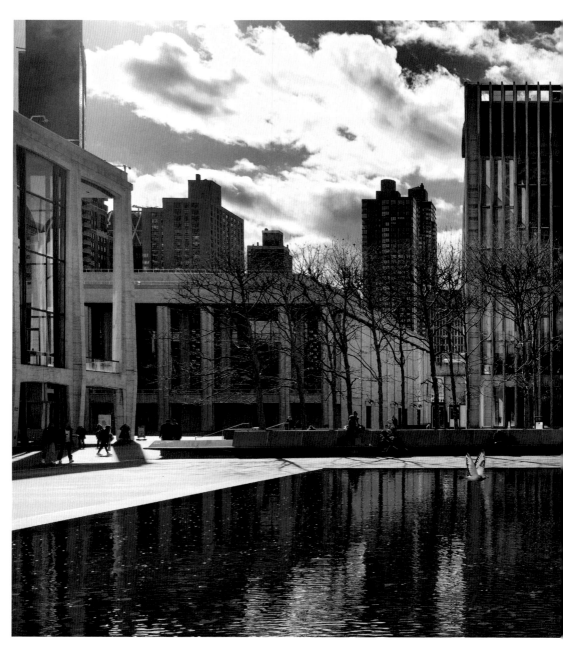

U18 林肯表演艺术中心 | Lincoln Center for the Performing Arts

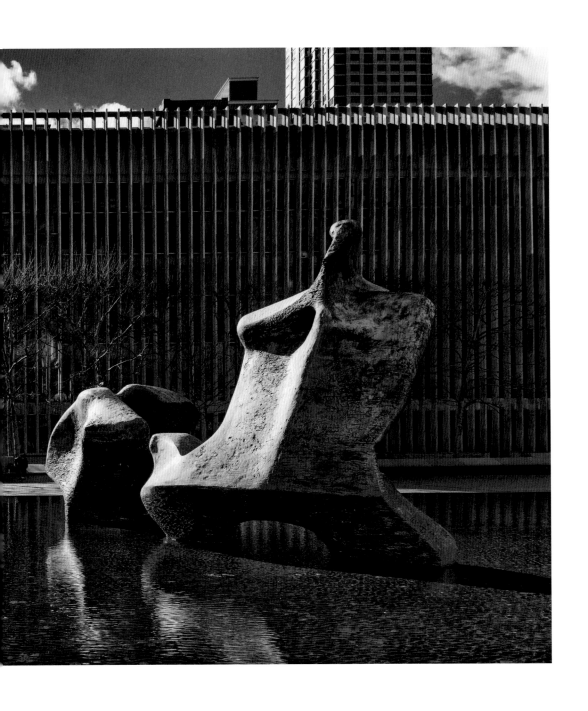

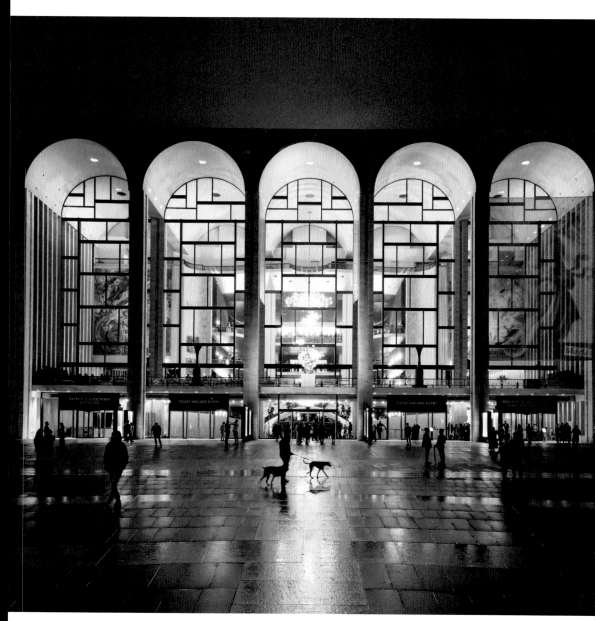

U19 大都会歌剧院 | Metropolitan Opera House

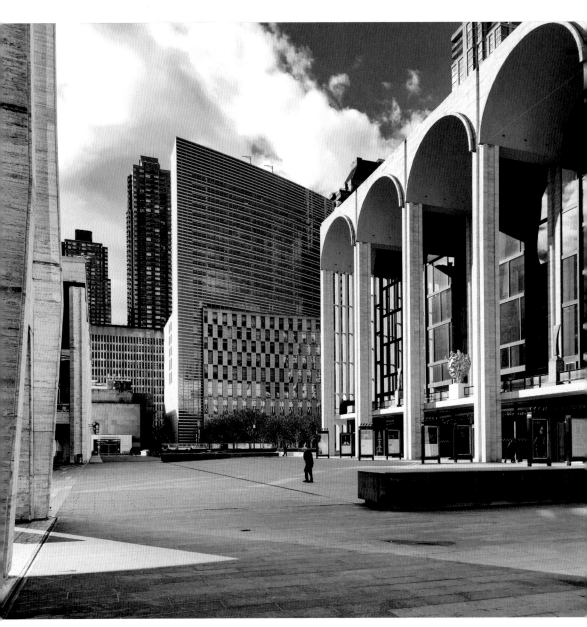

U20 福德汉姆大学 | Fordham University

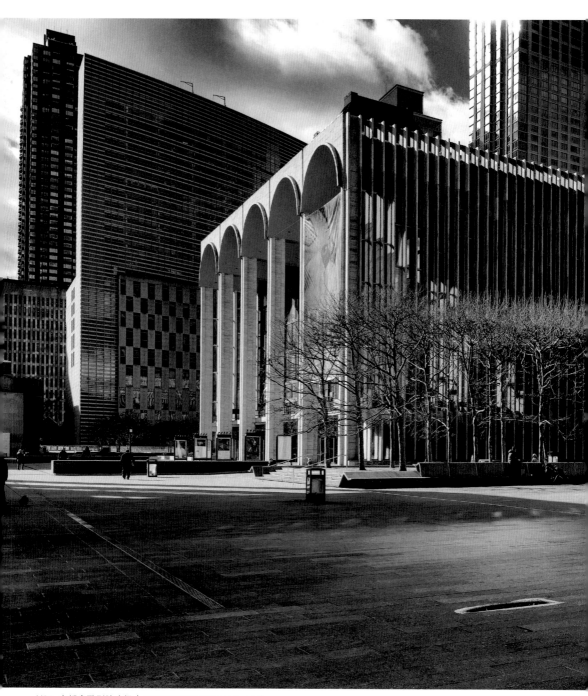

U21 大都会歌剧院广场 | Metropolitan Opera House Square

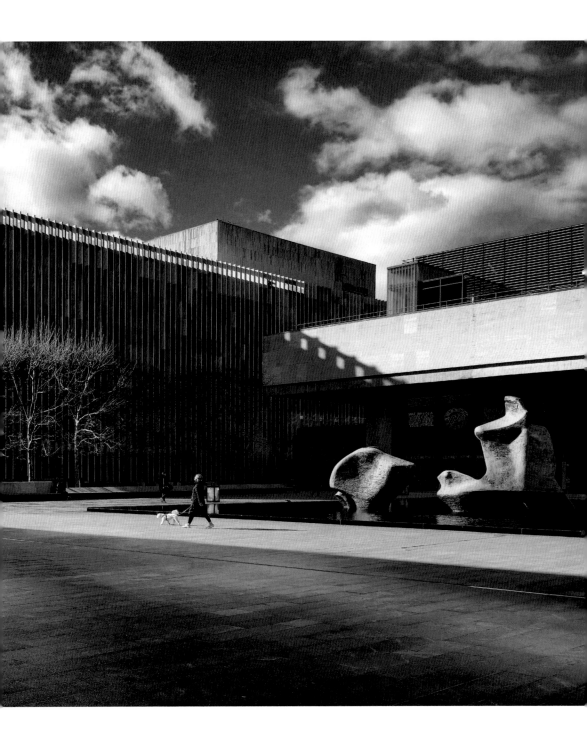

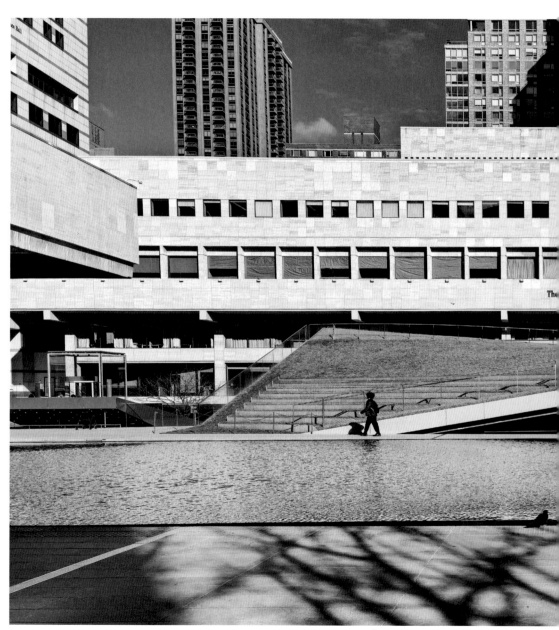

U22 茱莉亚学院 | The Juilliard School

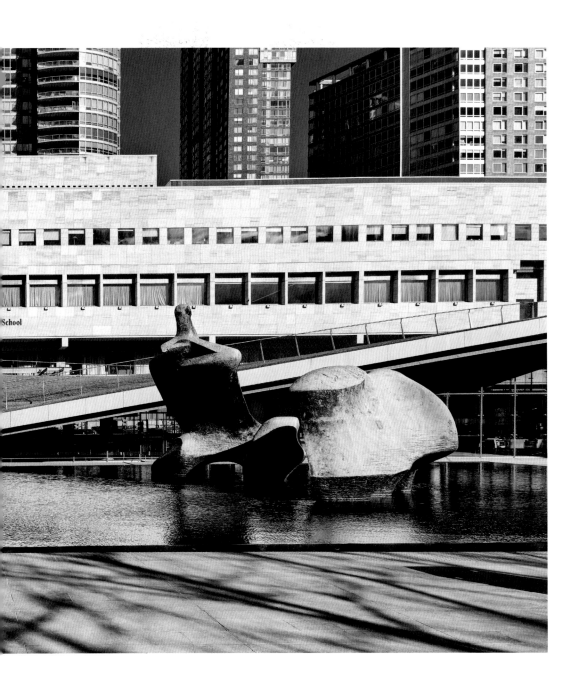

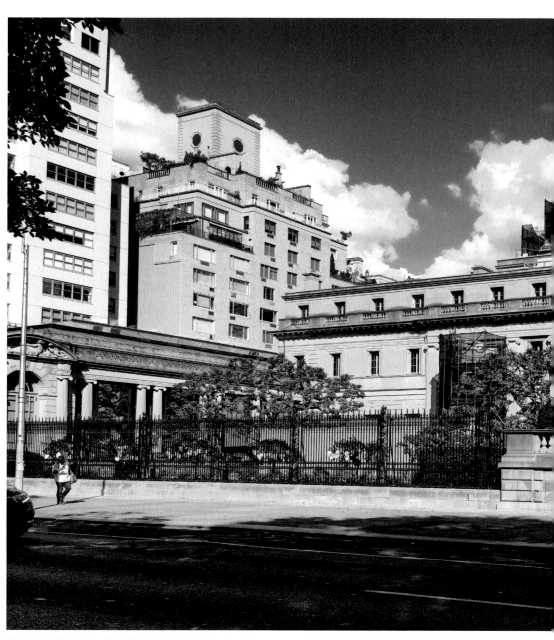

U23 在七十街至七十一街之间的弗里克收藏馆 | The Frick Colleclion between 70 & 71 St.

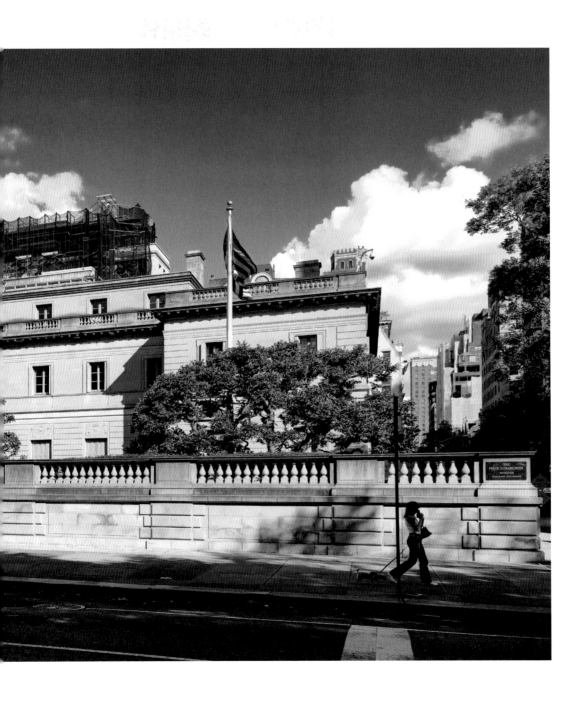

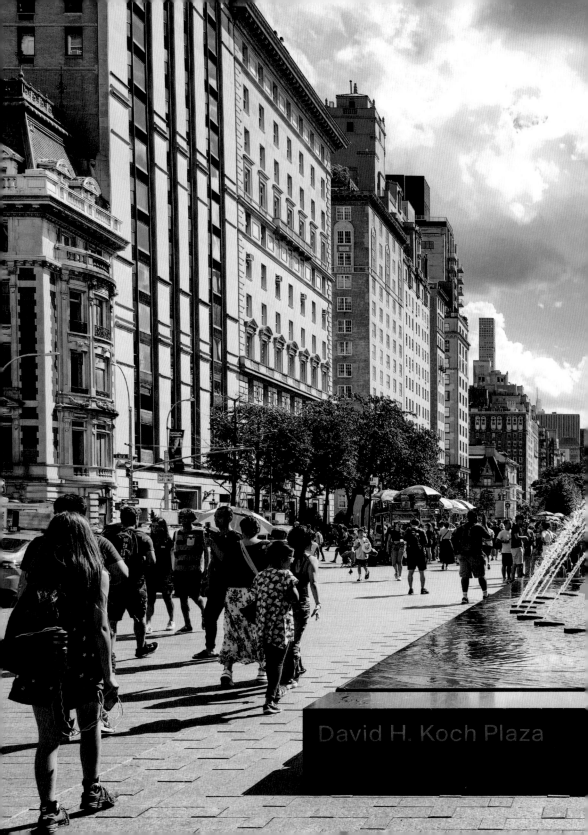

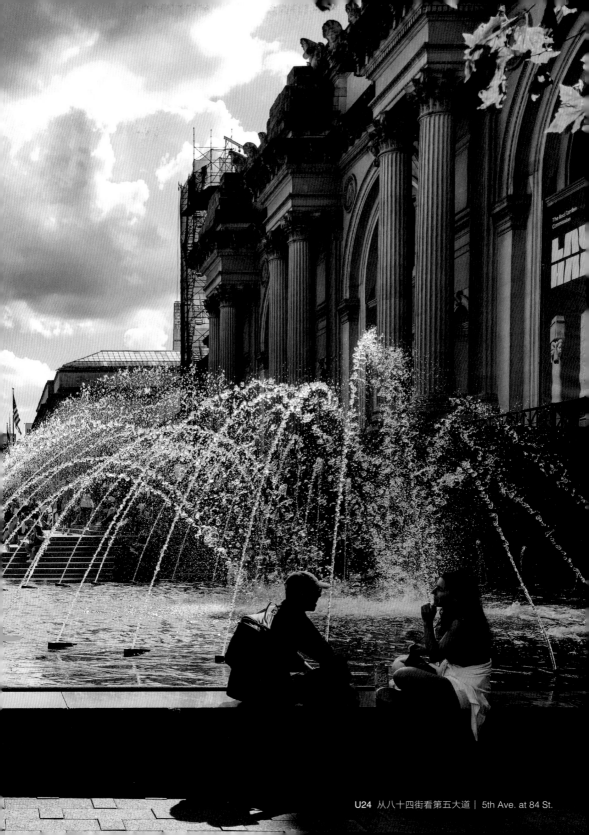

U24 从八十四街看第五大道 | 5th Ave. at 84 St.

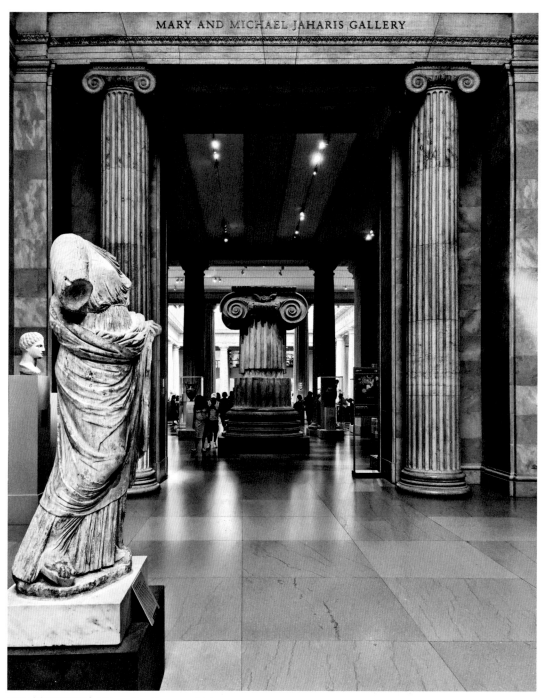

U25 大都会博物馆 | Metropolitan Museum of Art

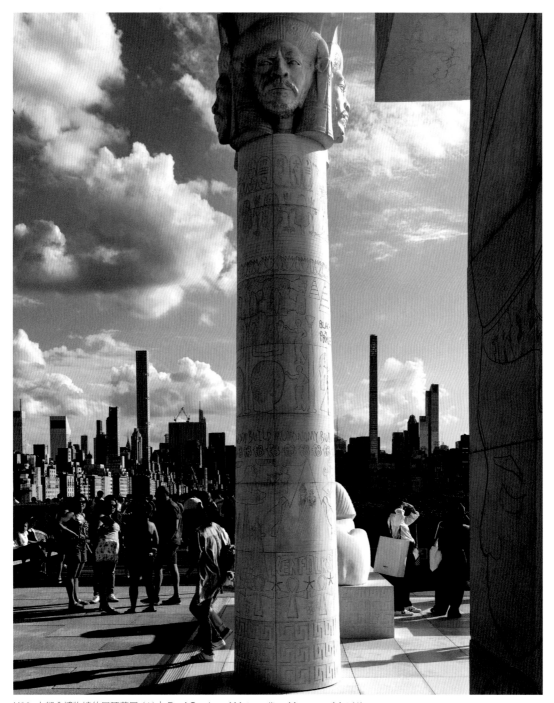

U26 大都会博物馆的屋顶花园（1） | Roof Garden of Metropolitan Museum of Art (1)

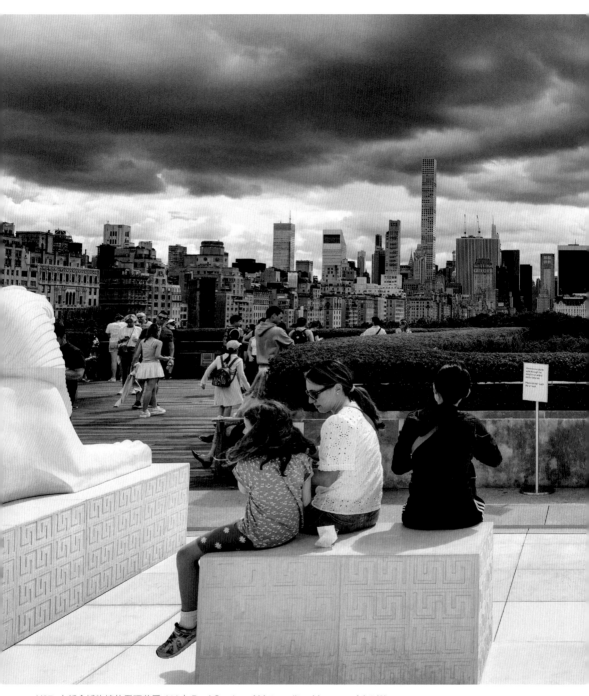

U27 大都会博物馆的屋顶花园（2）| Roof Garden of Metropolitan Museum of Art (2)

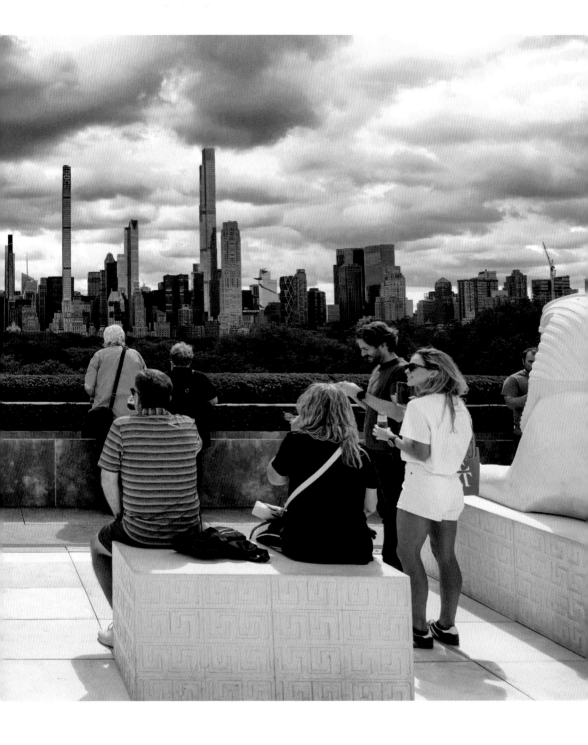

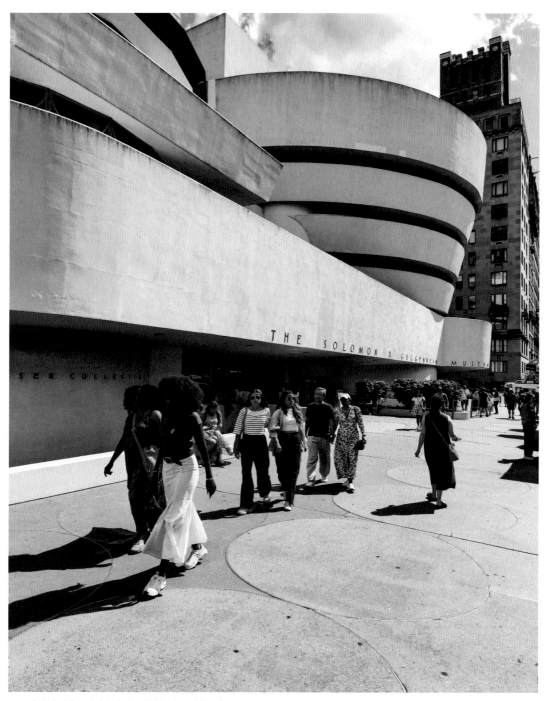

U28 在八十八街至八十九街之间的格根海姆博物馆 | Guggenheim Museum between 88 & 89 St.

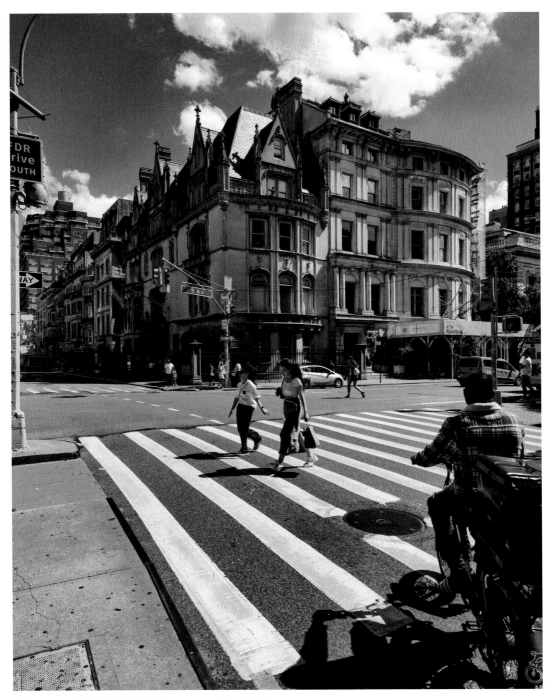

U29 从七十九街看乌克兰研究院 | Ukrainian Institute at 79 St.

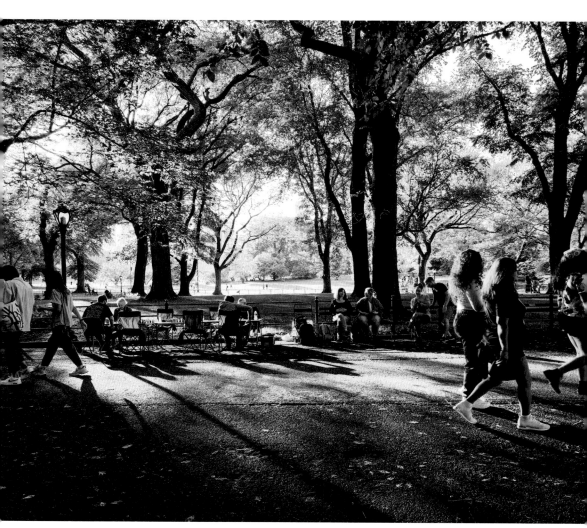

U30 中央公园的林荫道 | The Mall at Central Park

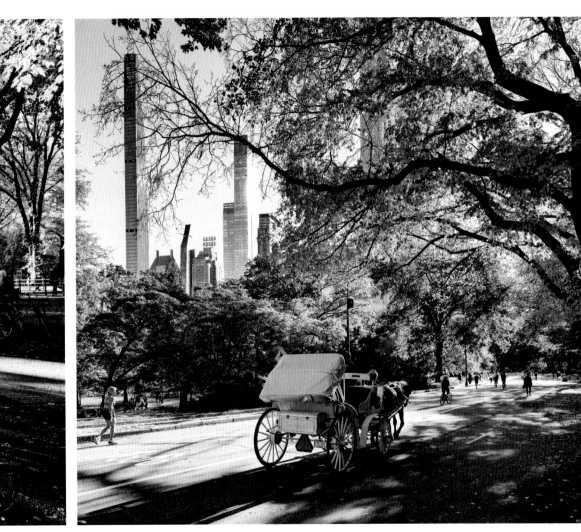

U31 中央公园的车道 | Central Park Driveway

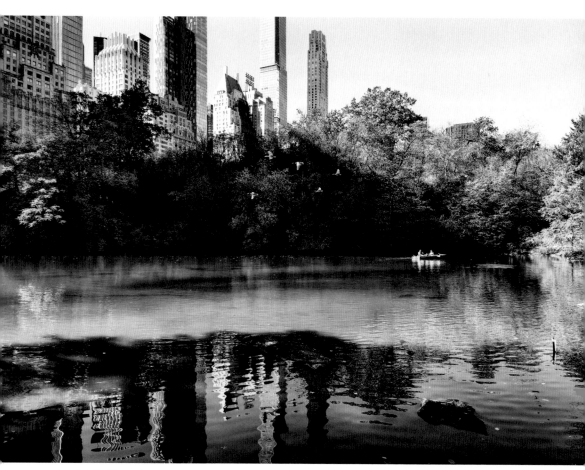

U32 中央公园的池塘（1） | The Pond at Central Park (1)

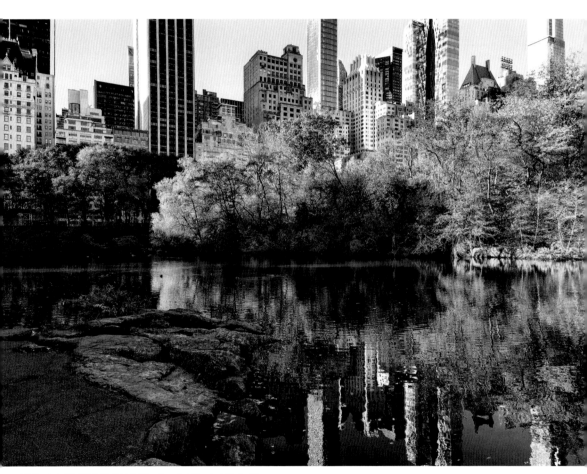

U33 中央公园的池塘（2）| The Pond at Central Park (2)

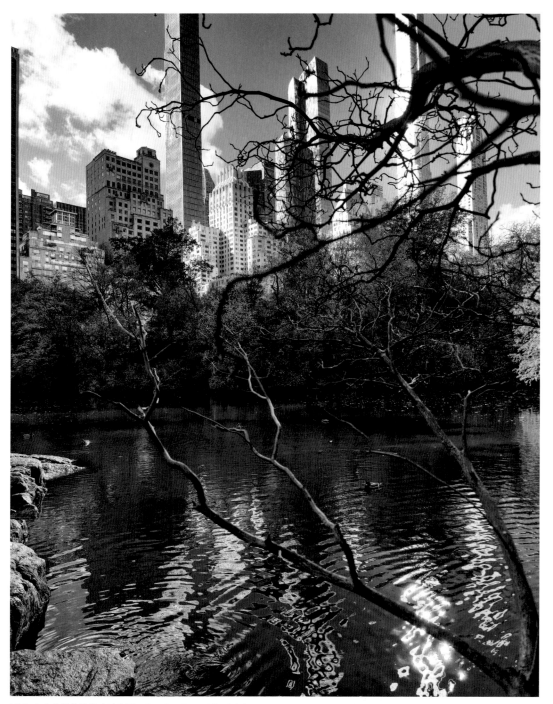

U34 中央公园的池塘（3）| The Pond at Central Park (3)

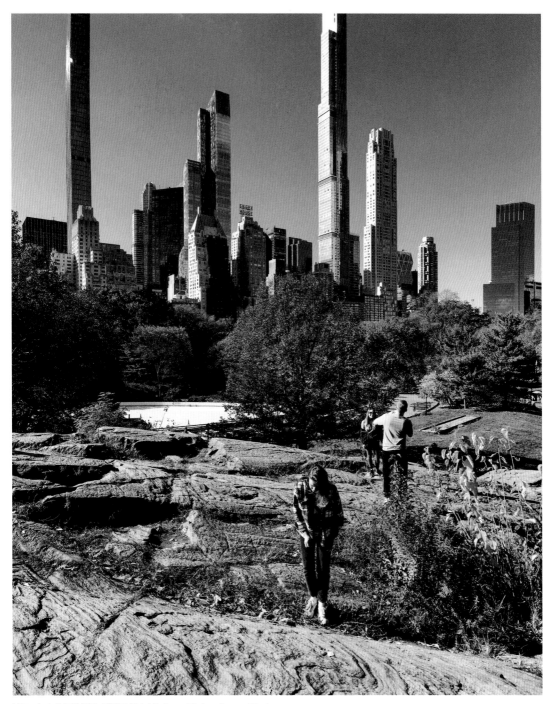

U35 中央公园的沃尔曼溜冰场 | Wollman Rink at Central Park

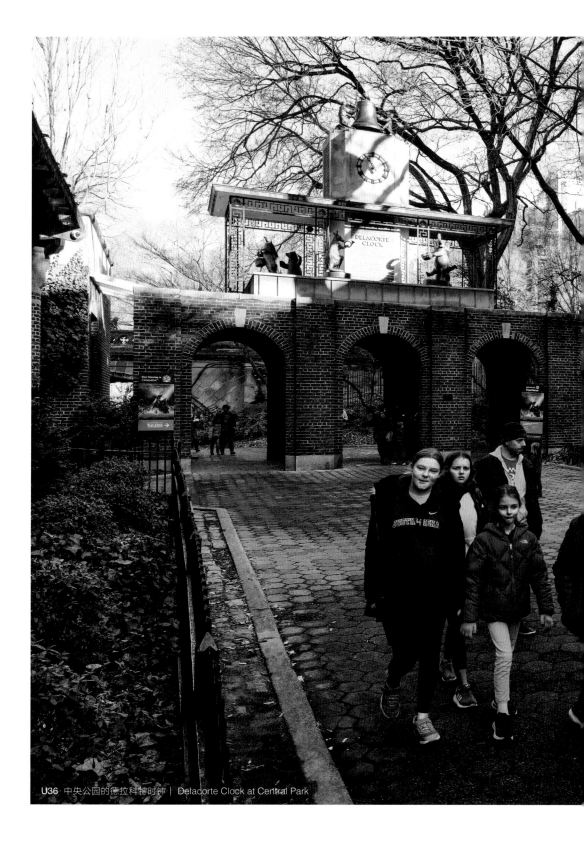

U36 · 中央公园的德拉科特时钟 | Delacorte Clock at Central Park

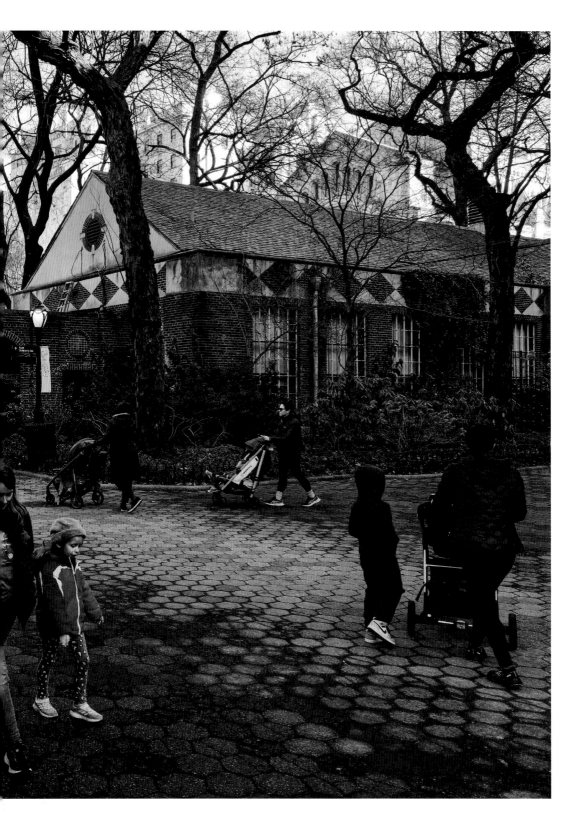

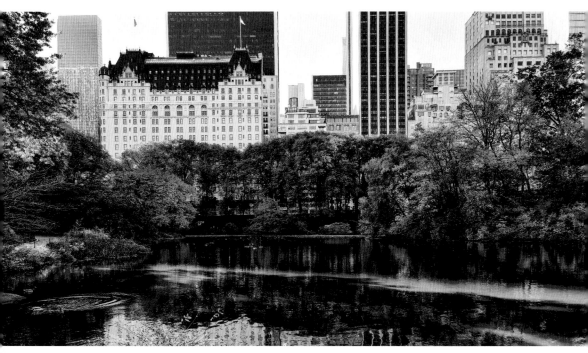
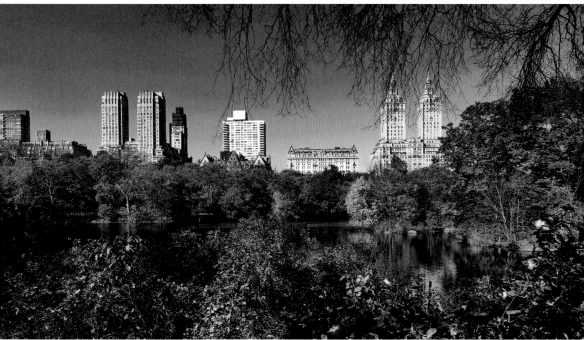

U37 池塘对岸的广场酒店 | The Plaza Hotel from the Pond
U38 中央公园以西的景观 | Bow Bridge View West at Central Park

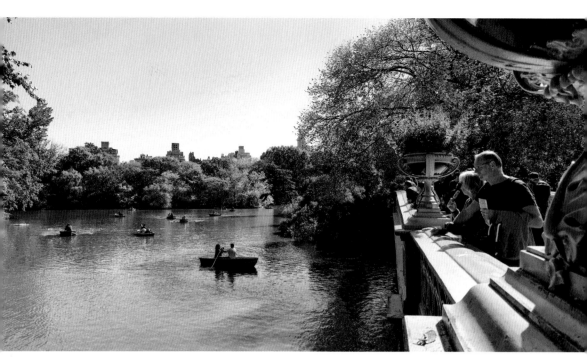

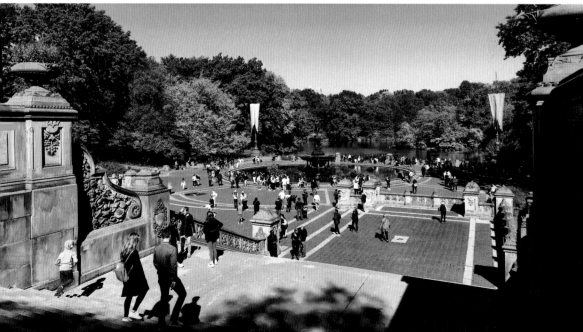

U39　中央公园的弓形桥 | Bow Bridge at Central Park
U40　中央公园的贝塞斯达露台 | Bethesda Terrace at Central Park

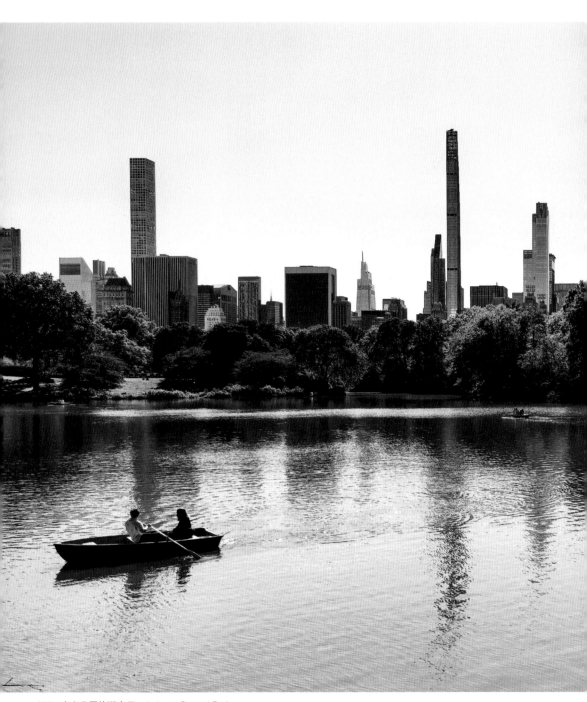

U41 中央公园的湖 | The Lake at Central Park

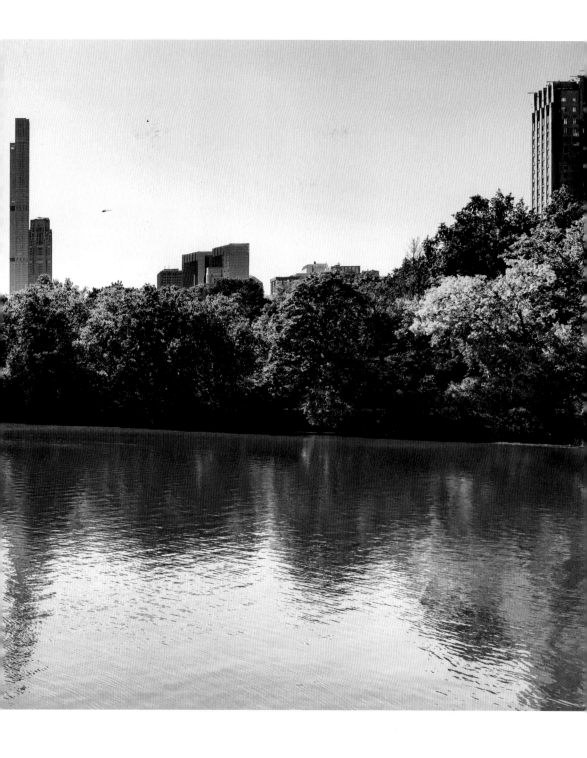

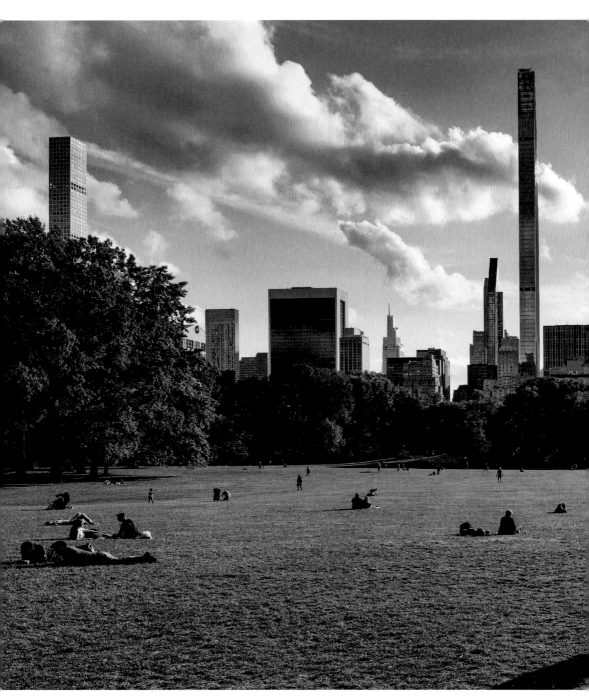

U42 中央公园的绵羊草地 | Sheep Meadow at Central Park

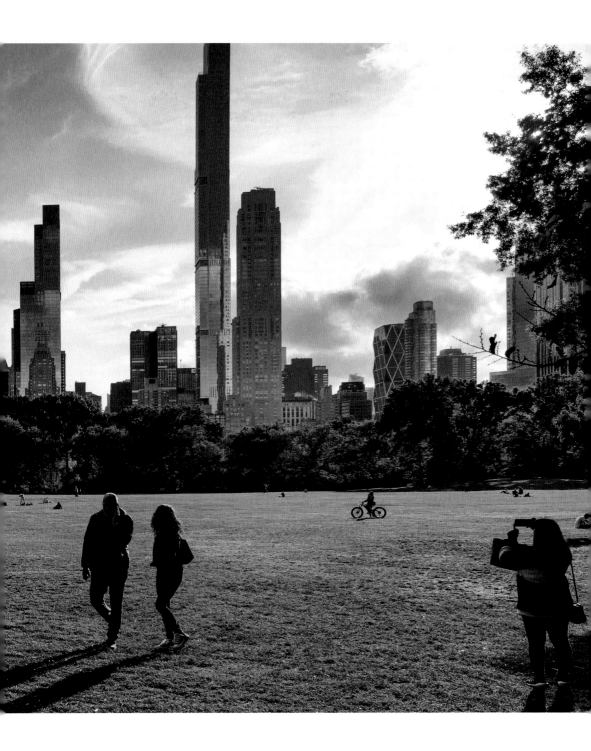

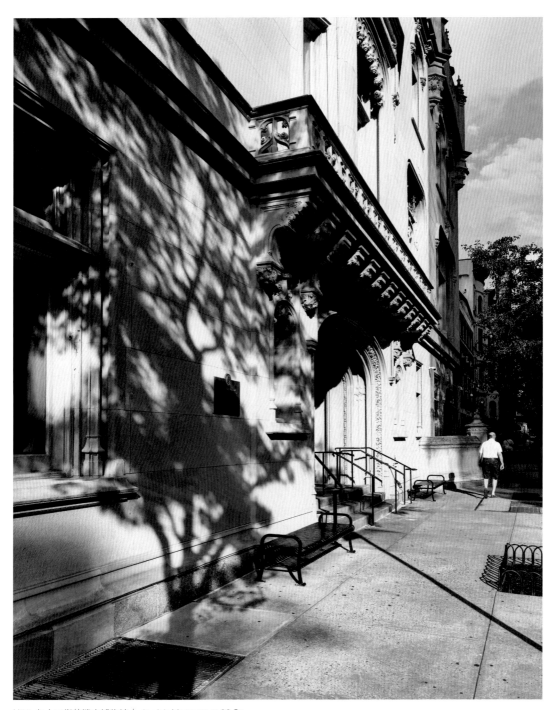

U43 九十二街的犹太博物馆 | Jewish Museum at 92 St.

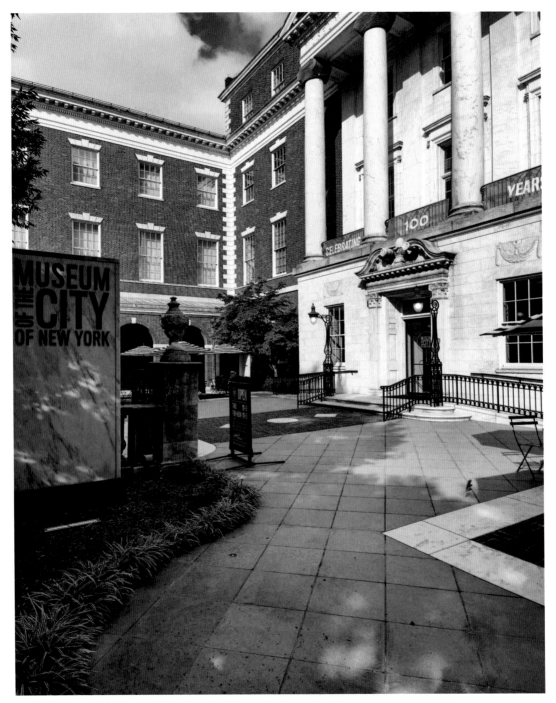

U44 纽约市的博物馆 | Museum of the City of New York

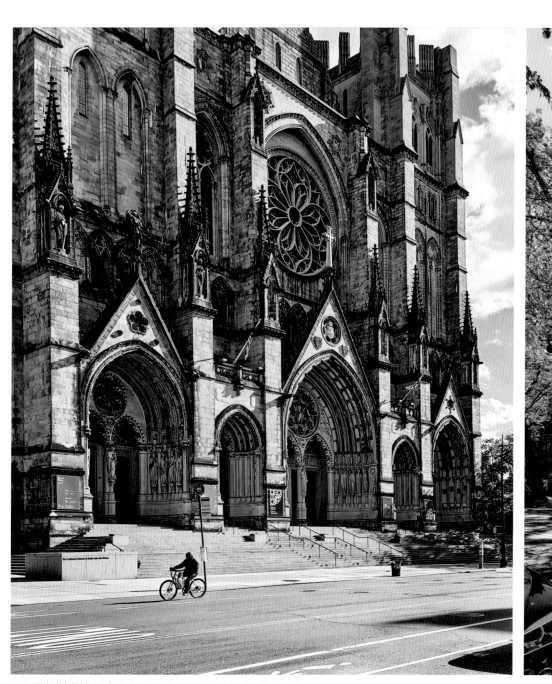

U45 圣约翰大教堂（1）| Catherdral Church of St. John the Divine (1)

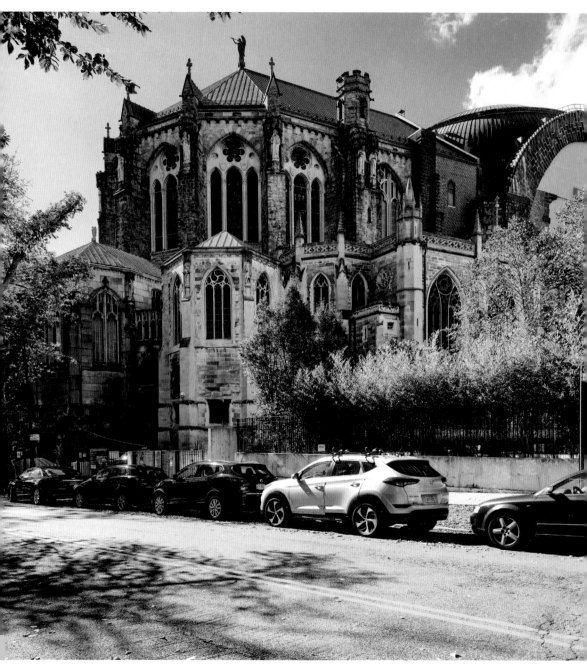

U46 圣约翰大教堂（2）| Catherdral Church of St. John the Divine (2)

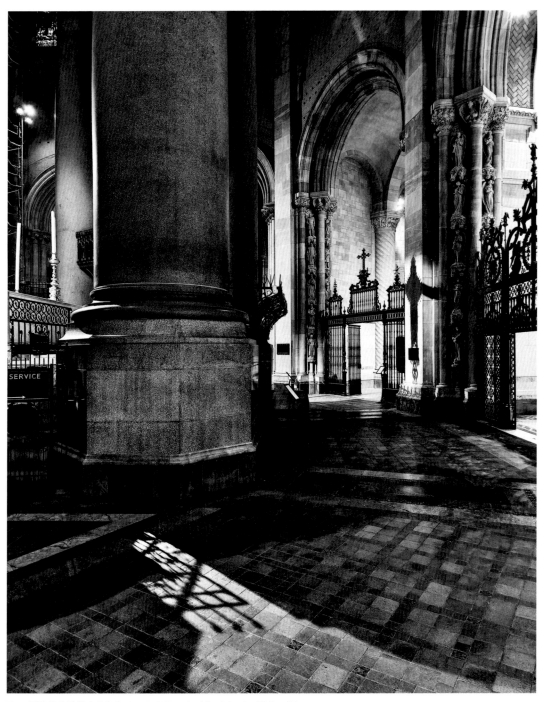

U47 圣约翰大教堂（3） | Catherdral Church of St. John the Divine (3)

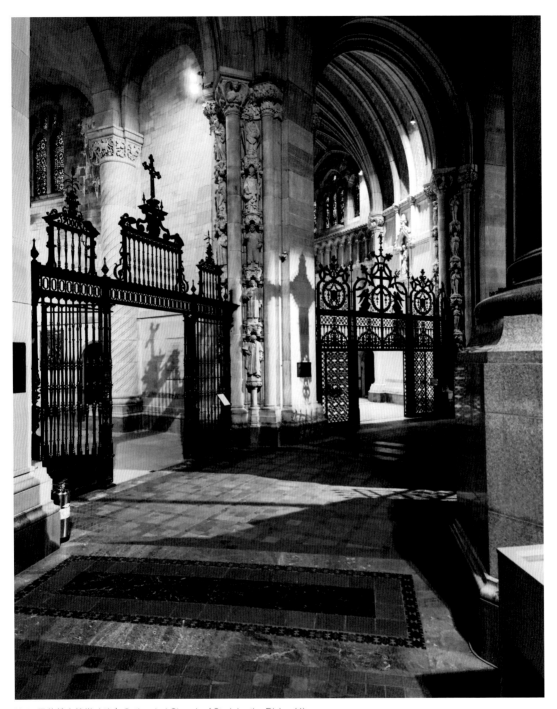

U48 圣约翰大教堂（4） | Catherdral Church of St. John the Divine (4)

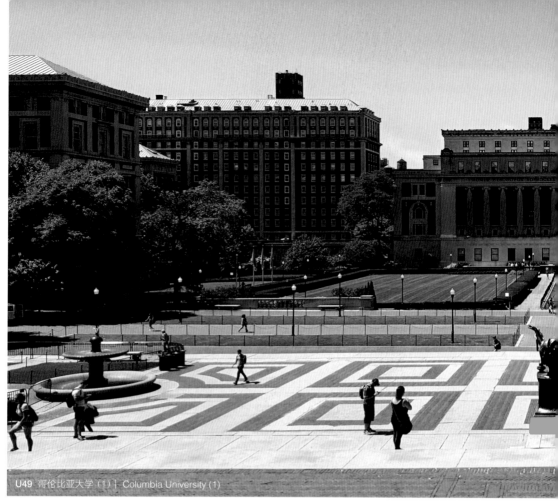

U49 哥伦比亚大学（1）| Columbia University (1)

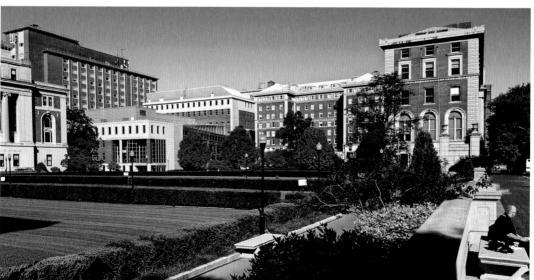

U50 哥伦比亚大学（2）| Columbia University (2)

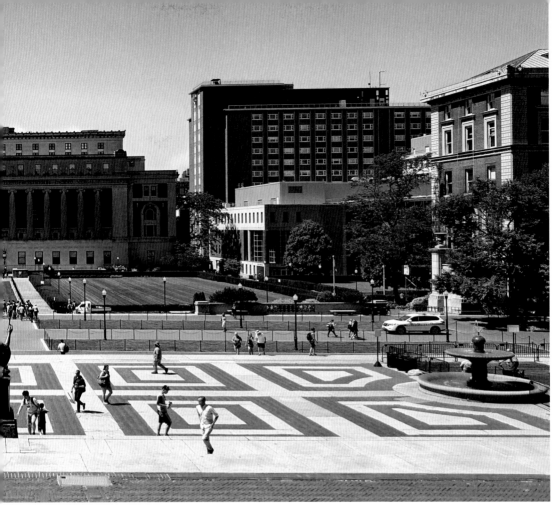
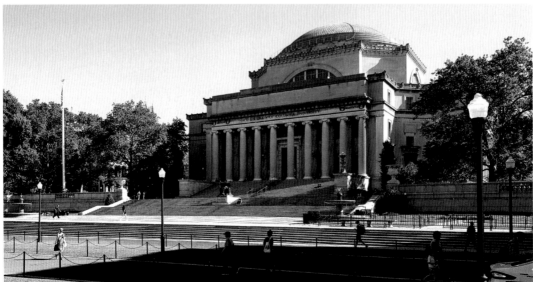

U51 哥伦比亚大学（3） | Columbia University (3)

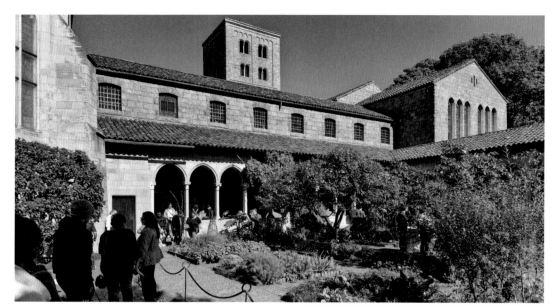
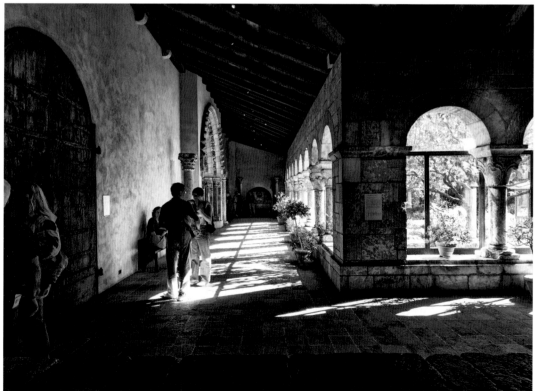

U52 / U53 修道院艺术博物馆（1/2） | The Cloisters Museum of Art (1/2)

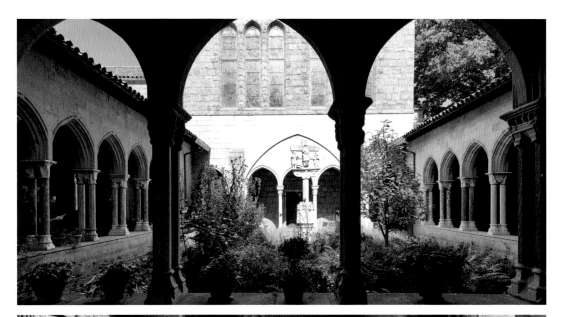

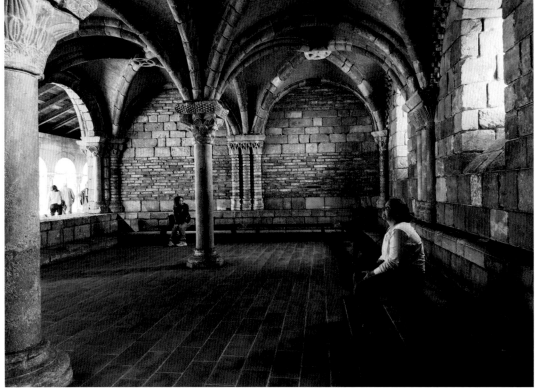

U54 / U55 修道院艺术博物馆（3/4） | The Cloisters Museum of Art (3/4)

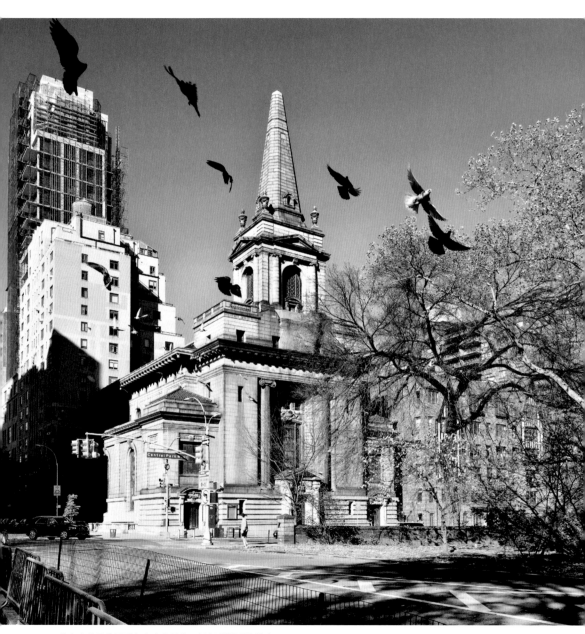

U56 从中央公园往西看九十六街的第一基督科学派教堂 | First Church of Christ Scientist 96 St. at Central Park West